FINE WINES

THE BEST VINTAGES SINCE 1900

© 2009 Assouline Publishing
601 West 26th Street, 18th floor
New York, NY 10001, USA
Tel.: 212 989-6810 Fax: 212 647-0005
www.assouline.com

Translated from the French by Josephine Bacon,
with additonal translation by Andrew Ayers

ISBN: 978 2 7594 0415 5

Color separation: Planète Couleurs (France)
Printed by Grafiche Milani (Italy)

MICHEL DOVAZ

FINE WINES
THE BEST VINTAGES SINCE 1900

ASSOULINE

INTRODUCTION

Of all the books on my favorite subject that have passed through my hands in recent years, I can honestly say that few have held for me such fascination as Michel Dovaz's *Fine Wines*.

The reason is easy to see but rather more complicated to explain. Indeed, like a fine wine, it speaks for itself. Also, like a fine wine, it not only appeals immediately to the senses but, the more one sips and tastes, the more is revealed.

What I am trying to say is that *Fine Wines* works on several levels. First, one notices the illustrations, which are a feast for the eye: a veritable kaleidoscope of color that manages to reflect the wide ranging scenes, varying from close-ups to panoramic views, and interspersed cunningly with double-page spreads in black and white, which encapsulate and evoke each period. But, however attractive the presentation, the meat of the book is the written word. Michel Dovaz is in a league of his own. I cannot think of any English writer, and there are many, who has the same approach to wine. If I use the term "intellectual," it might sound dry, perhaps even off-putting. But, the truth of the matter is that Dovaz displays in all his work an original mind. There is nothing secondhand about his opinions. He brings a freshness of approach and a rare sensitivity to what many of us wine lovers take for granted.

In the first part of the book, he takes us through the essentials: what exactly is needed to produce fine wines? The constant factors nevertheless vary from country to country, district to district: soil, subsoil, drainage—so mundane, yet so crucial.

There are the factors beyond man's control, the climate and its variables, which have such an effect on quality; and those which are at the disposition of the producer, from grape varieties and clones to vine husbandry, winemaking, and that French term *élevage*, which, like *terroir*, has no precise equivalent.

To be frank, once most of us have mastered the basics, or are at least aware of them, we tend to take them for granted. But I frequently remind myself that it is so easy for us to select, to buy, to taste, to criticize, to drink—and so difficult, so risky, so expensive to produce the wines that provide us with such a wealth of interest and enjoyment.

In the second and necessarily extensive part of the book, indeed the core of the work, more than a century of wines is handled in a direct yet ingenious way. Dovaz introduces each period by reminding us of significant events and personalities; setting the scene, historically and evocatively. Then—and this is his tour de force—picking out the greatest vintages and illustrating them with the most perfect examples of wine produced in each of these years. Moreover, and I have not seen it done before, he encapsulates the particular features and qualities of each representative wine. As this happens to be my particular area of expertise, I followed the progress of these vignettes (rather an appropriate term to sum up a description of vine, wine, and vintage) with particular attention and growing excitement. What vintages, what wines had Dovaz selected, and had he missed any? Not really. Of course, one could argue that perhaps another vintage, another wine could, should, have been included. In fact, all the truly great examples are in the text. Yet, to be fair, Dovaz lists the "also rans" under "other great vintages" (and wines) toward the end of the book.

I am entranced, and hope the reader will be, by the wealth of factual, instructive, vivid, tantalizing descriptions and evocative pictures. Well done, Dovaz and Assouline!

MICHAEL BROADBENT

Senior consultant, wine, Christie's International

PREFACE

Going back as far as recorded history, we have at our disposal the names of the most highly prized wines, from the Tanitic of the Egyptian pharaohs to the Chians of ancient Greece and the Falernians of Rome. Unfortunately, detailed descriptions of the wines themselves are rare, and to attempt to construct a list of the greatest achievements of oenological creation could truly be termed "mission impossible."

In reality, building a list of the greatest vintages is possible only if the arbitrary nature of such an undertaking is recognized and allowances are made. Thus, this book is not an encyclopedia but an anthology—or, more precisely, a garland of the greatest vintages, in which each flower is the wine or wines that are the best representative of their kind.

In fact, the great wines, as we know them today, date from the mid-seventeenth century. The "new French claret" debuted in 1633, at a time when wine was delivered in barrels and was drunk young. However, the great wines only reveal themselves through their tertiary aromas, which develop over several years in restricted conditions—such as when protected from oxidization by the hermetically sealed bottle. In France, the sale of wine in bottles was forbidden, as they were too easy to steal; the ban was lifted in 1725 for the Champagne region, and later for non-sparkling wines (at Château Lafite, for example, the first bottling occurred in 1781). So we see that what we now think of as the great wines could only develop as such from the beginning of the nineteenth century, and they were a European—and solely

European—concern until the late-twentieth century.

While assessments of quality can only be approximations, it is worth noting two coincidences: in the course of both the nineteenth and twentieth centuries, the thirties were relatively unproductive. The years '88, '89 and '90, on the other hand, were excellent. In fact, Nature has proved to be extremely fair and one can count on a great year approximately once every ten years.

It is also interesting to note that the vicissitudes of the economy have done little to affect the market in the highest-quality wines. Production remains limited and demand is small in volume but consistent, quite independent of economic crises because it emanates from a moneyed clientele.

But what influences will hold sway over the wines of the twenty-first century? There may be dramatic changes of climate ahead, resulting from the greenhouse effect; however, producers and consumers may take comfort in the fact that an examination of the past two centuries reveals considerable stability in the climate, and thus the consequences, for the world's vines. Nor should we assume that consumers' tastes have, or will, remain static. Emerging markets in the new wine-producing countries have already triggered shifts in taste, and therefore production.

Following the success of the acclaimed first edition of *Fine Wines*, this expanded edition adds new chapters to this saga of excellence, opening a vista onto a new horizon in winemaking. We are now seeing the fruits of the new producing countries' labors, with entries from Argentina, California, Chile, New Zealand, and Spain among the new additions. The effect on the market of these robust yet refined wines remains to be seen, but the staggering array of options may yet produce a new generation of oenophiles.

One thing is certain: all great wines, no matter their provenance, are "loners." They remain impervious, independent, superbly indifferent, and far from the madding crowd. This book will at least reveal who and what they are—even if it is not possible to sample them! At best, it will tell their stories.

Part One
The Great Wines

"Can you imagine, my whole fortune depends on three hours of sunshine."

MICHEL DE MONTESQUIEU
(as the philosopher-vintner wrote to
Madame Dupré de Saint-Maur)

Toward the Great Wines

Excellence is not a uniform characteristic, but the best of the excellent becomes the outstanding, and the outstanding is all that we are concerned with in this book.

Below: Wine-tasting in a cellar.

Despite all this, in a world in which everything is measured and assessed, is it possible to speak of evaluation methods in relation to

Opposite: Tasting a Vosne-Romanée.

wines as rare as those which are about to be discussed? Not really. The birth of a great wine is heralded by rumor. The rumor is confirmed by its persistence, and tastings indicate whether or not it is well-founded.

The whole problem of assessing an outstanding wine lies not in its nature, which, when all is said and done, differs little from that of a good wine, but in a set of factors that are as essential as they are infinitesimal, even indescribable. Oenologists are fully aware of the measurable constituents of wine: its percentage of alcohol, level of acidity, tannin content, residual sugars, and the volatile acidity that should not be exceeded, as well as the acceptable sulfur level (combined and free), and so on. They can thus determine, without even tasting the wine, whether it is "of saleable quality" or whether it is unfit for human consumption. An appreciation of the

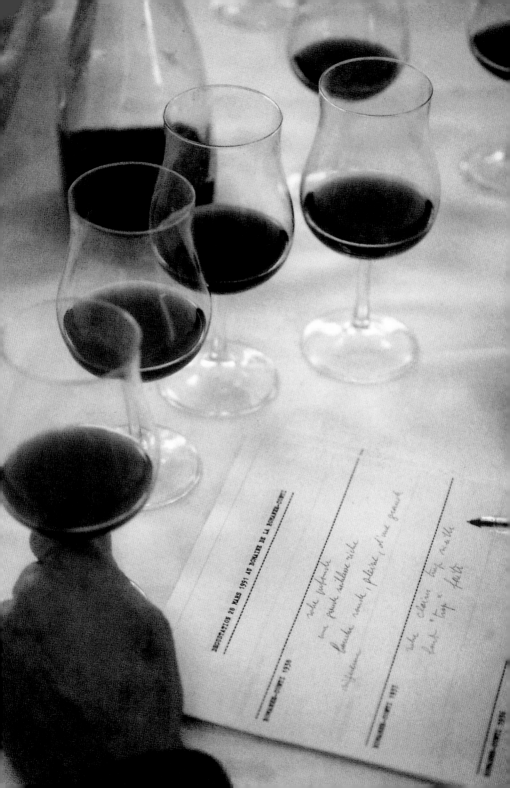

Sauternes.

quality of a wine lies elsewhere. Only a tasting can make things clear by combining the tactile impressions, an assessment of the aroma and "length in the mouth." Tasting alone reveals the balance and harmony resulting from several hundreds of items of information which combine, juxtapose, compensate, counteract, or complement each other in the various receptors of the olfactory organ.

When it is realized that the human nose can normally distinguish between 400,000 odors, which ought to be imperceptible (since they are carried in a millionth of a milligram per liter of air), words become quite inadequate to describe a wine, whether great or unexceptional, and justify—or merely explain—why one wine is exceptional and another is not. A great wine must fulfill two conditions. It must have absolute balance and a perfect aromatic harmony. A number of essays on wine have defined balance by using spatial representations to symbolize the golden mean between acidity, mellowness, and astringency. Harmony, on the other hand, or if you prefer, aromatic balance, cannot be described in words; concepts of strength, richness, purity, finesse, and aromatic complexity have to be taken into account.

A wine that is average in quality may be balanced and may even possess a simple harmony. The harmony will be judged as simple due to its limited number of aromatic components, which may not be powerful enough, pure enough, or perhaps complex enough.

A great wine, on the other hand, is conspicuous by its perfect balance, which is aromatically harmonious, pure, powerful, and above all, complex. It is rare for any great wine not to be "long in the mouth." Experience shows that the evidence for aromatic complexity is the appearance of what are called tertiary aromas of aging. A very great wine must therefore be a wine that possesses great longevity. Various factors may contribute to the longevity of a wine. These include the grape variety, age of the vine, vinification and, above all, the territory on which it grows, the term "territory" embracing both soil conditions and climates.

The nose.

The Land, a Constant

Where viticulture is concerned, the concept of land is fairly vague and encompasses several factors. Apart from the climate, two things must be taken into account: human intervention and the soil.

Human Intervention

Without this, the land would never reveal itself. Humans must discover the most suitable vine stock for the soil type, and must improve the land through drainage or by tilling the soil. In the countries of Europe which have a long winemaking tradition (those which produce the legendary vintages), the adaptation between grape variety and land is complete, at least as long as the current organoleptic prototypes persist. On the other, the countries that are termed "new producers" may well evolve in their present production.

It should be noted however, that human intervention is becoming ever more restricted now that propagation and growing techniques are becoming uniform through teaching.

Vineyard on the early slopes of Bordeaux.

The Soil

The soil type is fundamental. It is not a question of whether or not a grapevine will grow in a particular soil but of whether it is capable of producing grapes of high quality. In this respect, the soil's drainage ability is an essential factor. As early as 1857, the ampelographer Victor Rendu observed: "The vine adapts to any kind of terrain as long as water does not stagnate on it."

Therefore pure clay, with its very fine granulometry, is unsuitable for viticulture. The whole subject becomes more complicated when one realizes that in transverse section, the soil looks like a slice of flaky pastry whose various layers are different in type and thickness.

The water table, its distance from the surface, and the source of its water supply all constitute another fundamental element that must be taken into account.

The filtering capability of the soil is a vital factor, but the soil's ability to restore water—generally by capillary migration—is also very important, especially during dry summers. The orientation of the slopes, their gradient, and the environment also play an important part. Over and above the physical aspect of the soil is its chemical composition. Here, several thousand factors are involved, all of which play their own part in feeding the vine.

Even though the principal agents for improving the vitality of a vine stock are well-known, it is infinitely harder to determine the chemistry that differentiates a Château Lafite from a Château Mouton Rothschild. The combination of these determining factors at their best is the basis for the creation of great wines, but the plethora of complex data is what makes it so hard to analyze them.

The Climate, a Variable

On the other hand, we are better equipped to perform climatic analysis. Meteorological stations regularly report the air temperature, percentage of humidity, rain (in inches or millimeters per day), etc. This data, however summary, recorded over the annual growing period, is sufficient to indicate the quality of a vintage.

The Vintages

Winemaker Bernard Ginestet conducted research in the Bordeaux district in the 1970s concerning the consequences of climatic variables. It is summarized here in a graphic, but was the result of a long and arduous study, which took five factors into account:

- maximum temperature
- minimum temperature
- number of hours of sunshine
- number of hours of rain
- depth of precipitation

The formula he obtained appears to be fairly balanced because about half of the wines are above average, the other half below.

A very great vintage involves other factors, however, including the need for temperatures above 86°F. It is therefore important to know the number of days or hours on which the temperature exceeded 86°F and the amount and distribution of sunshine as the grapes ripened. In this respect, oenologist Émile Peynaud notes that the quality of the grape harvest is mainly conditional upon the amount of sunshine in the months of August and September, but he adds, "It can be said that the weather in the last week counts for double."

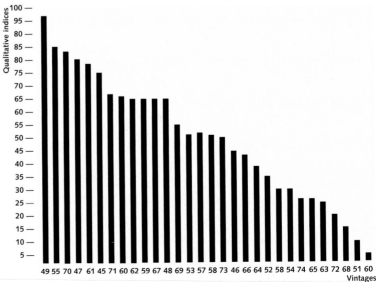

Qualitative indices

100 —
95 —
80 —
85 —
80 —
75 —
70 —
65 —
60 —
55 —
50 —
45 —
40 —
35 —
30 —
25 —
20 —
15 —
10 —
5 —

49 55 70 47 61 45 71 60 62 59 67 48 69 53 57 58 73 46 66 64 52 58 54 74 65 63 72 68 51 60
Vintages

Opposite:
Châteauneuf-du-
Pape vine stock.

Heat and dryness are almost always favorable conditions, unless a severe drought impedes growth, starving the grape of sugar, or if the sun broils it to a frazzle. On the other hand, although some rains are beneficial (the frequent summer storms in August), others are catastrophic. If it rains during a hot spell on ripe grapes, they will rot immediately, and if grapes have to be harvested in the rain, this will inevitably result in loss quality. These generalizations of climate and how it affects the vintage ought also to take account of two special cases, namely the influence of a microclimate where the data set differs from that of the nearest weather station, which may well be located several dozen miles from the vineyard, and the special position of the vineyard in relation to the others that enjoy the same appellation.

Finally, a great vintage is the result of a particular configuration of the bunch of grapes. It is imperative that the individual grapes be small with a thick skin, especially in the case of red wines. The advantage is easily understood if one takes account of the relationship between the volume of liquid (the volume of must) and the surface of the skin. For a given volume, the larger the surface of the skin, the more concentrated the extraction, since all the elements which constitute the

Below:
A bunch of Pinot Noir grapes.

Opposite: Vines in the rain.

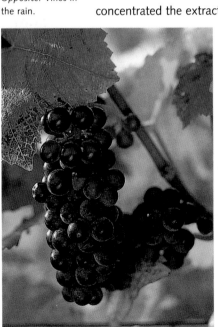

wine, with the exception of the sugar, are concentrated in the skin of the grape. A thick skin also makes it resistant to attacks from disease and insects and increases the quantity of extractable elements.

Climate and Land

Clos de Vougeot, near Burgundy, France, is a huge, hilly, enclosed vineyard, and so does not react uniformly to climatic variations. In the course of an average year, the upper and central areas of the enclosure produce the best wines, and the lower-lying plots receive all the runoff (especially as the Route Nationale 74 runs above and beside the land on an embankment that certainly never

existed in the twelfth century, when the Cistercian monks created their vineyard). On the other hand, in years of serious drought—1976, for example—the lower-lying plots produced better wine. The quality of a territory, in the geological sense of the term, has nothing absolute about it, since each parcel reacts differently to the vagaries of the climate depending on its own geological features, as well as its altitude, gradient, and the surrounding environment (hilltop, valley bottom, etc.). Under these conditions, the ideal vineyard would be one planted on a territory capable of adapting to all the possible weather conditions without losing its quality, and giving of its best under all circumstances. Does such a territory exist? No statistical survey of the plasticity coefficient (adaptability to the climate) of plots of land or estates has ever been produced. Yet everyone knows of or has heard of a château or an estate which is famous for being able to produce minor vintages on a regular basis.

Château Latour, in the Bordeaux district, has such a reputation. An examination of the Château Latour territory reveals the secret of its plasticity. The ground is particularly poor and with maximum filtration capacity (porosity) in its first 30 inches (this is called the topsoil), while the subsoil below it consists of clay loam, which contributes richness and humidity.

These various observations lead one to wonder whether there is such a thing as a vineyard grown on a soil that has no plasticity whatsoever and which only rarely produces an exceptional wine, for example every 10 years or every 20 years.

Theoretically, there is nothing to stop this happening, although the production of a great wine assumes great investments and perfect mastery of the technique. Hence the conclusion, which might be judged an exaggeration, of the wine expert Roger Dion, who wrote in 1959: "The quality of a wine is not so much the expression of a natural milieu, but is considered as the expression of a social milieu." There is a region of France in which investment, skill, technical prowess, and the "social milieu"—to borrow Dion's expression—are all at their peak. It is in that part of Champagne which produces red wines. In about one year in ten, certain Bouzy Rouges or an Ay Rouge

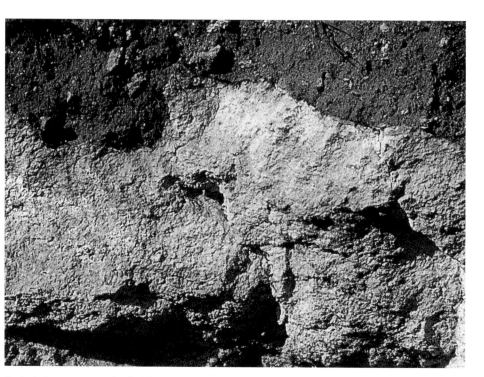

Geological cross-section of soil in the Bordeaux district.

(the Côte aux Enfants de Bollinger, for example) manage to haul themselves up to the dizzying heights of outstanding wine. (The two other factors that come into play here will be discussed later, namely archetypes and volumes of production.)

Once it is recognized that great wines are often born at the limit of the growing range of a vine variety, the question must be asked whether the limit can be extended when exceptional climatic conditions prevail (this question really only applies to vines used to make white wines.) It can well be imagined that many vineyards have been abandoned because they could only produce an outstanding wine on rare occasions. There are several examples in French history. For instance, the hill of Coucy, in Picardy, topped by an imposing ruined castle, might be considered an ideal place to plant a vine, and this is a perfectly reasonable assumption because in the late Middle Ages, Coucy wine had an extremely high reputation. But Coucy lies too far

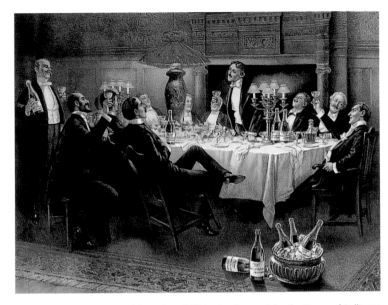

Late 19th-century British advertisement for the House of Bollinger.

to the north, and the Fromental variety (*aka* Pinot Gris) only achieved full ripeness on rare occasions. Yet when it managed to do so, all of the finesse of the north was brought to bear in a balanced acidity and sufficient percentage of alcohol to produce a white wine of very great lineage. Its unreliability proved fatal, however.

This vineyard of Coucy, alas long gone, belongs to the category of "phantom vintages" which would otherwise have found their place in this book, alongside the greatest wines.

Climate and Vines

The vegetative cycle is the succession of stages in the life of a vine between two periods of *dormancy*.

In temperate countries, in the winter, the vine sleeps. Vines prefer cold winters, since the cold destroys many of their parasites. Winters that are too cold, however, can do a lot of damage. While brief spells of -4°F do little harm, if they are prolonged, the vine stock will freeze

Opposite:
Menu by Alain
Chapel, 1979
(Archives of the
Château de Fesles).

A l'apéritif :

Petite friture de goujons du lac d'Annecy, persil & fanes de céleris frits,
Pieds de cheval, pleine mer ooooo & bouquet breton,

Gelée de pigeonneaux, trois sot l'y laisse & jeunes légumes,

Côteaux des sables de Vendée, en chaud-froid d'estragon,
toute petite salade de baraquets.

Xérès, très vieux Porto 1937
magnum Cristal Rœderer 1973
Bonnezeaux 1947 - Château de Fesle
Pêches blanches

Petit feuilleté de grenouilles de pays, d'écrevisses "pattes rouges"
& mousserons des prés, au cerfeuil

Poularde de Bresse, dans sa gelée, en terrine
petite salade de cèpes & premières truffes

Bassine de langoustes rouges bretonnes à la nage au meursault

Salade de roquette, reine des glaces, feuilles de chêne & éclergeons,
de canette de barbarie à l'huile de noix & aux chapons

Quelques fromages fermiers

Glace crème vanille & sorbet de pêches de vigne,
fruits rouges de Thurins
Glace crème pistaches & poires Williams au beurre,
tartes aux pralines
Aveline anniversaire & confiture d'oranges amères
Mignardises, candis & chocolats
Les cafés

and die. In the spring, the soil temperature grows warmer. When it reaches 50–52°F, the vegetative cycle is triggered. The sap rises, buds appear and burst forth, and *budding* begins. Twigs and branches cannot begin to develop until the air temperature is higher than 50°F. Then there are several important stages that involve the formation of the bunches of grapes.

Inflorescences lead to *flowering*, in early June, if the temperature is at at least 63°F. If the weather is too cold, the flower will not open, pollination is impossible, the grape does not form, and there is *wilt*. Heavy rain can do similar damage.

After fertilization, the grapes are formed, it is the start of *fruiting*. From late July, *maturing* begins and is indicated by a change in the color of the grapes: white grapes become translucent, and black grapes begin to darken.

Simultaneously, the vine stops growing. During this phase, the plant stores the nutrients it will need when the growing season begins again in the spring.

French grapes attain full ripeness in September. Meanwhile, the leaves turn yellow and begin to fall. The *shedding* is the last phase before dormancy. So throughout the cycle, it can be seen that climatic conditions are decisive and are responsible for the volume and quality of the harvest.

Note, however:

• The inverse relationship between quantity and quality is not as simple as one may have been led to believe. Very small harvests have sometimes produced poor quality wines (in Bordeaux, examples are 1957 and 1969). Large harvests, on the other hand, can achieve high quality (as they did in Bordeaux in 1982 and 1990). On the other hand, the huge harvest of 1973 was spoiled by defects and dilution, and the meager harvests of 1945 and 1961 nevertheless produced legendary wines.

Above:
Fall at Clos
d'Estournel.

Opposite:
Budding *(top)*;
flowering *(center)*;
maturing *(below)*.

• It is always difficult to compare a wine that *exists* with a wine that *might have been*. In other words, it cannot be claimed that 1982 or 1990 would have been better if the yield per acre or per hectare had been smaller. Many experts nevertheless take this view, and the use of reverse osmosis, a vinification technique which is designed to reduce the yield per hectare after the event, seems to prove them right.

• Nature offers ample evidence of her fertile imagination: no two years are ever alike. Even the most exceptional vintages were the result of an extraordinary diversity of climatic conditions.

There are several types of vintages:

• Quantitatively: small crops, average crops, and heavy crops

• Qualitatively: poor, average, and excellent vintages

Where soil type and grape variety do not vary, it is the weather that is solely responsible for variations in the result. It should thus be no surprise to learn that average vintages are the result of average or normal weather conditions.

Finally, here are a few examples of circumstances that can arise:

• Small harvests imply frost, wilting, and sometimes drought.

• Abundant harvests are the result of the right weather conditions, rain coming at just the right time, warmth, and large grapes.

• Poor vintages are a sign that the grapes did not ripen sufficiently, as a result of rot, lack of sunshine, or, much more rarely, stunted growth due to drought. It often rains during the harvesting season.

• The great vintages are the result of an exceptional amount of sunshine, heat waves, a sprinkling of summer rain (around mid-August) and harvesting being possible in dry weather. Under these conditions, the grapes themselves are generally very small.

Left and right: The fall and harvesting as it used to be at Château Latour.
Following pages: Falling leaves at Clos d'Estournel.

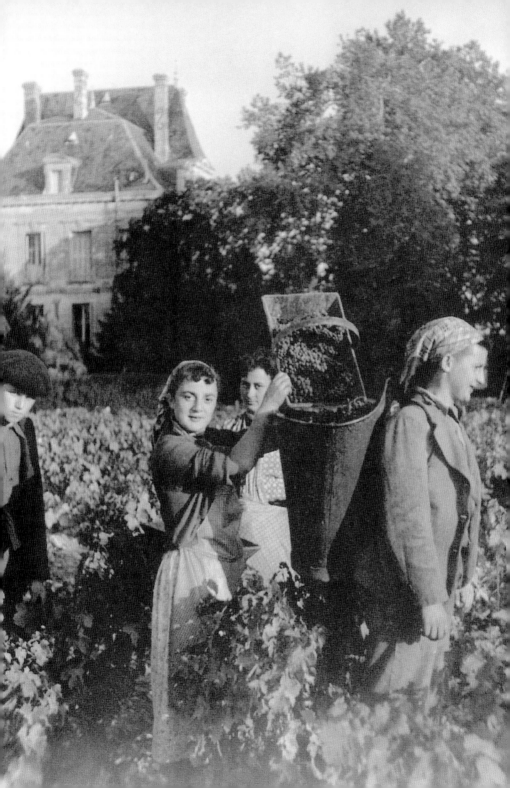

Outstanding Vintages

When the conditions for the birth of outstanding vintages are studied, we see that nature works on the basis of two possible scenarios. The first is obvious and logical, perhaps even a cliché—namely, that the weather must be just right from spring through fall. The years 1929, 1959, 1982, and 1990 belong to this category.

The second condition, more unexpected although recurring, has proved to be particularly effective. The principle is simple. It consists in a draconian reduction of the yield per hectare, resulting in a grape of exceptional maturity. In general, an early spring favors swift opening of the buds. Then a sharp frost will dampen off the buds, sparing only a very few. Occasionally, the initial damage is repeated, making flowering difficult and causing more buds to wither and die. From June through late September, the weather needs to be very dry and very hot, though a brief downpour will prevent the plant from drying out too much. That is how some of the great vintages were born, especially those of 1921, 1945, and 1961.

The great vintages that will be discussed in the second part of this book have become milestones of their times. Their yields provide an opportunity to analyze their achievements and attempt to understand what went into the creation of an exceptional wine. Anyone tempted to single out the "best" vintage of the twentieth century (1921?) and the "worst" (1910?) should be conscious of the subjectivity of individual judgement. As will be shown later, the combination of constant developments in technique and natural factors make it

Opposite:
Exceptional vintages on sale at Christie's.

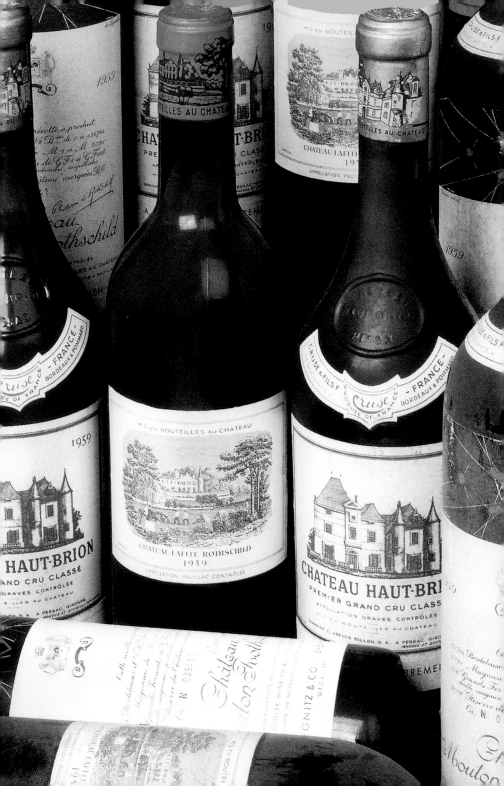

Auction at the
Hôtel Drouot,
Paris.

extremely difficult, if not impossible, to compare the great wines.
more a question of knowing whether such comparisons involve th
quality of the wines of a particular year. Have vine-growers and
winemakers always been able to get the best out of nature, starti
1900? To reply in the affirmative would be to deny progress—it v
be the equivalent of believing that grapes and wines had never b
improved through new vinification methods, changes in planting
techniques, grape varieties, and so on, and to claim that the taste

the consumer have not altered one iota. This is not the appropriate place to determine whether production influences taste, or vice versa. But the developments that have affected the vineyards are worthy of examination. What changes in the twentieth century had an impact on the organoleptic qualities of wine? Despite the fact that the great wines have changed far less than the ordinary wines, there are nevertheless a few milestones to be recorded. These include:

- The replacement of the horse by the tractor
- Changes in spraying (systemic and combination chemicals to protect the plant from the inside, as opposed to superficial protection) and the use and abuse of chemical sprays

- The invention of chemical weed-killers eliminated the need to till the soil, but in the best vineyards, partial tilling has been reintroduced, leaving grass and some weeds to grow again
- The improved adaptation of rootstocks to various soils, a change from rootstocks that slightly modify the growing cycle to those that are too powerful (such as SO4)

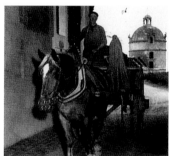

- The replacement in the 1970s of mass selection with cloning—not a particularly successful change; a reversion to the old ways soon intervened
- The introduction of mechanical harvesting, another rather unconvincing innovation; after trying the machines, the great vineyards soon reverted to harvesting by hand
- Soil analysis, which made it possible to identify and correct any deficiencies

- Extending the practice of sorting the grape harvest immediately, accompanied by a development in the sorting and grading conveyor belt
- The invention of green harvests
- The widespread technique of removal of the stalk before the grapes are sent for pressing
- The emergence of what might be termed an ecological reaction, leading to the development of "reasoned cultivation" and "biological cultivation."

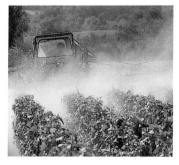

Entrance of the winestore at Château Latour *(top)*.
Omega grafting at Romanée-Conti *(center)*.
Spraying the vines in Burgundy *(below)*.

Modern cellar with
annular circulation.

The Fermentation Process

The cellar master and oenologist have both helped to improve the material with which they work and have seen a substantial increase in their options, which explains why their importance has increased. For example:

• Trituration of the grape, especially the use of pumps, is no longer necessary.

• Maintenance of the vats has been greatly improved. Tartar and deep-seated bacteria have been eliminated.

• Stainless steel has won the day for storage purposes, although in some cases there has been a return to wooden vats.

• Numerous procedures for regulating temperature have emerged over time.

• Malolactic fermentation, whether encouraged or provoked, has become generalized. The great wines already resorted to it if they required long periods of aging.

• The advent of cryoextraction, a controversial practice that is of particular interest to the great sweet white wines.

• The invention of gentle, antioxidant wine presses that reduce the amount of sediment is a development from which white wines, in particular, have benefited greatly.

Aging in the Winestore

The importance of new wood is now recognized by everyone—it was always understood by the great winemakers—as well as the importance of the origin and age of the wood, again something that the great winemakers were conscious of from the late seventeenth century. The duration of the aging process, another factor in the basic constituents of a fine wine, remains a question of style, however. The practice of analyzing wines is not an innovation because in the great estates, it has been common practice since the second half of the

Detail of a vat.

The sap rises, the wine weeps (Burgundy).

nineteenth century. Certain new techniques may alter the taste and style of wines, but they are never used to produce great wines. These include carbon-dioxide maceration (used mainly for Beaujolais) and skin contact for white-wine grape skins.

Nothing will be said about the various physical or chemical processes whose aim is to cure sick wiles or improve an imperfect balance. These measures include acidification, deacidification, decoloration, and doctoring with tannin. Of course, these evils are totally foreign to the great wines of great vintage years. Nor do great winemakers have any truck with the new "miracle" yeasts that introduce "foreign flavors" into the wine.

Innovation and progress obviously have organoleptic consequences that make it even harder to produce an objective comparison of wines. More will be said about this later. If they have been introduced it is because they brought a number of advantages with them, but the question could well be put as to who was the real beneficiary. Was it

the winemakers, whose work was made easier, more reliable, and more profitable? Or was it the consumers, who could "drink better wine for less money"?

No doubt these changes in agriculture and custom have enabled wines to be produced to a more consistent standard, giving the grapes better resistance to attacks of mildew and wilt, and thus improving the quality. On one hand, these forms of progress have done little to change the way in which the great wines of the best vintages are created, despite the fact that the standardization of the plant material has contributed to the simplifications and uniformity of flavor and odor. In the case of vinification and aging, however, the aesthetic consequences are immediate. At the turn of the twentieth and beginning of the twenty-first century, the wines being made are far less volatile than their predecessors. They are less sulfurous (especially the sweet white wines), fresher, and less dry (in the sense of "ending on a dry note") because the aging process takes much less time (and the old-fashioned methods could also lead to oxidation). Thanks to temperature control in fermentation, volatile acidity can be avoided, as well as the aromatic abnormalities that can occur even in outstanding years. These are the matters that concern us, for they demonstrate how important it is to take into account the consequences of changes in production methods when comparing vintages produced a long time ago. Despite the apparent impossibility of such a comparison, one must be sure to acknowledge the advanced age of a wine while refusing to make allowances for it. Too often, involving the age of a wine can excuse it for being too young, forgive it for being too old, or even present a false attempt to imagine or reconstitute the way it was at its apogee, or peak years.

There are so many parameters to be considered…

Chaptalization
(above).
Cooperage
(center).
Fortification
(below).

Refusing to be swayed by the age of a wine means judging it as it is today, as it now presents itself, and refusing to comment on what it will be or once was. At most, a wine taster can somehow project himself into the skin and tastebuds of a fellow expert from the period when the wine reached the zenith of its perfection. As an example, lovers of early music disagree over whether or not instruments of the period should be used to play it—in other words, whether or not an attempt should be made to reconstruct the sound as it would have been heard by the contemporaries of the composer.

The experience is possible but valueless. The sounds we hear today blur those that we believe to be "of the period." Our hearing has been distorted, or shaped, as is the palate of the wine taster, who has never known volatile acidity and is unused to oxidation or drying out. A taster who claims to be able to judge a very old wine more or less objectively should consequently imagine it at its apogee and try and reproduce in his mind the taste sensitivity of the period.

Caution must thus be paramount. Although the finest years and the greatest wines of the most prestigious appellations are known, this is of little assistance in an attempt to award the title "the best of the best." There is no one best; there is better. And so, when the top classifications of *premier cru*, *deuxième cru*, and so on, were first introduced for claret in 1855, their creators realized this, and specified that there was to be no hierarchy within each class.

Opposite: Documents classifying Bordeaux wines, 1855.

Vins blancs classés de la Gironde

Crûs	Communes	Propriétaires

Vins rouges classés du Dépat. de la Gironde

Crûs	Communes	Propriétaires

Premiers Crûs

	Pauillac		Château Lafite

Bordeaux, le 18 avril 1855

Les Syndic et Adjoints

Des Courtiers de Commerce près la Bourse de Bordeaux

à Messieurs les Membres de la Chambre

de Commerce de Bordeaux

Messieurs,

Nous avons eu l'honneur de recevoir votre lettre du 5 de ce mois, par laquelle vous nous demandiez la liste complète des vins rouges classés de la Gironde, ainsi que celle de vos grands vins blancs.

Afin de nous conformer à votre désir, nous nous sommes entourés de tous les renseignements possibles, & nous avons l'honneur de vous faire connaître, par le tableau ci-joint

Archetypal Wines

The world's best wines have become icons—they define their archetypes. But how many different archetypes are there? How are they created? Why are there some great wines that do not belong in any of these fixed and recognized categories? And can a wine be considered great if it falls outside one of these categories?

The very best wines are recognized on an international level. They reach this stature by means of a mysterious consensus and are universally sought-after, which results in their high prices. Only wines produced in sufficient quantity and belonging to a recognized archetype, such as Burgundy, Bordeaux, etc., can claim such recognition. This means that wines that could claim international recognition by virtue of their quality are excluded, since the volume of production is insufficient or they do not belong to an archetype.

It would be ridiculous to believe that the archetypes are fixed and that no new category will ever be created. Yet, curiously enough, the so-called "new producers" (countries outside Europe, the case of the United States remaining ambiguous) have never proposed a totally new archetype and are happy to model their products on existing types. These models or archetypes are as follows

:

Opposite:
Wine auction at
the Hospices
de Beaune
in Burgundy.

Red wines:

• Bordeaux or similar types

• Burgundy or similar types

• Châteauneuf-du-Pape (Grenache)

And to a lesser extent:

• Hermitage (Syrah), Barolo-Barbaresco (Nebbiolo), and Brunello de Montalcino (Sangiovese Grosso) types

White wines:

• White Burgundy and Chardonnay types
• Champagne types
• sweet white wines (all grape varieties)

There remains the case of Sauvignon, a grape variety which is used to make dry and sweet Bordeaux-style wines but which is incapable of being a serious rival to the international Chardonnay archetype. In the case of dry white wines, the same could be said of Riesling, an equally great variety.

Two grape stocks have the potential to contribute the degree of originality that one expects from the new producing countries. These are Zinfandel in the United States and Pinotage in South Africa, but neither variety has yet produced wines that can be described as archetypal in the way that the above reds and whites have done. It is hard to explain why these archetypes are so widespread and enduring. One part of the puzzle, however, is certainly economic. There is no producer without consumers, and the natural tendency of all consumers is to diversify production, so as to be able to sell the product at a higher price. Expensive wines attract wealthy customers, and these are to be found almost exclusively in the big cities of rich, powerful, and organized countries. Throughout history, whenever such conditions have combined, archetypal wines have appeared and have perpetuated their name. Examples of such memorable wines are Mareotic, from the days when Cleopatra ruled Egypt; Pramenian or Chio from ancient Greece; and the famous Falernian that Pliny drank in Rome.

It was not until the Renaissance that new archetypes, such as Tokay in Hungary and Ausbruch in Austria, emerged onto the scene. In the seventeenth century, the great red wines made their appearance with the new French claret. The major categories fixed at that time are

Opposite: Roman fresco from the Veuve Clicquot cellar.

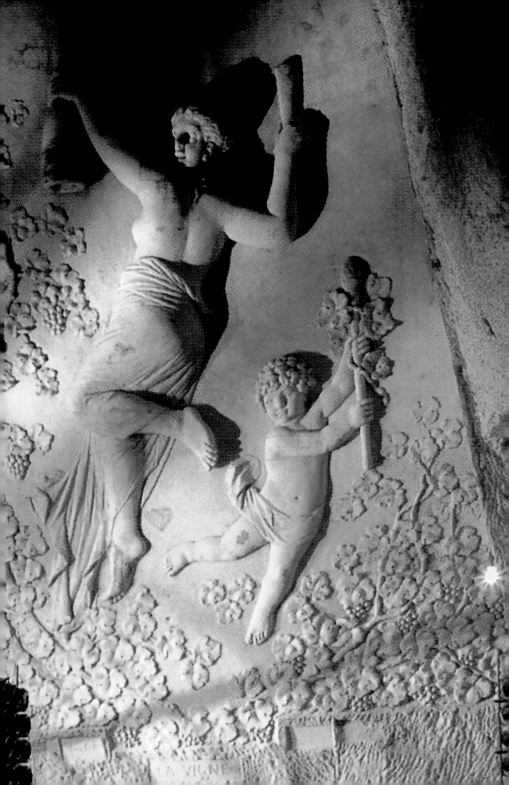

LA VIGNE

those that are still used to this day (but these wines were much more heavily oxidized and had a volatile acidity that would be rejected nowadays.)

To make a few generalizations, it could be said that the red Burgundies represented the French archetypal red wine (they were drunk by the French king and his court), while the clarets were favored by wealthy Englishmen (and were drunk by the English king and his court). Only the English thought it worth paying the high prices for the wines which today we call *premiers crus*.

It is a strange phenomenon that the archetypes have hardly changed at all in four centuries, while the food that accompanies the wine has changed so radically.

As always, in art as in wine, the canon law of esthetics was determined by the dominant power or powers. Yet we continue to classify wines along the old lines despite the fact that the United States is now the dominant world power. It can be imagined that in the twenty-first century the emerging countries of Southeast Asia will become the arbiters of fashion, in wine as in everything else. At the beginning of 2009, in fact, the Chinese authorities announced their intent to make China the premier-wine producing country in the world. After the "American taste," will we now have the "Chinese taste"? And what will become of our traditional models?

Opposite: Wine and high society.
Dining room of the Ritz Hotel, Paris.

Traditional Wine-producing Countries

France

Despite some assertions, it is unlikely that the Celts who occupied France before the Roman conquest ever made wine. On the other hand, it is admitted that the Greeks and Romans introduced viticulture into all the countries with which they had a relationship, whether through trading or occupation. It is acknowledged, however, that vineyards spread through the Midi and the Rhone Valley of France even before the Christian era.

By the thirteenth century, vines could be found throughout France, but it took six centuries to get the right grape varieties planted in the right locations, the last one being Merlot, introduced into Médoc in the mid-nineteenth century.

The major archetypes were born during this long period. Some are very ancient—the current Côtes Rotie/Hermitage may well be very similar to the *vinum picantum* the Romans imported from Vienna 20 centuries ago. But the Burgundy type is "only" six centuries old, Bordeaux as we know it today is 150 years old, and brut Champagne has been around for barely a century.

The first half of the century witnessed the birth of the Appellations d'Origine Contrôlée, or A.O.C.s, and the second half saw the emergence of a profession invented in the last half of the nineteenth century, but which is now vital to the trade. The twentieth century can be divided into two very distinct periods, the first from 1900 through 1965, when the vineyard "survived," and the second, from 1969 to the end of the

Opposite:
Winestore master,
Château d'Yquem,
1921.

century, when it which flourished like the golden age of the nineteenth century (1850–1880).

Bordeaux, clarets

Bordeaux has the largest growing area in the world for fine wines (110,000 hectares), and remains a model for France and the rest of the world. From the mid-seventeenth century, Bordeaux invented "the great wine" which the British hastened to adopt. Bordeaux-type wines are imitated in the French Midi, in Italy, Spain, the United States, and in the new wine-producing countries. In the category of great vintages, which is what we are concerned with here, a 1961 Bordeaux remains unequaled. Apart from these exceptional vintages, numerous blind tastings have revealed that there are plenty of "imitators" which are at least the equal of the original.

Burgundy reds

The Bordeaux grape varieties possess great plasticity, unlike Pinot Noir, which is choosy, fastidious, and difficult to please. So far, the Burgundy-type wines produced outside the Côte d'Or of Burgundy are the equal to the local *premiers crus* but the great *grands crus* (Romanée-Conti, Richebourg, Chambertin from the best growers, for instance) remain unrivaled. That may be because for the past eight centuries, Burgundy has made a virtue of isolating very small parcels of land of a particularly high quality.

Burgundy whites

It has been said and written that the great white Burgundies were unsurpassed. This fact is confirmed less and less often, however, by blind tastings. The plasticity of Chardonnay is only equaled by that of Cabernet Sauvignon, as long as temperatures remain moderate.

Châteauneuf-du-Pape

This wine has an international fame that is even greater than its reputation in France. The grape variety from which it is made is mainly Grenache, and it is true to say that the wine has neither imitators nor competitors.

Syrah/Shiraz wines
Tasters differ in their opinions. In this sector, however, new producers such as Australia are beginning to produce wines of a quality comparable with those of the French models.

Champagne
France was the inventor of sparkling wines. Despite the fact that it is inimitable, Champagne is copied everywhere, even in France, in regions which boast of having produced fizzy wine even before Champagne itself (Limoux, Die, and others). Champagne owes its quality and specificity to the land and the northern aspect of the 30,000-hectare vineyard from which it comes, as well as the fact that the varieties of grape used to make it are restricted to Chardonnay, Pinot Noir (for the very best wines) and Pinot Meunier. The best Champagnes are of an incomparable finesse. Paradoxically, the production of genuine Champagne is small (about 300 million bottles) compared to worldwide production of the other sparkling wines, and even the production of the two Spanish giants, Freixenet and Cordoniu.

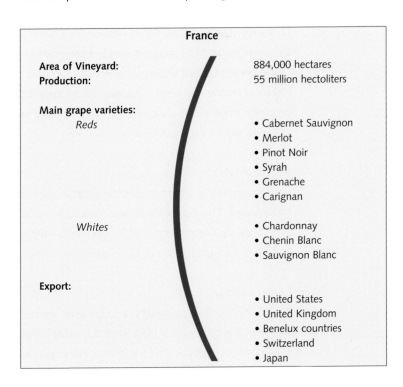

France

Area of Vineyard:	884,000 hectares
Production:	55 million hectoliters
Main grape varieties:	
Reds	• Cabernet Sauvignon
	• Merlot
	• Pinot Noir
	• Syrah
	• Grenache
	• Carignan
Whites	• Chardonnay
	• Chenin Blanc
	• Sauvignon Blanc
Export:	
	• United States
	• United Kingdom
	• Benelux countries
	• Switzerland
	• Japan

Germany

Germany is a country with a very ancient winemaking tradition. It remains to be discovered whether wine in the Mosel region was first made eighteen centuries ago—or only fourteen.

One thing is certain, namely that it was not the Romans who introduced the grape varieties that are able to cope with the colder climate, because they were only familiar with southern stocks. It is likely that a native wild grape was selected and tamed. There is every reason to believe that the wine in question was a Riesling, although this variety is not mentioned until the fifteenth century. The fixing of German-type wines therefore dates from ancient times. The sweet type appeared in the seventeenth century. In 1775, Johann Engert, steward of the Schloss Johannisberg, wrote to the Abbot-Prince Fulda, owner of the estate, describing the 1775 vintage as being extraordinary. History (or perhaps legend, since the same story is told about Château d'Yquem) relates that Engert harvested grapes that had rotted on the vine that year because permission to pick them had arrived too late.

The syrupy, sweet white wines that resulted were all the rage in the nineteenth century. They then fell out of favor, and it was not until 1921 (still known as the "year of the century") that a magnificent Trockenbeerenauslese was vinified.

After World War II, these sweet white wines rotted by the botrytis fungus became greatly sought after by oenophiles and became the most expensive wines in the world.

The regulations governing German wines, which were fortunately simplified in 1971, are among the very few which are not based on the French system. Although they define wine-growing districts, as do the French rules, they also regulate the sugar content of the must.

Opposite: Many historic vineyards are of Roman origin. Here, a Roman ship is transporting wine.

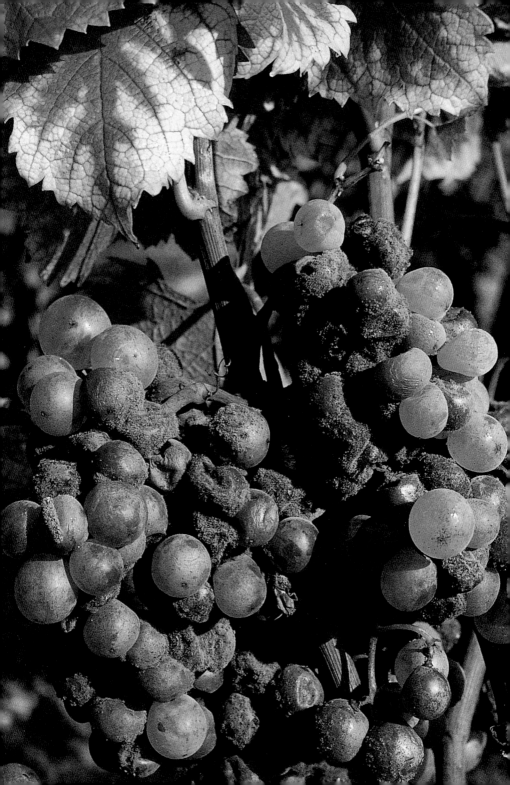

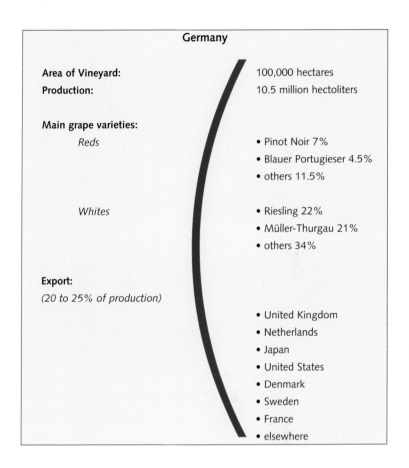

Germany

Area of Vineyard: 100,000 hectares

Production: 10.5 million hectoliters

Main grape varieties:

Reds
- Pinot Noir 7%
- Blauer Portugieser 4.5%
- others 11.5%

Whites
- Riesling 22%
- Müller-Thurgau 21%
- others 34%

Export:

(20 to 25% of production)
- United Kingdom
- Netherlands
- Japan
- United States
- Denmark
- Sweden
- France
- elsewhere

Austria

Vines have been grown in Austria since Roman times. Austrian reds
have character and are produced from local varieties of grape (Saint-
Laurent, Lemberg), but few are exported. As a result of scandals
involving noxious chemical additives, Austria has produced very strict
legislation governing wines. Sweet white wines have achieved
international renown, which ought not to surprise the connoisseurs
who have long placed them in the first rank of the wines made from
grapes subject to noble rot, or botrytis.

Hungary

The historic Hungarian vineyard is also of Roman origin, and reached the
height of its glory when grapes were harvested late and began to suffer

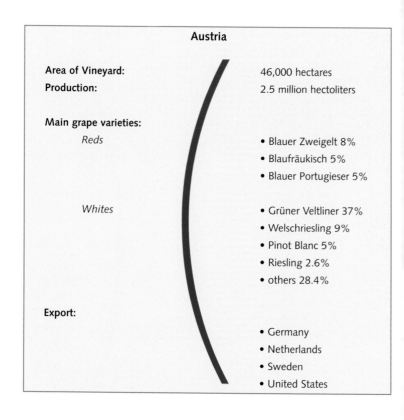

Austria

Area of Vineyard:	46,000 hectares
Production:	2.5 million hectoliters

Main grape varieties:

Reds
- Blauer Zweigelt 8%
- Blaufräukisch 5%
- Blauer Portugieser 5%

Whites
- Grüner Veltliner 37%
- Welschriesling 9%
- Pinot Blanc 5%
- Riesling 2.6%
- others 28.4%

Export:
- Germany
- Netherlands
- Sweden
- United States

from noble rot. Within a matter of a few years, Tokay became the wine drunk at court. The Hapsburgs even produced their own Tokay in their own vineyard. In Russia, the Tsar himself went wild over it. Rákóczi, the count, prince and great landowner (who also had a vineyard in Tokay), introduced his wine to Louis XIV in the early eighteenth century.

In 1816, Julien classified it as being among the two or three best wines in the world. In the twentieth century, this wine of kings virtually disappeared in the long night of Communism—like civilizations, wines are mortal. In South Africa, political and administrative incompetence has mostly killed off Constancia, Tokay's great rival in the nineteenth century and the favorite wine of Napoleon and Louis-Philippe.

Opposite:
Eszencia, the rare and precious wine produced in the Tokay region of Hungary.

It was at an opportune moment that the Communist economy foundered and the system of state farms ended, since it had proved incapable of vinifying a fine wine. Today, Tokay is an archetypal sweet white wine.

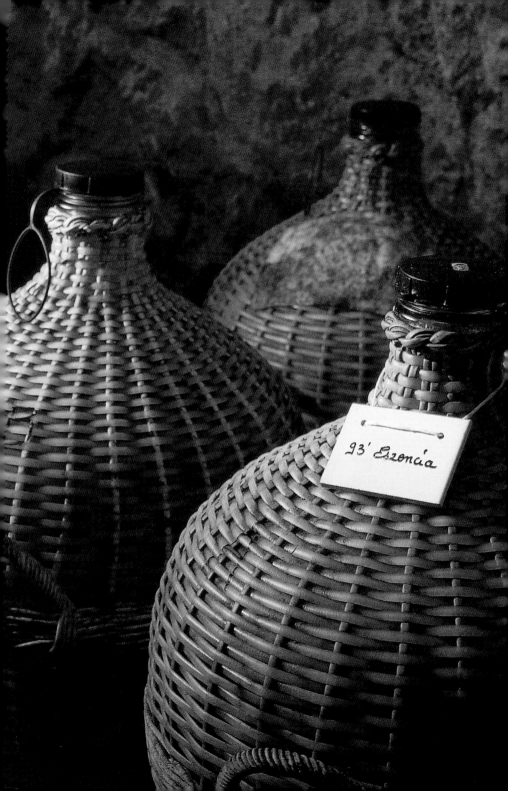

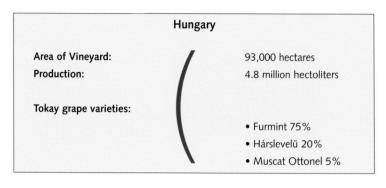

Hungary

| Area of Vineyard: | 93,000 hectares |
| Production: | 4.8 million hectoliters |

Tokay grape varieties:

- Furmint 75%
- Hárslevelü 20%
- Muscat Ottonel 5%

Italy

The collapse of the Roman Empire brought about the disappearance of the great Roman wines.

For many centuries, the Italians concentrated on producing cheap wines for local consumption. It was not until the late nineteenth century that Italy once again found its place among the countries producing great vintages of exceptional quality.

The great diversity of Italian wines made the task of the legislator more complex, but regulations inspired by the French system were introduced (The Italian D.O.C.G., or *denominazione di origine controllata e garantita*, is equivalent to the French A.O.C.). The first version of the legislation was heavily amended in 1992.

Although the return to the production of quality wines began more than 100 years ago, it was not until the 1970s that this rebirth of the Italian vineyard began to bear fruit—to such an extent that Italy could well be classified among the new wine-producing countries. Today, its local varieties attract increasing international renown.

Portugal

This is another vineyard that owes its origin to the Romans. But the Portuguese did not discover the true worth of their grapes until the eighteenth century, when port was invented, almost by chance. In order to better preserve red wines which were exported, spirits were added to them. It was soon discovered that red wine treated in this way was much more than mere red wine *plus* spirits. That is how port wine was born.

Italy

Area of Vineyard:	675,000 hectares
Production:	55 million hectoliters

Main grape varieties:
(great diversity — 400 varieties)

Reds
- Sangiovese
- Nebbiolo
- Cabernet Sauvignon
- Merlot

Whites
- Trebbiano
- Vernacchia

Export:
(34% of production)

- United States
- United Kingdom
- Benelux countries
- Germany

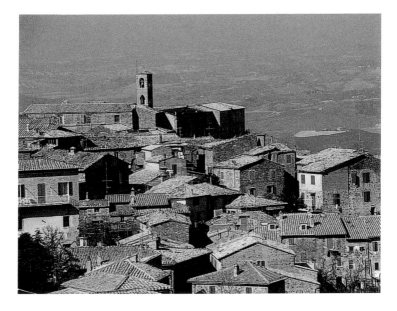

Opposite: The village of Montalcino, in Tuscany, whose vines produce Brunello wine.

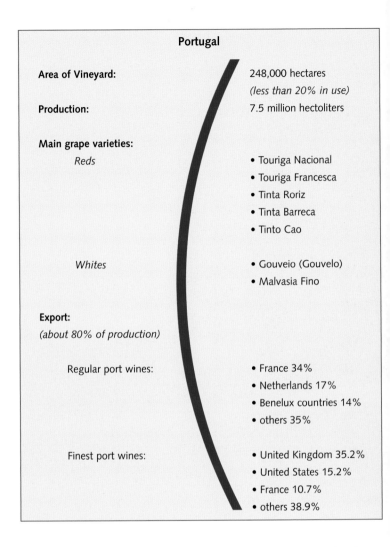

Portugal

Area of Vineyard: 248,000 hectares
(less than 20% in use)

Production: 7.5 million hectoliters

Main grape varieties:

Reds
- Touriga Nacional
- Touriga Francesca
- Tinta Roriz
- Tinta Barreca
- Tinto Cao

Whites
- Gouveio (Gouvelo)
- Malvasia Fino

Export:
(about 80% of production)

Regular port wines:
- France 34%
- Netherlands 17%
- Benelux countries 14%
- others 35%

Finest port wines:
- United Kingdom 35.2%
- United States 15.2%
- France 10.7%
- others 38.9%

At the end of the twentieth century, the Douro region's unrealized potential for red wines began attracting more producers, and already some remarkable wines have been vinified there.

Preceding pages: Vintage bottles of Brunello di Montalcino.
Opposite: Cellar containing port, Portugal.

New Producers

The United States

To include the United States, or even the North American continent, among the ranks of new producers is historically questionable because the conquistadors and Spanish missionaries introduced European grape varieties into Mexico in the sixteenth century, and these later spread northward and southward.

Grapevines and wine have had a certain amount of bad luck in the United States. Thomas Jefferson imported great vine stocks from Burgundy and Bordeaux in the early nineteenth century, which he had taken from vineyards that he knew well (he had bought wine from such prestigious estates as Yquem, Latour, Lafite, and Montrachet), and this should have been the birth of American viticulture. But that was without taking into account phylloxera, the plant-lice whose existence had been hitherto unknown. It attacked the roots of the European grapes (*Vitis vinifera*), doing little damage to the native American vines (*Vitis lambrusca*), which had built up some immunity to them.

By the late nineteenth century, the Americans were producing quality wines. They proved to be more than a match for European wines at the Paris exhibitions and won medals. At the time, there were more than 800 wineries in California.

Then came Prohibition (1919–1933), followed by the economic crisis and World War II. This explains why it was not until the late 1960s that oenophiles began to take an interest in American wines.

Since then, American production has won its letters of nobility, and is

popular locally as well as internationally. Blind taste tests of American wines produced from Chardonnay or Cabernet-Merlot grapes are equal of the best European wines.

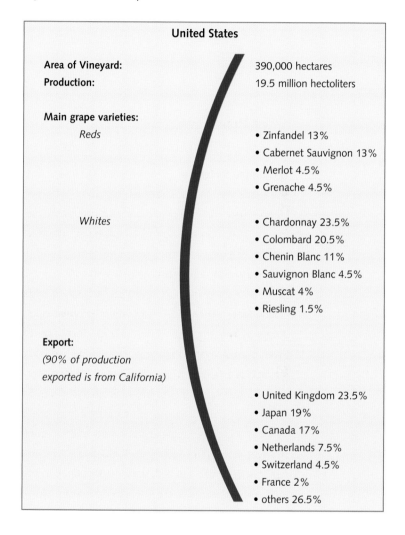

United States

Area of Vineyard: 390,000 hectares
Production: 19.5 million hectoliters

Main grape varieties:

Reds
- Zinfandel 13%
- Cabernet Sauvignon 13%
- Merlot 4.5%
- Grenache 4.5%

Whites
- Chardonnay 23.5%
- Colombard 20.5%
- Chenin Blanc 11%
- Sauvignon Blanc 4.5%
- Muscat 4%
- Riesling 1.5%

Export:
(90% of production exported is from California)
- United Kingdom 23.5%
- Japan 19%
- Canada 17%
- Netherlands 7.5%
- Switzerland 4.5%
- France 2%
- others 26.5%

Argentina

Even though wine has been produced there for nearly five centuries, Argentina should be considered as a "new" producer, since it is only over the past 20 years that its wine industry has aimed for high-quality production, following the example of Chile (which has won the publicity battle even though it produces less). Can one attribute this lag to the fact that its population is of principally Hispano-Italian origin—two countries that historically favored quantity over quality? Viticulture in Argentina is characterized by two particularities especially suited to "new style" wines: the Malbec grape variety, introduced to Argentina in 1852, and the planting of vineyards at altitude, above 3,200 and up to 5,000 feet!

The cultivation of Malbec (also know as Cot or Auxerrois) is on the decline in the Bordeaux region, but still strong in the vineyards of Cahors (70% minimum). But it is in Argentina that the variety has found its ideal environment, provided it is not grown on the low plains, which are too hot, but instead on the flanks of the Andes, where the alternating daytime heat and nighttime cold act as a brake on the grapes' ripening, resulting in complicated aromas in the finished wines.

Today, the Mendoza region, among others, has become highly sought after among international investors and producers, particularly the French and Americans. The construction of high-performance wineries coupled with input from some of the most knowledgeable specialists (French oenologist Michel Rolland, for example) has propelled Argentine wine into the exclusive circle of internationally prized vintages.

Argentina

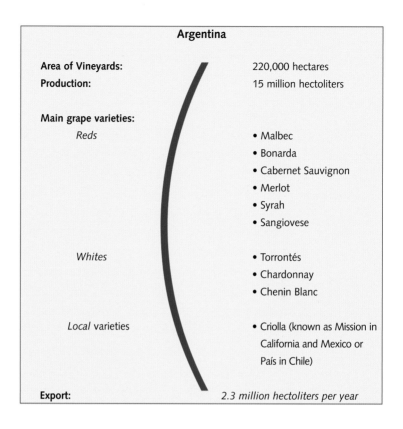

Area of Vineyards: 220,000 hectares

Production: 15 million hectoliters

Main grape varieties:

Reds
- Malbec
- Bonarda
- Cabernet Sauvignon
- Merlot
- Syrah
- Sangiovese

Whites
- Torrontés
- Chardonnay
- Chenin Blanc

Local varieties
- Criolla (known as Mission in California and Mexico or País in Chile)

Export: *2.3 million hectoliters per year*

Spain

Spain is not a new producer of wines, but it is a new producer of top-quality wines.

The history of Spanish viticulture is not dissimilar to the Italian experience. Once again, it was the Romans who introduced the art of wine into the Iberian peninsula. Eight centuries of Islamic rule, however, did not encourage the production of wine, nor did the feudal system of land management that persisted long after the Middle Ages.

However, in the mid-nineteenth century, a few growers revived viticulture in the Rioja region by introducing methods and grape varieties from the Bordeaux district. They grew mainly Grenache, as well as a local variety, Tempranillo. It was a wine made from the latter variety that won the Marquess of Riscal first prize at the great 1865 wine competition in Bordeaux. The diseases of the vine from which France was suffering at the time contributed to Rioja's orientation toward basic wines of good average quality. It was not until after World War II that modern, rational oenology opened the gates of international markets. Curiously, it is not in Rioja but further to the southwest, on the banks of the Duero, that is the birthplace of the great postwar Spanish wines which have taken their place among the ranks of the world's outstanding vintages.

Of course, Spanish production was already world-famous in the nineteenth century for its fortified wines, Malaga and sherry. In the twenty-first century, some promising new growing regions are beginning to assert themselves, among them Toro and Priorat.

Preceding pages: Vineyard in the Napa Valley, California.
Opposite: The Vega Sicilia *bodega*, Valbuena de Duero, Spain.

Spain

Area of Vineyard:	1.3 million hectares, of which 650,000 are D.O. (*Denominación d'Origen*)
Production:	40 million hectoliters of which 9.6 are D.O.

Main grape varieties:

Reds
- Grenache Noir
- Bobal
- Tempranillo

Whites
- Airén
- Pedro Ximenes

Export:
- Germany
- United Kingdom
- France
- United States
- Netherlands

Left and right: Vega Sicilia vineyard, Valbuena de Duero.

Australia

This country is a special case. Vines were not introduced until the nineteenth century, and no local variety has been developed. In Europe, tradition had often been an obstacle to innovation, but in Australia, winemaking has always incorporated the latest growing and production techniques, to such a point that Australian oenologists were the first to become professional international consultants.

These *flying winemakers* even vinified in France. It should be stated, however, that French oenologists have since caught up with them and are dispensing their advice in the four corners of the earth! Australia is now one of the countries that is producing wine of the finest quality. This is due to the wide range of climate types, a variety of soils and aspects, enormous opportunities for expansion, and complete mastery of the vinification techniques. The country's financial resources back up the wine trade, enabling Australia to produce fine vintages. Australia may be inspired by the achievements of New Zealand, which has already produced a wine with an international reputation, Cloudy Bay, made from Sauvignon Blanc grapes.

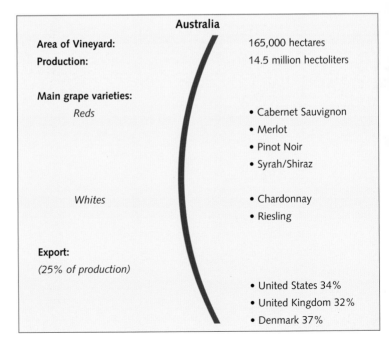

Australia

Area of Vineyard:	165,000 hectares
Production:	14.5 million hectoliters
Main grape varieties:	
Reds	• Cabernet Sauvignon
	• Merlot
	• Pinot Noir
	• Syrah/Shiraz
Whites	• Chardonnay
	• Riesling
Export:	
(25% of production)	
	• United States 34%
	• United Kingdom 32%
	• Denmark 37%

Opposite and subsequent pages: Vineyards of the Barossa Valley, Australia.

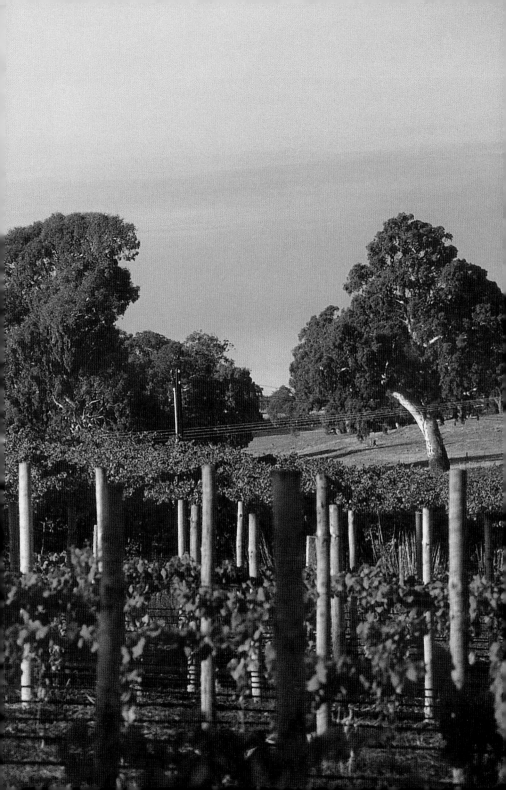

Chile

The late Henri Enjalbert, a geographer from the Bordeaux region who specialized in identifying the best wine-growing environments, always maintained that Chile had the greatest possible wine-growing potential. Although Professor Enjalbert has been dead for some years, a great Chilean wine capable of rivaling Lafite and Latour has yet to make its appearance.

Chile produces excellent wines but none has hitherto been able to compete with the greatest in the world. This is hard to explain, given that the local climate is perfect, tempered by the Pacific Ocean and cooled by the cold night air from the Andes, while benefiting from plenty of sunshine. As far as the geology is concerned, the siliceous or clay-and-limestone soils are very well drained. Furthermore, the plethora of valleys at right angles to the coast create microclimates and aspects that are very favorable to grape-growing. If Chile has not yet produced great wines, it may be due to a superabundance of favorable conditions which have resulted in a huge harvest, encouraging the production of wines that are easy to sell. What Chile lacks is the small, enthusiastic grower who is passionate about wine, has plenty of funds at his disposal, and is determined to produce a masterpiece. One will emerge sooner or later.

The country has never experienced the phylloxera plague, and most of the grapes grown are of an old, local variety, the País, plus a few of the great European grapes.

Chile

Area of Vineyard:	190,000 hectares
Production:	6.3 million hectoliters

Main grape varieties:

Reds
- Cabernet Sauvignon 24%
- Merlot 8%
- Pinot Noir 5%

Whites
- Sauvignon Blanc 10%
- Chardonnay 8%
- Riesling 4%
- Chenin 1%
- Sémillion 1%

Local varieties
- País
- Chardonnay
- Riesling

Export:
- United States
- United Kingdom
- Japan
- Canada
- Denmark

Opposite:
Errazuriz, a Chilean cellar.

Following pages:
Viña Undurraga, a Chilean wine.

South Africa

The first wine produced in South Africa was drunk in February 1659, when Louis XIV had been king of France for about twenty years. Since then, South African wine has been through some chaotic times. The creation of a national cooperative (KWV) in 1918 did not bring about the hoped-for innovations and improvements, with the exception of the invention, in 1926, of the Pinotage variety, the result of crossing Pinot Noir and a Cinsault. In 1973, a system similar to the French A.O.C. system, called *Wine of Origin* (W.O.), was created. Apartheid took a heavy toll on exports and isolated South African viticulture but the country has now begun a resurgence, emerging as a player in the international wine market.

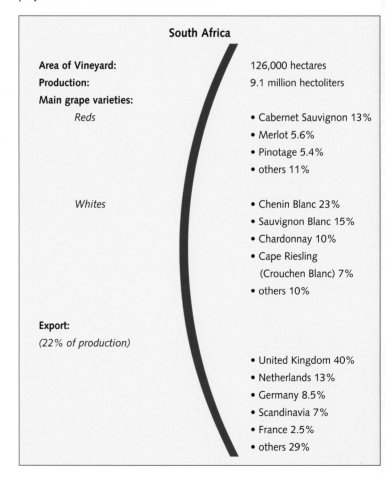

South Africa

Area of Vineyard:	126,000 hectares
Production:	9.1 million hectoliters
Main grape varieties:	
Reds	• Cabernet Sauvignon 13%
	• Merlot 5.6%
	• Pinotage 5.4%
	• others 11%
Whites	• Chenin Blanc 23%
	• Sauvignon Blanc 15%
	• Chardonnay 10%
	• Cape Riesling (Crouchen Blanc) 7%
	• others 10%
Export:	
(22% of production)	
	• United Kingdom 40%
	• Netherlands 13%
	• Germany 8.5%
	• Scandinavia 7%
	• France 2.5%
	• others 29%

Opposite:
Winestore of the Plaisir-de-Merle estate at Franschhoek, South Africa.

Following pages:
Vineyards of the Thelema estate, at Stellenbosch, South Africa.

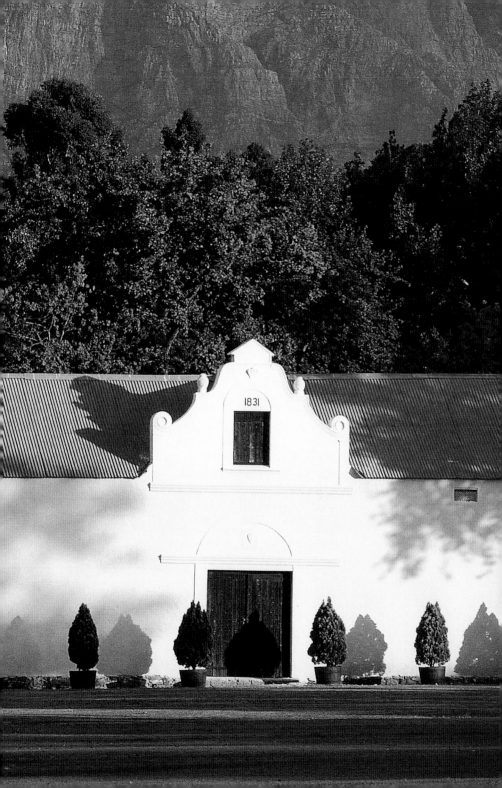

New Zealand

Grapevines were introduced to New Zealand in 1819 by the Reverend Samuel Marsden, a missionary who brought a few plants from Australia. Phylloxera first made an appearance in 1895, no doubt for the same reason as it did in Europe, namely the importation of American vines. For many years, New Zealand produced poor-quality wines from hybrid varieties, then white wines from German varieties, and finally, excellent white wines made from Sauvignon and Chardonnay grapes.

This talent for producing good white wines is due to the coolness of the climate. The delay in producing quality wines was due largely to the prohibitionists, whose activity reached a peak in the 1930s. They managed to achieve a ban on the sale of wine in most public places, including restaurants! Wine could not be sold in supermarkets until as recently as 1989. Today, however, wines from New Zealand are consumed domestically as well as abroad.

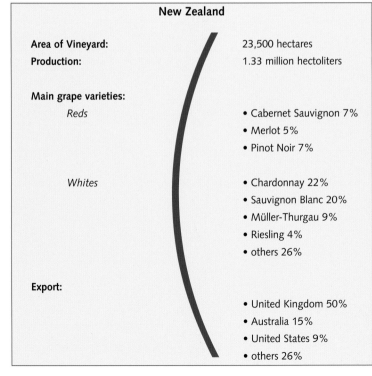

New Zealand

Area of Vineyard:	23,500 hectares
Production:	1.33 million hectoliters

Main grape varieties:

Reds
- Cabernet Sauvignon 7%
- Merlot 5%
- Pinot Noir 7%

Whites
- Chardonnay 22%
- Sauvignon Blanc 20%
- Müller-Thurgau 9%
- Riesling 4%
- others 26%

Export:
- United Kingdom 50%
- Australia 15%
- United States 9%
- others 26%

Opposite: Vineyard on the Omaka Springs property, Marlborough, New Zealand.

Following pages: Pinot Noir grapes before sorting for pressing, Montana property, New Zealand.

84

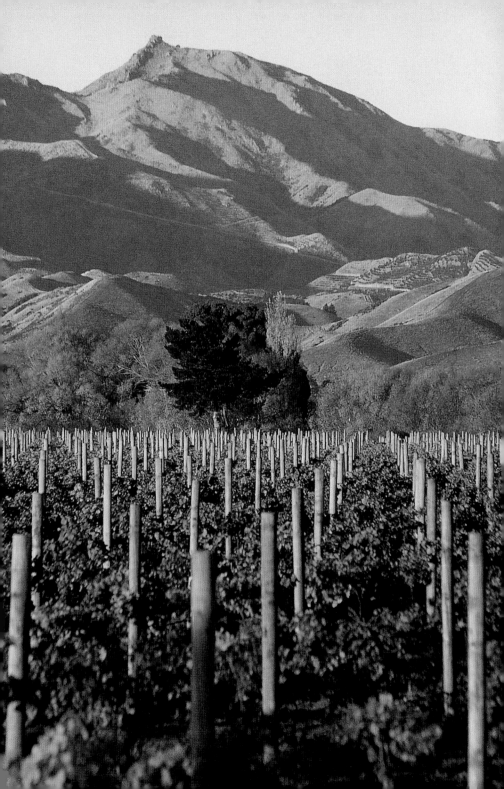

Part Two
Best Vintages Since 1900

Part Two | **Vintages of the Century**

Overview of Nineteenth-Century Vintages

The centuries roll by and end up resembling one another, always with the same mixture of excellent and mediocre vintages. Statistically the ratio of good to bad years remains fairly stable, although hotter or colder periods can occur, such as the miniglaciation around the time of the French Revolution. For nineteenth-century vintners everything was "natural," human intervention had no global consequences, and the idea of climate change caused by man was unimaginable. Nevertheless, natural phenomena could have a noticeable effect, such as the eruption of the Tambora volcano in Indonesia on April 10, 1815, responsible for the freezing summer of 1816 and the miserable wines of that year. Where vines were concerned, however, the nineteenth century saw the arrival of three serious diseases that affected the grapes, and hence the wines produced. The first was oidium, a powdery mildew that attacked the leaves and consequently lowered the sugar level in the fruit. It arrived in Europe from the United States in 1845 and spread everywhere, *Vitis vinifera* being very susceptible. A remedy was quickly found—pulverized sulfur—but its effects did not last more than ten days. The result was an increase in labor costs and, in the absence of rigorous treatment, a reduction in wine quality.

The second disease, which was disastrous, was phylloxera. Again of American origin, phylloxera is an aphid-like insect which destroys the roots of *Vitis vinifera*. Discovered in 1863 in the Rhone Valley, it ravaged vines the world over. There is still no treatment, the only remedy being to graft onto resistant rootstock. As a result of the epidemic, wine quality was very irregular and the cost of replanting the world's vines mounted to breathtaking sums.

The third scourge appeared in the Bordeaux region in 1878: The vines dropped their leaves and the rare grapes turned brown. It was yet another American fungus, downy mildew, which was fought with *bouillie bordelaise* (a mixture of slaked lime and copper), a treatment perfected after seven years' research. Affected vines produce little (and eventually no) wine, the finished product being thin and generally awful. Both downy mildew and oidium are still rampant worldwide, as was demonstrated in 2007 in Europe.

These three calamities had consequences which go beyond our subject. Where wine quality was concerned, the diseases introduced disparities between vineyards. Plant health was no longer determined only by weather conditions but also by the existence or application of treatments. Despite this, the vintages we quote here were indisputably excellent, because fungal diseases proliferate in hot, humid weather— that is to say, in conditions that preclude the production of truly great wines. Phylloxera, on the other hand, is entirely unaffected by climate. Nineteenth-century wines are now between 110 and 210 years old, and consequently of interest to only a few specialists who attempt to reconstitute what they might have been from the vague hints of structure and aroma that remain. A task as much sentimental as archaeological, it generally results in a description of geriatric phenomena: The wine's state of aging is noted; its light-tawny (red wine) or dark-bronze (white wine) color is a first sign; on the nose it may be oxidized, flat, or "advanced"; on the palate it may taste sour, thin, emaciated, washed-out, etc. Of course, wine tasters all have their own preferences and particularities where aging is concerned, but the destiny of every wine is to die—as late as possible, naturally.

The nineteenth century began well, with 1801 and especially 1802 being good years. The year 1811, which was baptized "the year of the comet," was above all good for white wines (Sauternes) and particularly so for Champagne: The widow Clicquot made it a vintage year, which was a first. A great year for everyone was 1815, and the Champagne region stood out from the pack by branding its production the "Waterloo vintage," evidently with the English and Russian markets in mind! Other notable years include 1818, 1822, 1825, 1844, and 1854.

Also deserving of mention is 1855, because it was the year of the famous classification of Bordeaux wines, which, practically set in stone, has been religiously respected ever since.

Where quality is concerned, 1855 does not deserve mention: It was what is known as a *petite année*, a year of limited potential whose wines have disappeared. I have had occasion to taste only one bottle, a Gruaud-Larose (Saint-Julien) which had never left the château's cellars. In the glass, the wine was a tawny reddish-pink, while on the nose it was flimsy but delicate, seemingly having escaped oxidization. But 30 seconds later this 120-year-old wine had evaporated: the nose was gone and on the palate there was almost nothing but water!

There are, however, a few other mid-century years that should be remembered: 1864 and, above all, 1865, which was exceptional everywhere, as was 1868, when harvesting occurred earlier than ever before, around September 8.

With the arrival of phylloxera, the golden age was over. Viticulturists fought for the survival of the species until, in the year 1893, the vintage of the century was harvested, on August 15 to boot—astonishingly early. Having begun with a double success, the nineteenth century finished with a triple hit: 1898, 1899, and 1900. If the 1893 vintage was the century's best, the worst was the sorry 1809.

1900

Naturally, the advent of the twentieth century was celebrated in style. (A few party poopers insisted that the nineteenth century actually lasted until December 31, 1900, because the first year of the century had ended on December 31, 1800, but few people took any notice of them.) The year 1900 was an eventful one for France. It was the when the first Metro (subway) line was opened, between the Porte Maillot and the Porte de Vincennes. The entrances, designed by Hector Guimard, have become classic examples of the Art Nouveau style. The Paris Universal Exposition that year offered a glimpse of the future. There was brilliant electric lighting and cinematography in every shape and form, including a movie theater called the Cineorama with a completely circular screen, Louis Lumiere's giant screen, and the Phonorama, an early forerunner of the talkies. Many of the exhibition buildings at the lower end of the Champs-Élysées have lasted the whole century. They include the Petit-Palais and the Grand-Palais, as well as the Alexander III Bridge over the Seine.

Nietzsche died in Vienna and a certain Dr. Freud discreetly published a book on the subject of the interpretation of dreams. In Germany, Max Planck refuted the theory of energy waves, proving that energy is distributed discontinuously in the form of "grains," which he called "quanta." The painter Claude Monet exhibited a series of ten Impressionist paintings called *Water Lillies*.

Facing page: 18th century map of Margaux.

Plan
du chateau
MARGA

argaud est une tresbelle Maison
De beaux jardins Son Seigneur a m[...]
antité de vins et L'on tient quil
it quelque fois pour plus de cinqu[...]
ille livres par an

r Vignes de ces quartiers Sont le[...]
vec des Echalas comme au tour d[...]
ari, et non celles de Saintong[...]

Château Margaux 1900 Bordeaux

Château Margaux was very quick to learn from its fellow Bordeaux producer Haut-Brion and was sold on the British market, under its own name, from the early eighteenth century. This was especially easy to achieve since these two pioneering estates were linked by the ties of marriage: Jean-Denis d'Aulede, owner of the Château Margaux, had married Therese de Pontac, whose father was the owner of Haut-Brion.

In the seventeeth century, Château Margaux added a historic building block to the creation of a great Bordeaux when the manager of the estate, Berlon, recommended separating white grapevines from red and produced red wines solely from red grapes and white wines solely from white grapes.

Facing page:
Vintages in storage
at Château
Margaux.

The estate changed hands several times. Certain owners were rather eccentric (and wealthy), such as the one who built the château (1810), no doubt to commemorate his being ennobled with the title of the marquis. Later, the estate came into the ownership of the bankers Aguado (1836) and Pillet-Will (1879). The latter undertook the replanting of the estate after the devastation caused by phylloxera. Under his aegis, the memorable vintages of 1899 and 1900 were vinified.

Pillet-Will's son-in-law was one of the most eccentric owners of the property. There was no question of his noble lineage, his blood was the bluest; he was a Tremoille, and a duke to boot—but his politics were leftist and he was known as the Red Duke! This was not a good

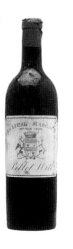

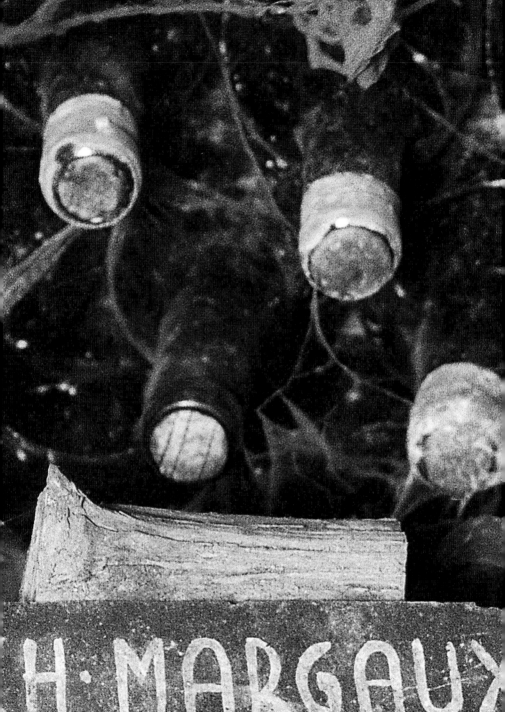

time for the property, however, and the duke was forced to hand over Château Margaux to agents, who badly mishandled its affairs. When the Ginestet family bought the estate, they nurtured a proposal, one that was wise but heartily condemned by wine buffs, to sell non-vintage Château Margaux wines. The project was abandoned.

In 1970, the American firm of National Distillers made a bid for Château Margaux. Bordeaux wines were experiencing a crisis, but a *premier cru* had to remain French, and the government decided to oppose the sale.

It was the owner of the Felix Potin grocery-store chain, Andre Mentzelopoulos, who finally bought the estate. He invested large sums of money but his shrewdest move was to hire Émile Peynaud, who became the Château's most famous oenologist. His first vintage (1978) was a triumph. Since then, Château Margaux has maintained its high level of quality, although it is no longer a piece of French heritage, having changed hands twice—first bought by the Italian Agnelli family, and then Corrinne Mentzelopoulos took charge.

Château Margaux 1900 is, without a doubt, the finest vintage of the estate. It is also the most highly esteemed by those who know it well, such as Bernard Ginestet and Paul Pontallier, the house's current oenologist.

Perhaps it was in honor of this vintage that Ernest Hemingway insisted that his granddaughter be named for the prestigious wine of the Margaux estate...

The grape harvest at Château Margaux.

Organoleptic Description

The robe has developed. It remains fine, though brownish when seen in the mass. The delicate aromas of burnt toast are evidence of the perfect ripening of the grape. It has a smooth harmony in the mouth, melting though now a little old-fashioned (the tannins are on the verge of separating out). In the 1970s, this wine of infinite grace was a symbol of the flower of civilization, the crowning glory of Margaux.

Secrets of Quality

Balance and successful vinification.

Availability

Very rare.

Current Price

$12,000 (a jeroboam sold at auction for $65,725 in 2006).

Apogee:
1920.

Comparable or almost comparable vintages: 1947, 1953, 1961.

Development:
Beginning to decline.

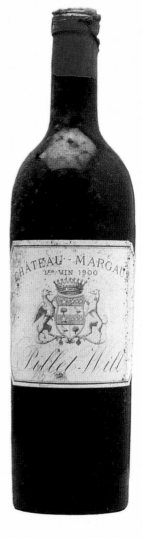

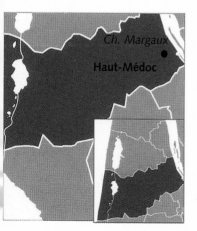

Weather Conditions

In 1900, spring and summer were ideal for grape-growing. There were no problems with flowering, so the harvest was abundant. In this respect, 1900 is closer to 1982 than it is to 1921 or 1961. Everything went well, just as it had the previous year. The wines were excellent, balanced but not of consistent quality. At the time, some of the brokers discovered that a few of them had been diluted.

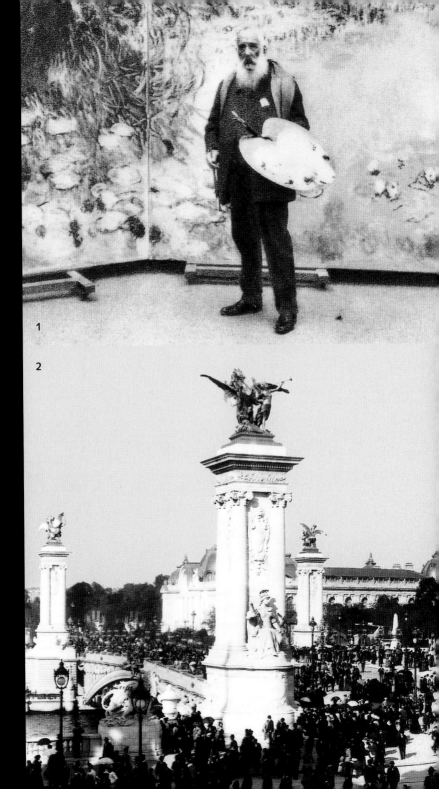

1

2

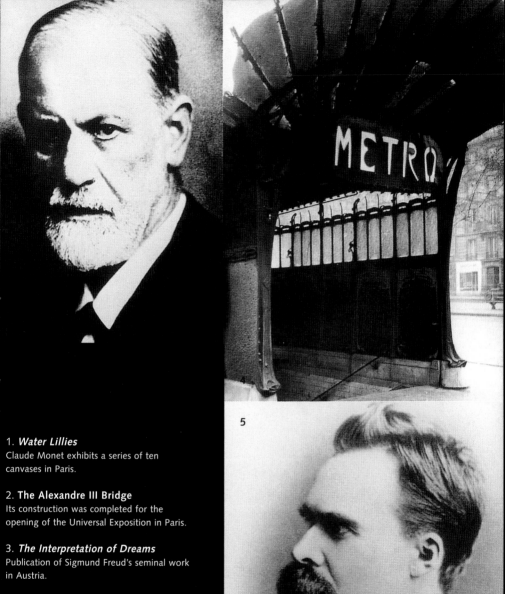

5

1. *Water Lillies*
Claude Monet exhibits a series of ten
canvases in Paris.

2. **The Alexandre III Bridge**
Its construction was completed for the
opening of the Universal Exposition in Paris.

3. *The Interpretation of Dreams*
Publication of Sigmund Freud's seminal work
in Austria.

4. **Art Nouveau style**
One of the many entrances to the
Métropolitain, the first subway line in Paris,
designed by Hector Guimard.

5. **Friedrich Nietzsche**
Death of the German philosopher.

1911

A Franco-German war was narrowly avoided in the name of colonial balance. The crisis point came when the German battleship *Panther* menaced the Moroccan port of Agadir. Although a 1906 agreement guaranteed Moroccan independence, it was only partially obeyed, and in May 1911 French troops restored order in Fez, purportedly at the request of the sultan. Negotiations between Germany and France ended with an accord that recognized Morocco as a French protectorate. In exchange, France ceded nearly 116 square miles of the French Congo, which were incorporated into the German colony of Cameroon. Simultaneously, at the opposite end of the earth, the Manchurian dynasty lost control of much of China. The Chinese Republic, which became a dictatorship, was officially proclaimed in 1912. In Great Britain, George V was crowned king.

In the arts, 1911 saw the founding of the famous French publisher, Gallimard, and the creation of the ballet *Petrushka*, with music by Stravinsky, by Diaghilev's Ballets Russes. Ernest Rutherford published his theory that the atom was not a homogenous particle but instead consisted of a nucleus surrounded by electrons. Marie Curie won her second Nobel Prize, this time for chemistry, and the discovery of radium and polonium. (She had won the Nobel Prize for physics in 1903.)

Facing page:
Ancient bottles
of Bollinger
Champagne with
stapled corks.

IꝋII

Bollinger 1911 Champagne

The author asks the reader's indulgence for introducing a personal reminiscence. A few years ago, at the end of a meal at the Bollinger establishment in Ay, we were supposed to be treated to a Bollinger 1914. Probably the cellar that contained the ancient bottles was dimly lit, because in fact the bottle that was opened was a 1911. I was delighted, almost moved.

Delighted, because the 1911 is far superior to the 1914 and it is well known that no Champagne has attained this level of quality since 1874, when the yield per hectare was very low because a frost had descended on the vineyard and lasted without interruption from May 1 through 22, severely damaging the flowering; the subsequent summer was perfect. Moved, because 1911 was the year of the Champagne riots. At Ay, on April 22 of that year, 6,000 vine growers faced up to four squadrons of 600 horsemen, who were brandishing sabers because they had been given an order not to fire. Nothing could stop the rioters. They pillaged and burned everything that stood in their path, setting fire to homes and warehouses, then took the road that led to the Bollinger estate. It is said that rioters were overcome with respect for the venerable establishment and turned back. More likely is the theory that it was late in the day, and the most turbulent of the rioters were overcome with fatigue.

The reason for these disturbances was the cumulative effect of two phenomena, which rendered the local winemakers' situation unbearable. The first, known as "the fraud," was the making of "Champagne" from grapes grown outside the region, which enraged the local growers

Facing page:
Souvenirs from the house of Bollinger.

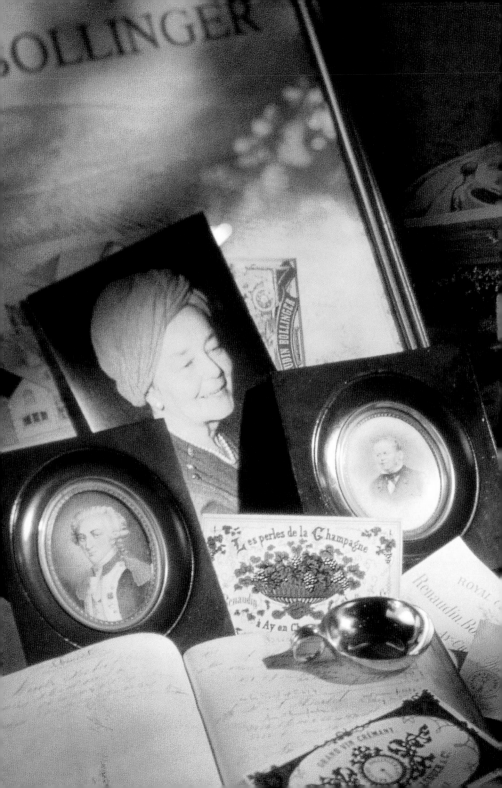

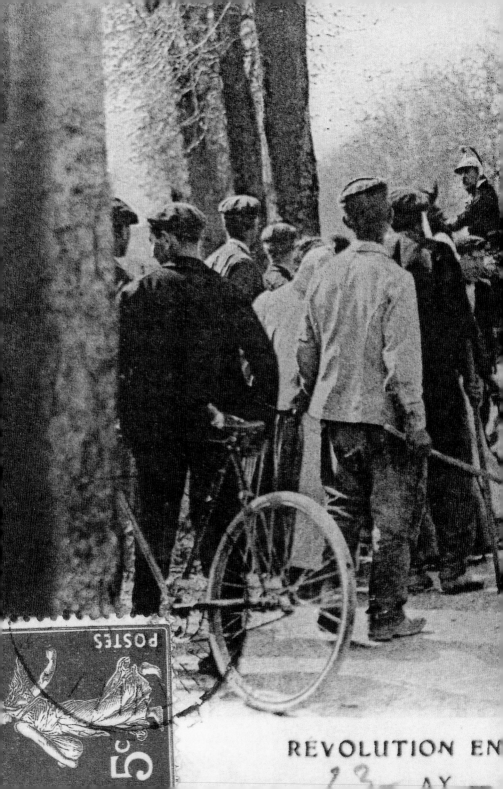

POSTES

5c

REVOLUTION EN

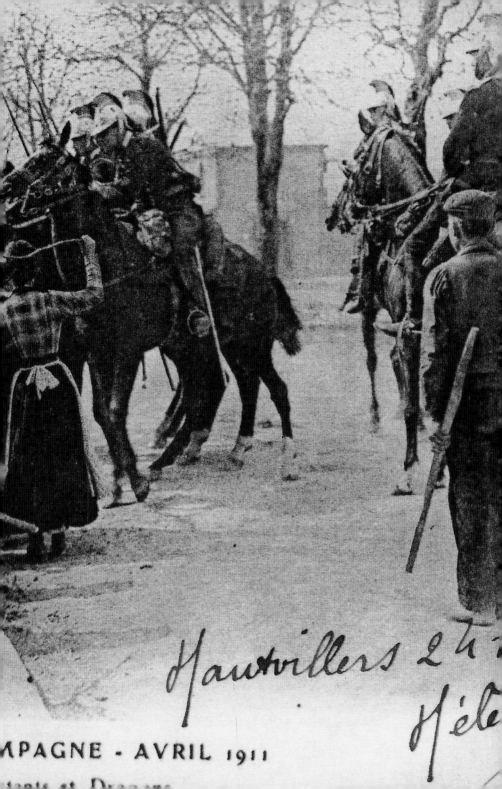

Hautvillers 2 h...

Hélè...

MPAGNE - AVRIL 1911

...tants et Dragons

(although there was no A.O.C. for Champagne at the time). The second was the clumsiness of French politicians. Although they had introduced a law on February 10 that specified that only grapes from the area beside the River Marne and known as "Marne" had the right to go by the magic name of Champagne, they were considering revoking the decision. This is all that was needed to ignite the powder keg. Shortly thereafter, the politicians committed a further gaffe by placing the Aube district outside the Champagne area. The growers stopped paying taxes and more than 6,000 of them demonstrated in Troyes. Paris took notice, and a commission recommended incorporating Aube into the Champagne district. But the legislators, continuing to act crassly, invented a new appellation: *champagne de seconde zone*.

It was not until the end of the World War I that good sense prevailed. Tensions were so high that from spring through fall of 1911, 40,000 soldiers under the command of seven colonels occupied the vineyards.

Above: Jacques Bollinger (1938), founder of the firm.

Preceding pages: Rioting in Champagne, 1911.

The army did not leave until after the harvest, spending a most uncomfortable summer in the record heat.

The house of Bollinger was founded in 1829 and remains family-owned and independent. Today, the vineyard covers more than 120 hectares. In 1911, the planted area, which has since been greatly extended, embraced the communes of Cuis, Ay, Verzenay, Louvois, Tauxières, and Bouzy. In 1955, Bollinger launched the "RD" (*récemment dégorgés*) series, with the date of the removal of sediment indicated on a special label on the opposite side of the bottle. In 1969, the very rare *Bollinger vielles vignes françaises*, a blanc de noir produced from two, then three, small plots of ungrafted vines debuted. There are 30,000 plants to the hectare, the harvest is trodden underfoot as in the eighteenth century. It requires careful vinification, fermentation in the bottle, *tirage* on the cork, and a long time on the lees. At the beginning of the twenty-first century, phylloxera invaded the non-grafted vines at Bouzy, the largest parcel. Production is uncertain.

Organoleptic Description

Once the wire had been removed, the cork did not resist being pulled. It was stapled in place, the wine having popped it many years previous. Yet, contrary to all expectations, the wine still contained gas. It was not "bubbling" but full of tiny bubbles which rose constantly to the surface. They streaked a uniform yellow robe which contained no shadows or browning. The wine was ripe without being old, the balance was perfect because there was still a measure of acidity but no oxidation. The aromas which emerged were lemony and slightly candied with a hint of hazelnut; a long, subtle symphony. It all goes to disprove what one often hears said: "Champagne is not a wine."

Secrets of Quality

Exceptionally hot weather, grapes ripening with acidity.

Availability

None.

Current Price

Not on the market.

Apogee: Probably around 1925–1930.

Comparable or almost comparable vintages: 1921, 1928, 1937, 1947, 1953, 1961.

Development: When the cork can no longer retain the gas, it will not be Champagne.

Weather Conditions

Early harvesting in the magnificent weather around September 10 sent the soldiers back to barracks. The harvest did not last long because there were so few grapes, only 3,520 pounds per hectare (compared with an average harvest of 26,400 today). This was a poor yield even for the the period, but there was no need to pick over the grapes, which were in perfect condition.

1. **The British royal family**
King George V, shown here soon after his coronation on a trip to India.

2. **Fall of Manchurian dynasty in China**
This was the beginning of the Republic of China, which was proclaimed in 1912 and soon became a dictatorship.

3. **The Ballets Russes**
Illustration from the first decade of the century, the fabulous era that saw the triumph of Igor Stravinsky, Sergei Diaghilev, Vaslav Nijinsky, and Leon Bakst.

4. **Second Moroccan crisis**
Occupation of Fez by French troops during the fight with the Germans.

5. **Rioting in Champagne**
On April 22, 6,000 winemakers demonstrated in Ay to protest against the use of grapes from outside the region to make Champagne.

1921

1921

Hitler proclaims himself the president of the NSDAP (National Socialist German Workers Party—the Nazis) on July 29. In Italy, Mussolini makes the Fascist Party the official party of the government, taking the title of Il Duce ("leader"); Hirohito, son of the emperor of Japan, accedes the imperial throne on his father's death and rules as regent from 1921 through 1926. In China, Mao Zedong helps form the Chinese Communist Party.

In the aftermath of World War I, there are endless negotiations over the reparations owed the Allies by Germany. The German mark is massively devalued and the country's economy tumbles into crisis. Spanish Morocco rebels against Spain, under the leadership of Abd el-Krim. The British attempt to establish a protectorate in Persia, where oil production is on the increase, through General Reza Khan. In the same year, Southern Ireland is granted home rule and Great Britain recognizes the Irish Free State. Northern Ireland obtains dominion status.

There are great advances in medicine, with the discovery of insulin and introduction of BCG vaccination. It is the year of the first helicopter flight, the first aerial photograph of Paris, the first freeway (in Berlin), and the invention of wireless telegraphy. A certain Walt Disney produces his first cartoon film. The composer Saint-Saens dies in Paris, opera star Enrico Caruso in Naples. Anatole France wins the Nobel Prize for literature.

Facing page: Bottle of Romanée-Conti.

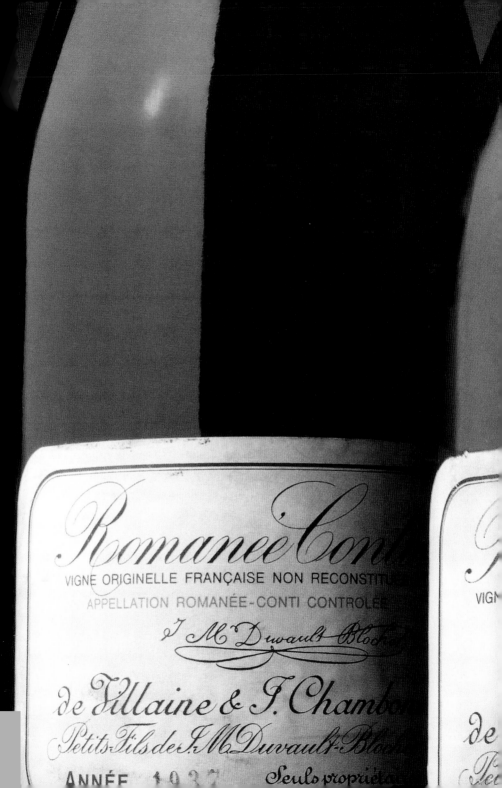

Romanée-Conti 1921 Burgundy

The Pinot Noir grapes from which this wine is made were planted by Claude Cousin in 1584, 337 years before the 1921 harvest. This is a unique case, because all the rest of the French vines were replanted after the phylloxera epidemic, between 1880 and 1910. Romanée-Conti, which had been regularly treated with sulfur carbonate to protect it from the attacks of the dreaded plant-lice, escaped harm. (This practice continued until 1945, when the vines were uprooted, which is why there is no Romanée-Conti wine between 1946 and 1951.)

Facing page: Ancient vintage bottle of Romanée-Conti.

The Pinot vines were pure French stock and were not grafted but were propagated by layering. A branch was buried in the earth to enable it to take root. It is thus indisputable that the Pinot planted in 1584 is actually and genetically the one that bore fruit in 1921. When Claude Cousin bought the vineyard from the Benedictine Monastery of Saint-Vivant de Vergy in the Hautes-Cotes district of Burgundy it covered an area of five journals. The plot was sometimes referred to as "Cloux des cinq journeaux." (*Cloux* means "enclosure," and a journal was a measurement roughly equivalent to 857 acres.) It was later called Cros des Cloux, meaning "Hollow of the Enclosures," indicating the slight dip in the slope at the bottom of the vineyard.

The famous vineyard passed in succession to the Croonembourg family and mysteriously acquired the name of Romanée, which was used for several vineyards in the area. It is not known if this is a late allusion to Roman presence in the area or a distortion of the old word "romenie," which is a reference to a legendary wine from the Greek isles.

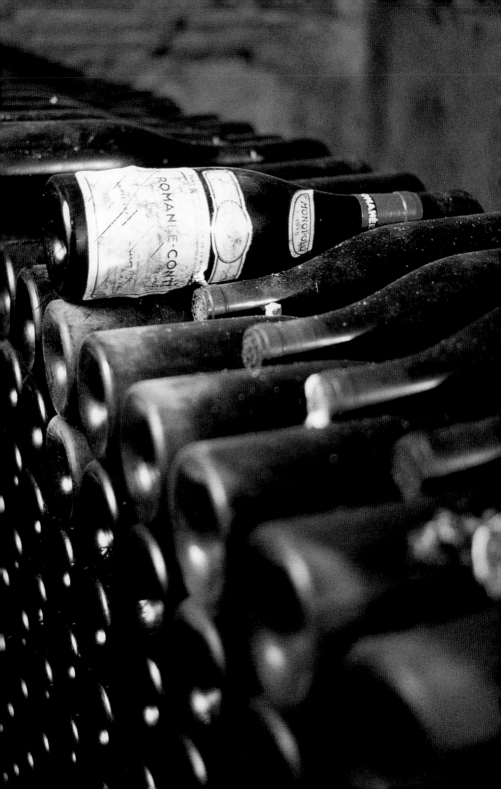

In 1790, Louis-François de Bourbon, Prince of Conti, acquired the Romanée for 92,400 sovereigns, a handsome sum, about ten times the price achieved by neighboring vineyards!

Until the French Revolution, Romanée was reserved for the prince's table and never traded on the open market. When national treasures were sold off, the prince's name was tacked on the end of Romanée. (The revolutionaries must have considered that the aristocratic provenance of the estate was a powerful sales pitch in itself, despite their egalitarian views.)

Romanée-Conti fell into the hands of speculators for a time, but this ended when Ouvrard acquired the Romanée-Conti estate and the neighboring Clos de Vougeot, in 1818. He kept the vineyards for forty-three years, until his death. His children did not follow his example: Romanée-Conti was sold in 1868, then again in 1869 this time to Mr. Duvault-Blochet, a wine merchant from Santenay. Since

Edmond Gaudin, estate manager from the early 1920s until 1942.

then, half the estate has belonged to his descendants, the other half having been sold in 1942 to Henri Leroy, a wine merchant. The two families run Romanée-Conti jointly through a company that also manages other *grands crus*, such as La Tâche (monopole), Grands Echezeaux, Richebourg, and some of the Montrachets. Until 1989, the grapes harvested were trodden underfoot in the time-honored way. The stalks are not discarded, which generally increases the potential for aging in the wine. The wine is fermented in open vats (with added yeasts) and then aged in new bottles. It is only drawn off once (so left on the lees for a long time) and clarified with egg white. When tasted a few years ago, it showed no sign of weakness.

Organoleptic Description

The robe is opaque, brightly colored, and very dark, brownish in the mass, the sign of extreme concentration. The mouth is an extension of the nose, redolent of all the fruitiness of Pinot, the most delicate of all the grape varieties, a clear fruitiness melting into darker tertiary aromas. The alcohol-acid and tannin balance is perfect, a magnificent harmony, supple, powerful, almost velvety; the finale is as elegant as it is long.

Secrets of Quality
High heat, small harvest, balanced concentration.

Availability
Practically impossible to find.

Current Price
$24,000.

Apogee:
1950, but still extraordinary.

Comparable or almost comparable vintages: 1928, 1929, 1937.

Development:
Appears to be unchanging. Should be drunk before it is a century old.

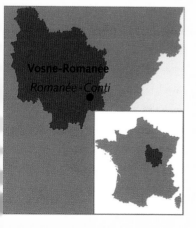

Tradition

Wine drunk by the Prince of Conti was made in exactly the same way as the 1921 vintage. It came from the same vines, planted in the same place, in a vineyard of the same size. The yield per hectare may have been smaller in the eighteenth century than it was in 1921, though in that year the harvest was very small, even considering the property's severely limited yield of between 25 and 30 hectoliters per hectare.

Château d'Yquem 1921 Bordeaux – Sauternes

The Château d'Yquem is a ruined twelfth-century fortress, of which only
a few walls remain. Shortly before the French Revolution, Count Louis-
Amédée de Lur-Saluces married Josephine Sauvage, whose ancestors had
acquired Yquem in 1592. Since that time, the Lur-Saluces family worked
tirelessly to pursue consistent perfection for this incomparable château-
bottled wine. However, in March 1999, Château d'Yquem was bought by
the French luxury group LVMH.

The vineyard is huge, a single stretch of 113 hectares, planted with 80%
Sémillon and 20% Sauvignon (7,000 plants per hectare). The siliceous soil
of Graves is poor. It has been improved by human intervention since the
nineteenth century—the Lur-Saluces laid sixty-two miles of drainage pipes
in the soil! The grape-pickers pass along each row of vines several times,
so as to pick only those attacked by botrytis (noble rot). These grapes are
dubbed *rôties* (roasted). The grapes are then lightly trodden and pressed
gently several times. The must ferments in casks until the degree of
alcohol reaches about 58° F, when fermentation stops spontaneously.
Aging, in new casks, lasts for three and a half years. The wine is drawn
off several times and is clarified twice with bentonite. It is then filtered a
final time before being bottled. Atmospheric conditions do not always
favor noble rot, in which case there is no Château d'Yquem at all. This is
what happened in 1951, 1952, 1964, 1972, 1974, and 1994, and in the
postwar years as well. On the other hand, 1921 was the year in which
everything combined to make it the Yquem of the century.

Following pages:
Old wines from
Château d'Yquem.

Organoleptic Description

Today, the robe of the Château d'Yquem 1921 is a dark mahogany. A heady mixture of aromas of citrus, plum, honey, and vanilla-scented candied apricots precedes the basically creamy, smooth, and subtle texture, and its mouth is as long as it is harmonious. It is an ageless masterpiece because it develops without turning rancid.

Secrets of Quality

Maturity, concentration, and botrytisation.

Availability

Rare but not impossible to find.

Current Price

$5,000.

Apogee:
1950?

Comparable or almost comparable vintages: 1967, 1988, 1990.

Development:
To be drunk before it is 100 years old.

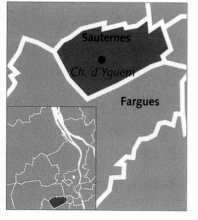

Weather Conditions

In the spring, a sharp frost attacked the vine as it was sprouting. A lot of heat was then needed to obtain the perfect ripening and hoped-for concentration upon maturity. In 1921, conditions were just right. After the usual mid-August storm, the fine weather returned and continued until the fall, without being affected by the morning mists rising from the Garonne and Ciron. The wines had never been watered so little, hence the unparalleled richness and concentration of the grape juice.

The pickers began work on September 13, and spent 39 days in the vineyard, passing along each row five times. The ideal balance of 14-15° of alcohol plus 6° of potential alcohol (120 grams of sugar per liter) was easily obtained.

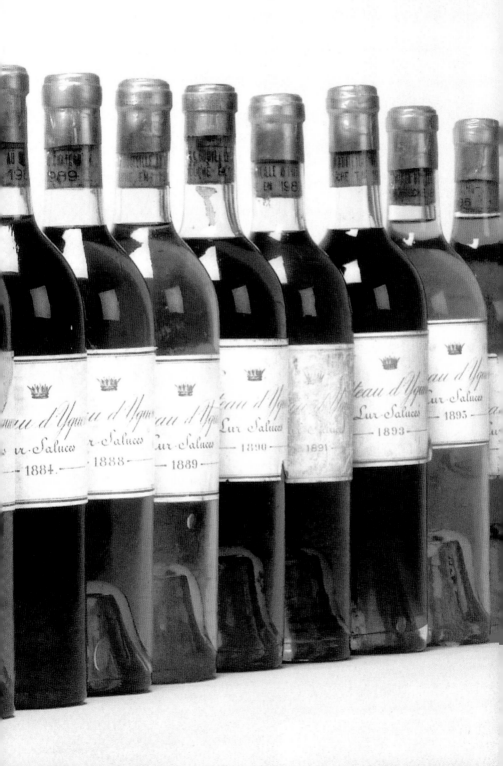

1

2

4 LA T.S.F.

5

1. Germany in crisis
After World War I, unemployment and deflation caused the German economy to slump to its lowest level.

2. Racing circuits
In the 1920s, automobile races attracted large and enthusiastic crowds.

3. The Landru trial
Henri Landru, dubbed "the French Bluebeard," was sent to the guillotine in 1922 for strangling and burning eleven people, ten of them women, in his huge iron oven.

4. Wireless telegraphy
This invention made it possible to simultaneously transmit messages to the four corners of the earth.

5. Walt Disney
Walt Disney, producer, director, and animator, releases his first film.

1928

From today's perspective, the most important event of 1928 is the accidental discovery of penicillin by Alexander Fleming. But there was a more immediate and apparent milestone when telephone lines linking Paris to New York and Algiers were inaugurated. Television sets are manufactured by the new production line techniques and offered to New Yorkers at reasonable prices, although the clarity of the images leaves a lot to be desired, since they were composed of between 28 and 48 lines. (The American system now uses 625 lines.) Von Opel could get up to a speed of 125 miles per hour in his *fusauto* (rocket automobile) and aeronautical applications are considered. In politics, extremism becomes the order of the day. Pope Pius XI had excommunicated the right-wing Action Française two years earlier; the French Communist Party engages in class warfare; the Nazis are elected to power in Bavaria. Chiang Kai-Shek becomes president of the Republic of China, whose seat of government is located in Nanking.

The French dominate world tennis and the Roland Garros Stadium, a rival to Wimbledon and Forest Hills, opens in Paris. Sport begins to arouse overenthusiasm. Thirty spectators are injured after a soccer match between France and Belgium.

Facing page:
Dovecote on the
Château Latour
estate.

Disney creates Mickey Mouse in this year. Musical hits include George Gershwin's *An American in Paris* in New York, Bertolt Brecht's *Threepenny Opera* in Berlin, and Maurice Ravel's *Bolero*.

Château Latour 1928 Bordeaux – Pauillac

In 1928, the masters of Château Latour could claim to be celebrating
more than 250 years of ownership, but they could not have known
that they were about to vinify the greatest red wine ever produced—
though Romanée-Conti comes a close second. The aforementioned
1928/1929 pair of vintage years feature a rigorous construction and a
magnificent fruitiness, respectively. We stated that it was logical to
compare the wines side by side, glass by glass, as wines at their
respective apogee. To be able to to make such a comparison the wines
had to reach their respective peaks at the same time. It might have
been expected that two successive vintages would come together at
their best, but this did not happen. The 1929, despite starting a year
later, made up for lost time and blossomed in a brilliant firework; and
as it went out with a bang, the colossal 1928 vintage began its
inevitable rise. Thus when the younger wine had generally passed its
prime, the older wine was only just getting there.

The yields per hectare of these two vintages were normal, about
eighty barrels. The harvesting weather was magnificent, and both
vintages sold at the same price, 20,000 francs a barrel, a record
at the time.

Following pages:
Harvesting basket.

Organoleptic Description

Terribly tannic with a high alcohol content and incredibly concentrated. Château Latour 1928 is a legendary wine. Even today, it needs to be heavily oxygenated by decanting in order for it to be seen in its best light. Even after all these years, the robe is a deep pomegranate color and has hardly developed at all. The complex, spicy bouquet with tertiary aromas of licorice and leather heralds a mouth with a tight warp and weft, in which the tannins are clearly present but eventually melt and concentrate in an exemplary manner, which is indefinitely prolonged into a harmonious finale.

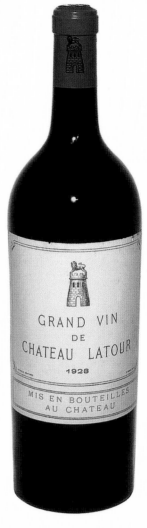

Secrets of Quality

Very small grapes and exceptional ripeness.

Availability

Fetches high prices at auction.

Current Price

$3,000–$4,000 per bottle, but a case of 12 removed from the Latour cellar in July 2003 commanded $72,6000 at auction in 2007.

Apogee:
2000 (magnum).

Comparable or almost comparable vintages: 1945, 1961.

Development:
Drinkable until its 100th birthday.

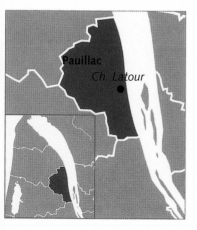

Weather Conditions

There is no doubt that for thirty years or so, the Latour 1929 was the best wine, but since then the Latour 1928 has overtaken it.

Why are the two wines so different in character? Weather factors are partly to blame. The summer was slightly hotter in 1928 than in 1929. There were more grapes to the bunch but they were smaller and their skin was very tough. That is due to an excess of heat and lack of rain, whereas in 1929 a few showers "humanized" the grape.

Salon 1928 Champagne

The harvest began on September 24 with perfect bunches of grapes and the must reaching the crucial level of 10–12° of alcohol. The acidity was considerable—on the order of seven or eight grams a liter, an indicator of quality. A serious drought in August had caused the growers to predict a limited harvest, but they had not counted on the cool, damp nights and early morning dew of September. The bunches of grapes were plentiful and weighed about 200 grams (seven ounces) each, twice as much as usual. At the time, the volume of the harvest was judged to be satisfactory (6,000 kilos per hectare), but it would not be considered very good today, with customary yields of twice that size.

Aimé Salon was a self-made man, a hard worker but great sybarite. He was a hard worker because he had started with nothing and made his fortune. The term "sybarite" also fits him perfectly because he kept a table open at Maxim's in Paris, so that his friends could dine at his expense even in his absence. As one of the richest men in France, he had developed a taste for the good life. He had an immoderate love of Champagne and employed two chefs. His sister married a cellar master from Mesnil-sur-Oger, which gave him a taste for chardonnay, and he soon discovered a passion for the area's wines. He bought a few vines and had some Champagne produced for his own use and that of his friends. Unaware of custom, he fixed his own rules of production and decided that his Champagne would be made exclusively from white grapes. At the time, Blanc de Blanc, now so fashionable, did not exist.

The 1928 vintage in the Salon cellar.

He decided to use only grapes from the commune of Mesnil-sur-Oger and only to make Champagne in the good years, so that his would always be vintage. Needless to say, only the first pressing, the *cuvée*, was good enough to make this exceptional Champagne. These four rules still govern the making of Salon Champagne. It was so heavily in demand that Aimé Salon eventually sold his Champagne on the open market. The first vintage was the 1911. It subsequently became Maxim's "official" Champagne.

Aimé Salon died in 1943 and was succeeded by his sister, who bequeathed the firm to her grandson, Marcel Guillaume. It was sold, first to Dubonnet-Cinzano, then to Pernod-Ricard, and finally to Laurent-Perrier, but none of them altered the idiosyncratic operating methods. Where the money to operate the estate comes from does not matter if those who run the firm are unshakable in their resolve, as was the case with Robert Billon until his death.

Again, the author begs the reader's indulgence for bringing himself into the story, because he knew those involved and was a neighbor of Marcel

Guillaume until his death. Guillaume drank Champagne morning, noon, and night, and always in tall glasses, to show that there was nothing special about this habit, which was merely part of everyday life.

From Aimé Salon, he inherited not only the Champagne-producing firm but also a love of good food. He loved to cook and created dishes using the tricks he had learned from his uncle, of whom he spoke such a lot that I ended up by feeling I had met him myself. Robert Billon ran the firm and lived in an attractive modern house facing the Clos du Mesnil (which now belongs to Krug). He operated a small grape-purchasing cooperative, reserved exclusively for the winemakers of Mesnil-sur-Oger. Marcel Guillaume had devised this system in order to be certain of the provenance of grapes destined to be used to make his Champagne. Billon was what some people would call "macho" and others would call a philanderer. One day, he came home and his wife,

who had reached the end of her rope, was waiting for him with a knife in her hand. She stabbed him in the stomach, killing him instantly. Going down into the Salon cellars with Billon was a memorable experience. It was also a dangerous one, because there has never been such a damp cellar and more slippery steps. Water did not merely ooze from the walls, it poured out. Billon would withdraw the 1928 "hoard" from a narrow cleft, and this was the first bottle we would drink. It had to be tasted immediately after uncorking. (Cork oak was used, of course, because crown caps for wine were unknown at the time.) It was a masterpiece.

Aimé Salon, founder of the firm in the early twentieth century.

At the time of writing, Didier Depond runs Salon. It is owned by Laurent-Perrier, which is to say, by Bernard de Nonencourt. He has taken over Salon Champagne and Delamotte Champagne—two adjacent firms. Delamotte belonged to his brother, Charles de Nonencourt, who married Marcel Guillaume's sister!

The world of Champagne is quite a closed one, as this story shows.

Organoleptic Description

The golden color of the robe is faded, but the gas is still there, the tiny bubbles constantly moving the liquid around. The nose is rather that of buttered hazelnut than almond, and there is a complete absence of maderization. The lemony aroma is rounded, but the words "candied" or "crystallized" do not apply, because the wine is too lively for that. There may be a hint of honey, but without the heaviness this could imply. In the mouth, there is complexity and vigorous finesse. And what length in the mouth! A very great white wine.

Secrets of Quality

Magnificent summer weather and cold nights.

Availability

Extremely rare.

Current Price

Not on the market.

Apogee:
Around 1945.

Comparable or almost comparable vintages:
Possibly 1996?

Development:
Drink as long as the cork keeps the gas inside.

Marne
● Le Mesnil-sur-Oger

Weather Conditions

That year, the whole of France experienced the same weather conditions, a hot, dry August followed by more of the same in September. In Champagne, there were frosts as late as May and in some places hail had fallen in June and damaged the vines. The clincher was the September weather, when nights and mornings were very cool. Experience shows that strongly contrasting temperatures at that time of year are likely to produce great vintages.

1. Tennis
Heroes of the French tennis team: Borotra, Brugnon, Cochet, and Lacoste, the golden age of French male players.

2. Republic of China
Chiang Kai-Shek becomes president.

3. Al Capone
In the Unites States, the prohibition of alcohol (1919–1933) produces smugglers, bootleggers, and speakeasies—and, of course, the Mafia and organized crime.

4. The Roaring Twenties
Evening on the Champs-Élysées in Paris in the late 1920s.

5. Traffic
Parisians discover the joys of traffic jams.

1929

The sensation of the year is unquestionably New York's Wall Street crash, which occurs on Thursday, October 24. Stocks lose one-third of their value, causing some speculators to commit suicide. The day becomes known as "Black Thursday." Italy finally sorts out its problem with the Vatican, which became a sovereign state as a result of the Lateran Pact. In Geneva, the writer Aristotle Briand launches a plan for a United States of Europe. In Jerusalem, Jews and Arabs clash at the foot of the Wailing Wall.

Automobile races are all the rage; Monaco organizes its first Grand Prix, which is won by William Grover-Williams, driving a Bugatti. A "gentleman driver" who also won acclaim for finishing brilliantly in a Bugatti was Philippe de Rothschild, owner and dynamic manager of Château Mouton Rothschild, a *premier cru classé* from Médoc and one of the greatest wines in France. Shortly thereafter, he came second behind Louis Chiron in the Grand Prix des Nations, at Neubergring in Germany. Both were driving Bugattis, beating the Mercedes on its own ground.

The era of mergers has already begun. General Motors bought Opel from Carl Benz (who built the first gasoline-fueled vehicle and "self-propelled" himself on a motorized tricycle on July 3, 1886). Several leading Frenchmen die this year, notably Georges Clemenceau, Marshal Foch, Georges Courteline, and Antoine Bourdelle.

Opposite:
Château la Mission
Haut-Brion.

Château la Mission Haut-Brion 1929
Bordeaux – Pessac-Léognan

From 1630 until the French Revolution, this estate belonged to the clergy. It then passed through three or four hands until 1920, when it was acquired by Frédéric Woltner. An innovator and perfectionist, he was the first to try vinification in metal vats (in 1926) and understood the need to check and regulate the fermentation temperature. The sublime 1929 vintage was the result of this technical progress.

In 1983, the Woltner Estates (comprising Château la Mission Haut-Brion, Latour Haut-Brion, and Laville Haut-Brion), were incorporated into Clarence Dillon S.A., a corporation based at Haut-Brion. Today, the vineyard covers about 21 hectares of gunzian gravel soil planted with 60% Cabernet Sauvignon, 35% Merlot, and 5% Cabernet Franc. The vines are old and the yield is low, only about 35 hectoliters per hectare. These days, the winestore is all stainless steel and computerized, the cutting edge of wine technology. Frédéric Woltner had just as modern an outlook in 1926, but vinification and grape cultivation techniques have hardly changed since 1929. Fermentation is at 86° F and aging is in new hogsheads (casks). Although the 1929 is later than 1928, the more recent wine should be drunk earlier. Château la Mission Haut-Brion is a delightful claret, devoid of mischief or superficiality, and richly elegant. Some vintages are great in their excess, but this is not the case with the 1929, which is all harmony, the supreme expression of balance. The Château la Mission Haut-Brion exemplifies the epitome of the qualities required for a great vintage, an unforgettable composition of unsurpassed harmony.

Organoleptic Description

A wonderful robe, as is frequently the case with Mission: complex, abundant, and varied fruitiness, followed by a mouthfeel that is a combination of sugarplums and pureed mulberries, highlighted by a hint of licorice and pitch. All this, with the roundness of an old Banyuls—an unparalleled harmony.

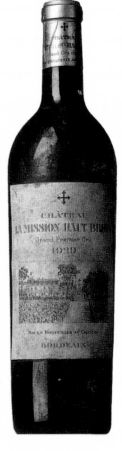

Secrets of Quality

The grapes and perfect vinification.

Availability

Rare.

Current price

Around $3,000–$4,000.

Apogee:
1950.

Comparable or almost comparable vintages: 1949, 1955, 1956, 1961.

Development:
Still good to drink.

Weather Conditions

The previous year, 1928, had been very hot and dry, almost excessively so. The year 1929 was similar, but with a series of perfect seasons. Growers were hoping for rain, and when the rain fell, it was just enough to encourage the harvest without drowning it. It should be remarked in passing that the last such "double," or two great years in succession—1899/1900—was followed by three disastrous ones. That is exactly what happened after 1928/1929, when there were three poor years.

2

1. Vatican
As a result of the Lateran Pact, signed by Cardinal Gasparri on the behalf of the Holy See and Mussolini on the behalf of Italy, the Vatican becomes a sovereign state subject only to the authority of the Pope.

2. The Wall Street crash
Wall Street on Thursday, October 24: The stock market crashes and this day goes down in history as Black Thursday. It was the first, but by no means the last, great crisis of international capitalism.

3. Georges Clemenceau
Death of the great writer and former prime minister of France.

4. Automobile races
The first Monaco Grand Prix.

5. *Marius* staged in Paris
This four-act play is the last in the Marseille Trilogy (the others are *Fanny* and *César*) by Marcel Pagnol.

1934

1934

A turbulent year of violence and assassination. In Paris, rioting against political corruption claims several victims. In Marseilles, King Alexander I of Yugoslavia, the former crown prince of Serbia, and Louis Barthou, the French foreign minister, are shot dead by a member of the Ustashi, the pro-Nazi Croatian terrorist movement.

In Germany, Hitler uses his SS to organize the Night of the Long Knives to rid himself of his staunch supporters, Ernst Röhm and the SA (brownshirts). The death of Paul von Hindenburg opens the way for Hitler to declare himself Chancellor of the Reich, and combining this with the presidency, Nazis assassinate the Austrian chancellor, Engelbert Dollfuss. In Spain, two provinces demand independence and the young republic is threatened by civil war.

War breaks out in China. Chiang Kai-Shek's army defeats Mao Zedong's Communists, who begin their long march. The very popular Belgian king Albert I, is killed in a mountaineering accident. His son, Leopold III, succeeds him on the throne.

France, under the right-wing Laval, tries appeasement with Italy and signs a nonaggression treaty over Africa. Poland signs nonaggression treaties with Germany and the Soviet Union, and a pact is entered among Yugoslavia, Greece, Romania, and Turkey. The Labour party wins its first election in Great Britain, and in France, Marcel Cachin, a Communist, sets up a left-wing alliance, the Popular Front.

Opposite: Austrian vineyard in the Rust region.

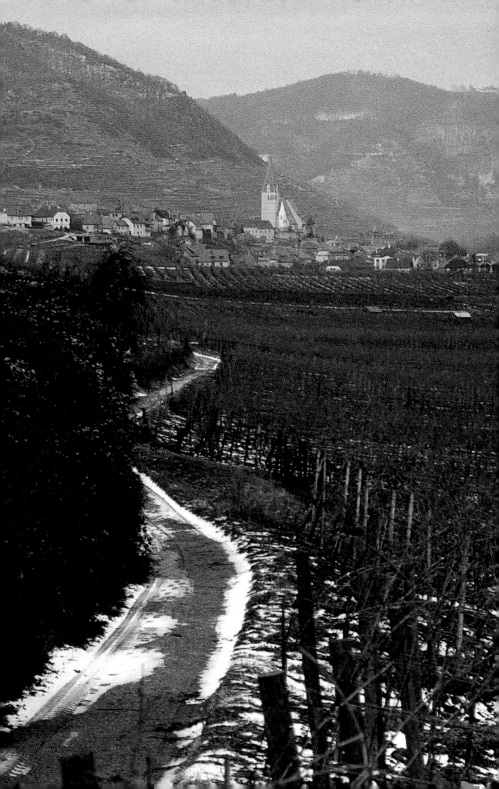

Ruster Ausbruch 1934
Austria – Neusiedlersee-Hügelland

The name is hard to translate. *Ruster* indicates that the wine comes from the village of Rust, in the Burgenland region of Austria. As for *Ausbruch*, it may be derived from the word Aszü, a wine made from withered grapes or those rotted by *Botrytis cinerea*, but this would not be absolutely accurate because the words *Ausbruch* and *Aszü* also have a technical meaning indicating a specific method of winemaking. This will be explained later in greater depth.

Ruster Ausbruch is not as famous a wine as, say, those by Château Lafite or Clos de Vougeot, but a wine from Rust won a medal at the Vinexpo in 1985, and a Ruster Ausbruch won the International Trophy for Sweet Wines in London in 1995.

Grapes have been grown in Rust for a long time. There are records of winemaking here and in neighboring villages dating from 1317, and it is even possible that Charlemagne introduced Burgundy wine stocks into Burgenland in the late eighth century. In the Middle Ages, the wines of Rust were designated "wines of the emperors" because the Hapsburgs drank them. The honor is an interesting one, because it shows that the reputation of the region's wines preceded the dominance of its sweet wines, for which we hail it today.

There has always been a dispute between Austria and Hungary as to which was the first to make fine wines. It should be remembered that Burgenland has only been a part of Austria since 1921; prior to that date, it belonged to Hungary, and the present frontier is very near Rust. This explains the presence of the Furmint grape, which is well known in the

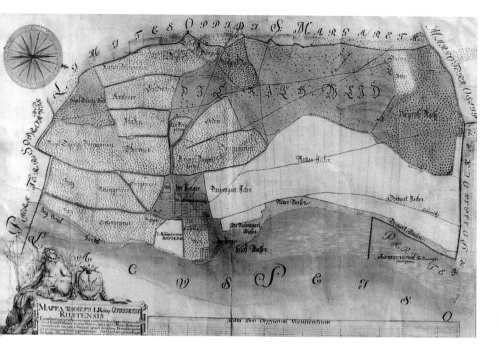

appa Terreni
vitatis Rustensis,
map of the Rust
eyard, 1783.

Tokay region across the border. In fact, Rust and Tokay vie with the honor of being the first to make wines from grapes attacked by noble rot. However, according to an account published in Venice in 1441, the first such wine came from Moldavia (today Romania) and was called Cotnari, a sweet white wine that gained international renown in the nineteenth century and is still made today.

To return to the chronology, in 1526 a wine made from the juice of "rotten grapes" was mentioned in the village of Donnerskirchen, a few miles to the northeast of Rust. The tax ledger of the village of Weiden records that from October 16 through November 13 ,1617, moldy grapes were harvested, yielding 357 hectoliters of Ausbruch.

All of these wines were made from Furmint grapes attacked by botrytis, as was the earliest known Tokay, vinified in 1631 by Maté Szepsi Leczko, from grapes harvested in the Oremus vineyard. The fact that Leczko was a reformist minister is not surprising because the Lutherans encouraged the vinification of rotten grapes, unaware or deliberately flouting the proscription of this grape, judged "impure" by the Catholics. (After all, these wines were intended for use in Mass.) The Protestants were the traveling salesmen of the botrytised grapes.

If the technique of making wine from rotten grapes emerged in Rust and the neighboring villages of Donnerskirchen and Weiden, it is because this is the European heartland of botrytis. The fungus mold, *Botrytis cinerea*, proliferates here because the natural conditions are ideal for its growth. These villages lie close to a very large expanse of water that covers several dozen square miles. The Neusiedlersee is the largest lake in Central Europe and it is very shallow—only about five feet on average. This means that, despite the semicontinental climate of extremes, there is a thick morning mist produced by evaporation of the Neusiedlersee, as much as 225 million hectoliters annually!

Harvesting is performed either by the *trie* method, picking only the rotten grapes and returning several times as in the Sautermes district, or as in Hungary, using two buckets and sorting as they are picked, or simply cutting out the moldy grapes. Ausbruch comes from the German word *ausgebrochen*, meaning "cut out." Ausbruch is the result of a special

Friedrich Seiler, present owner of the estate.

vinification process. The botrytised grapes pass through a prefermentation phase, then a must that is not so rich is added to them, which reactivates fermentation. The result is a wine that is richer in alcohol but less rich in sugar. An Ausbruch is balanced when it has 13° of alcohol and 150 grams of sugar. A Trockenbeerenauslese has 9° of alcohol and 220 grams of sugar. Tokay Aszü (*see page 344*) is an inverted Ausbruch. The grapes affected by noble rot are incorporated into the basic wine; the quantity of botritysed grapes is expressed in *puttonyos*. (A *puttonyo* is a wooden tub that can hold around 35 liters of grapes.)

The balance of a dessert wine is not expressed entirely in terms of the sugar-alcohol ratio, it also needs a lot of acidity. In the Rust region, the wines are rich in tartaric acid. Then there is the aging process. The problem is the same at Tokay as in Rust. The extended, oxidizing aging process is disappearing because the result is unpopular with modern consumers. That is why prewar Ausbruchs are so different from those of today, though it is impossible to compare them with prewar Tokays, as none are left.

Organoleptic Description

A rare bottle of 1934 Ruster Ausbruch was found and drunk in 1973. The robe was mahogany colored and the wine was distinguished by the complex elegance of the bouquet, the lively and delicate balance, and by the very long length in the mouth. The discernable oxidation of the wine was clearly the result of old-style vinification methods rather than aging, since the longevity of the Ausbruchs is exemplary. The wine is extremely rich—it can attain 25° of alcohol—and is made from Welsch Riesling (a very sweet grape rich in tartaric acid). There is a fruitiness with a hint of burnt toast and the oxidation marries well with the creamy complexity of the noble rot. This memorable Ruster Ausbruch is very different from the livelier and fresher wines that have been vinified since World War II, and especially since 1980.

Secrets of Quality

Perfect mastery of the noble rot technique.

Availability

None.

Current Price

Not on the market.

Apogee:
1960.

Comparable or almost comparable vintages:
1963, 1981; contemporary style: 1993

Development:
Long past its prime.

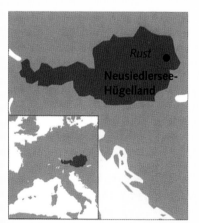

Weather Conditions

Winemakers remember the year 1934 as the one when the noble rot was most vigorous, striking with amazing speed. It attacked the overripe grapes, which were the result of the hot, dry summer that caused an early harvest (starting September 2).

1934

1

2

1. Murder in Marseilles
King Alexander I of Yugoslavia, traveling through France, and Louis Barthou, the French foreign minister, were assassinated by Pétrus Kalemen, a member of the Croatian right-wing terrorist organization called the Ustashi.

2. The Long March
In 1934, Mao Zedong's army began its Long March, which did not end until 1936.

3. Rioting in Paris
Violent demonstrations and confrontations between the police and the Communists left twelve dead and hundreds of wounded.

4. Pierre and Marie Curie
Death of Marie Walewska Curie, two-time winner of the Nobel Prize: for physics in 1903 and for chemistry in 1911.

5. Hitler and Mussolini
The rise of Nazism and Fascism in Europe.

1935

The hit song of the year in France is the strangely prophetic *Tout va tre bien, madame la marquise* ("Everything's Going Swell, Milady"), preformed by Ray Ventura and his orchestra, while Italy and Germany were defying the rest of the world.

Germany is busy breaking the Treaty of Versailles and rearming to the hilt, reintroducing military service, and promulgating legislation to exclude Jews from normal daily life. Italy invades Abyssinia (today Ethiopia), heedless of the sanctions against it voted by the League of Nations. The Soviet Union invents the *stakhanovite*, a word taken from the name of a model miner who broke all the productivity records. A *stakhanovite* becomes the word for a "work hero," a model, and privileged Soviet citizen in receipt of a higher salary and extra privileges. Work begins on building the *Normandie*, the French flagship ocean liner. Paris holds its first Concours d'Elegance, in which luxury cars are displayed along with models dressed in the latest haute-couture fashions. Queen Astrid of Belgium is killed in a car accident while being driven by the king, causing a wave of grief to sweep through the country. Paul Signac, the painter who made Saint-Tropez famous, dies, as do André Citroën and T. E. Lawrence (Lawrence of Arabia), who is killed in a motorcycle accident. This is also the year of the death of the French writers Paul Bourget and Henri Barbusse, the Portuguese poet Fernando Pessoa, and the composer Alban Berg.

Opposite: Frank "Smiler" Fladgate *(right),* director of Taylor from 1897 through 1950.

Taylor's 1935 Portugal – port wine

In Bordeaux, no one mentions the year 1935. In Burgundy, 1935 does not have much of a reputation. The summer was not unpleasant, but the rains came early in the fall. The wines were not very concentrated, although the ripeness was acceptable. Not a single French appellation produced a memorable wine, but the story was very different in Portugal's Douro Valley.

It is interesting to note that it is often the case that a great year for Portugal's wines is a poor one for the rest of Europe, and vice versa. Thus, 1928 and 1929 were merely average in Portugal, whereas 1927 and 1931 were praiseworthy. The situation was reversed on the French side of the Pyrenees, and the same applies to 1960 and 1963: great Portuguese vintages, miserable results elsewhere.

Like Champagne, port is not always given a vintage, and its vinification, blending, and aging are very special because it is not bottled until it has spent two years in a pipe or cask, with tawny ports remaining in the wood even longer. The two types of port can easily be distinguished by sight, as tawny port turns a reddish color as it oxidizes in the wood, while vintage ports remain very dark, because they are protected from such oxidation in the bottle.

Taylor is a very old, traditional firm, founded in 1692 by the English, of course, like most of the great port wine producers. The vintage ports have the distinction of aging very slowly, to such an extent that the experts recommend they need fifteen years in the bottle for them to mature properly and reveal their typical aromas.

Organoleptic Description

The robe of this 1935 vintage port is starting to show its age at the edge of the disk. It is thick and oozes down the glass. To the nose, this heady richness, which is far from heavy, is characteristic of vintage ports. There is an alliance of brutality and grace, a complex fruitiness that approaches but is never overwhelmed by oxidation. Once this first challenge has been met, the art is to put virility into the sweet roundness of the mouth, and Taylor's 1935 achieves this memorably. The result is immense harmony, finesse, and length in the mouth. It is the quintessence of a valuable vintage port.

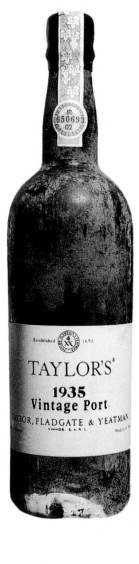

Secrets of Quality
Perfect maturity, limited yield.

Availability
Only at English auctions.

Current Price
Around $1,000.

Apogee:
1985.

Comparable or almost comparable vintages:
1945–1963.

Development:
Should be drunk before 2010.

Weather Conditions

The summer of 1935 was warm and dry in the Douro, ideal conditions for maturity and superb harvests. The volume was average and the grapes were harvested at the usual time, the last week in September. Considering the conditions, it is not surprising that a number of *quintas* decided to make a vintage port.

1935

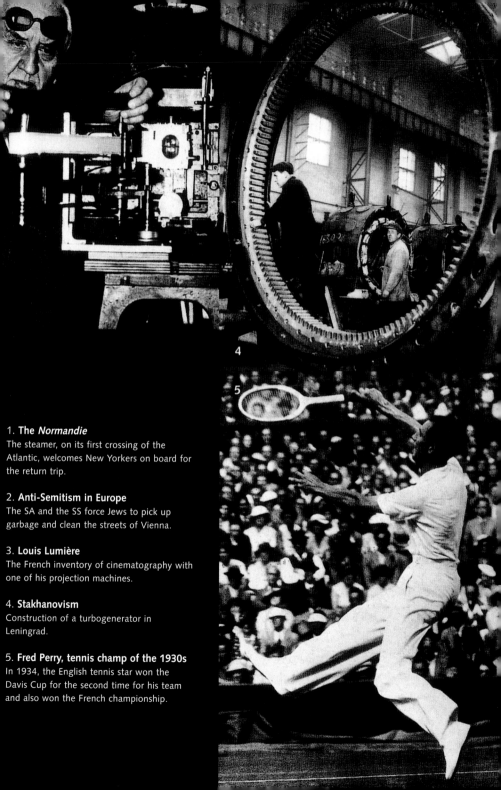

1. The *Normandie*
The steamer, on its first crossing of the Atlantic, welcomes New Yorkers on board for the return trip.

2. Anti-Semitism in Europe
The SA and the SS force Jews to pick up garbage and clean the streets of Vienna.

3. Louis Lumière
The French inventory of cinematography with one of his projection machines.

4. Stakhanovism
Construction of a turbogenerator in Leningrad.

5. Fred Perry, tennis champ of the 1930s
In 1934, the English tennis star won the Davis Cup for the second time for his team and also won the French championship.

1937

Civil war breaks out in Spain while Japan invades China. Guernica is bombed by the Germans and Generalissimo Franco leads the Falange, the sole political party. Italy bans marriage between blacks and whites in its colonies and slams the door on the League of Nations, becoming the ally of Japan and Germany in an anti-Komintern pact.

In Great Britain, George VI is crowned in December 1936, his brother Edward VIII (who became the Duke of Windsor) having abdicated the throne in order to marry an American divorcée, Wallis Simpson.

In France, the national railway is established and the Universal Exposition is at its height. The *Normandie* wins the Blue Riband prize for the fastest crossing between Europe and the United States. The German dirigible *Hindenburg* explodes upon arrival in New York, causing the death of 100 people. Travel by airship is banned.

In the United States, Henry Ford introduces a 32-hour work week in his factories. Du Pont in Nemours, Belgium, patents a new type of fiber called Nylon. The world of music loses Maurice Ravel, George Gershwin, and the blues singer Bessie Smith. The Baron Pierre de Coubertin, who revived the modern Olympic Games, also dies. In Italy, the Communist theoretician Antonio Gramsci and the physicist Marconi, inventor of radio, breathe their last.

Opposite: A vintage bottle of La Tâche.

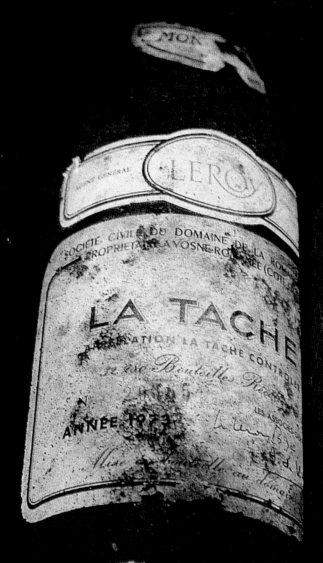

La Tâche 1937 Burgundy

It might be surprising that the year 1937 could be the best year for red wine. It is well known that 1937 was a great year for whites in the Bordeaux district (among dry and dessert wines, the Château d'Yquem 1937 is still as full and majestic as ever) as well as in the Loire, where the best of the oldest vintages were harvested in 1928, 1937, and 1947. One had to have tasted a sparkling Vouvray 1937 by Huet or the 1937 Château Moncontour to know that a Champagne never offered such delicate and complex aromas of tea and linden blossom as the old Chenin grapes were capable of producing. The year 1937 was also a great one in Champagne, Alsace, and Germany, where the hocks made from Riesling grapes had not produced anything as great since 1921. So why La Tâche? Because in that year, the red Burgundies were unparalleled, and there is no question that these were the greatest red wines of the century.

The faintness of the acidity, which is typical of the 1937 vintage, improved the white wines and incorporated itself ideally into the red Burgundies. They still had a hint of vigor, a touch which would have affected the balance of a claret, but in this case simply enhanced and developed the fruitiness of the Pinot grapes.

And why La Tâche 1937? It is a rare wine in all senses. Rare because so much of this excellent wine has been drunk, hardly any is left; rare because war interfered with its normal distribution; and rare because it combines elements that are often contradictory.

Organoleptic Description

The robe is dark, typical of this vineyard, which is generous in the color of its wines. The density is repeated in the mouth. There is a certain paradox between this roundness and the fresh vigor, a tone above what one might expect. The bouquet is flamboyant and rich, so typical of the grape variety that it could be a wine used for teaching. It seems to be saying, "This is what Pinot is all about!" The fruitiness of the Pinot resists tertiary aromas, but a hint of smokiness sneaks in. The finale is very rich and lasts for a long time. Some bottles seem to be unsurpassable.

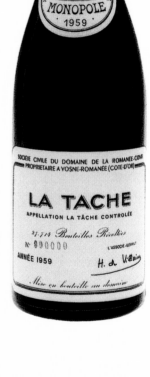

Secrets of Quality
Fine weather with cool evenings.

Availability
Extremely rare.

Current Price
Around $13,000 a bottle.

Apogee:
1975?

Comparable or almost comparable vintages: 1921, 1929.

Development:
Its vigor and richness have been maintained but it ought to be drunk as soon as possible.

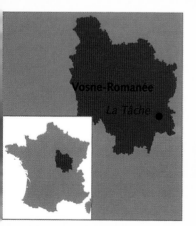

Weather Conditions:
While the average summer temperature in the Bordeaux region was mild, the sun shone brightly in Burgundy from July through September. Harvesting began in late September in optimum conditions—the grapes were healthy and ripe.

2

4

5

1. Coronation of King George VI
After the abdication of Edward VIII, who chose to marry twice-divorced Wallis Simpson, George VI is crowned king of England.

2. Civil war in Spain
Guernica is bombed and a bloody civil war engulfs the country.

3. Invention of Nylon
The Belgian company Du Pont de Nemours starts making Nylon fabric.

4. French railways and paid vacations
French vacationers leave from the Gare d'Orsay in Paris in 1936 on their first paid summer vacation.

5. The *Hindenburg*
Upon arrival in New York at the end of its twenty-first voyage, the German dirigible explodes, causing the death of 100 people.

1945

1945

The war is over at last, and Europe celebrates the Liberation. General Charles de Gaulle takes over the French government and nationalizes the banks, Air France, and Renault. Social Security becomes compulsory and French women are finally granted the vote. The Communists win the elections in France and there is a Labour landslide in Great Britain; Clement Attlee becomes prime minister. In the United States, President Franklin D. Roosevelt dies in office and Harry S. Truman takes over, ordering the first usage of atomic weapons against the Japanese cities of Hiroshima and Nagasaki, forcing Japan's capitulation. At the conferences of Yalta and Potsdam; Eastern Europe is handed to the Soviet Union. In Palestine, clashes between Jews and Arabs become more frequent, and both attack the British to hasten their departure (they rule the country under a mandate from the League of Nations). The Jews demand a national homeland. Ho Chi Minh proclaims the Democratic Republic of Vietnam. The consequences of the war are not long in coming. The trials of the Nazi war criminals opens at Nuremberg. In the space of two days, Hitler commits suicide and Mussolini is executed, and in France, the collaborationist Marshal Petain is condemned to death but instead interned in the fortress of Portalet. The United Nations charter is ratified.

On the cultural level, the French poet Paul Valéry and Hungarian musician Bela Bartok die. The first postwar Nobel Prize for medicine is awarded to Alexander Fleming, for the discovery of antibiotics.

Opposite: Mouton Rothschild 1945.

CHATEAU

a produit
de A à Y
M 1 à M 173
de 1 à 74622
marquées R.C.
56,802
ppe de Rothschild

1945

Cette récolte
dans numérotées
gneurs numér de
à 92 bout nomé
serve du Château
bouteille porte le N

ANNÉE DE LA VICTOIRE

MISE EN BOUTEILLES AU CHATEAU

1945

Château Mouton Rothschild 1945
Bordeaux – Pauillac

Never—aside from 1893, which could be considered "the" vintage year of the nineteenth century—had flowering been so early. Under such conditions, it is no surprise to learn that harvesting began at the end of the first week in September. Nor should it be a surprise to learn the yield per hectare was the lowest it had been for 50 or 60 years, on the order of ten hectoliters per hectare. (This record was beaten, however, in 1961, when the harvest was even smaller.) Not only were there few grapes to a bunch, but they were very small. The juice was greatly concentrated and the ratio between skin area and volume was extremely favorable to maximum extraction. Furthermore, the grapes were completely ripe, the richness of the musts sometimes attaining 15° of potential alcohol. Other factors contributed to making the first postwar harvest an exceptional and rare one, and these were due to the war itself. For one thing, the vineyard was not replanted, so the average age of the vines was high. Nor had they been fertilized for several years. In any case, since 1750 at least, winemakers have known that fertilizer and quality do not go together. So the raw material was ideal; now it was up to the vinification, without removal of the stalks and without the modern cooling methods. As might be expected, the best vinification is performed by the cellar masters of the *grands crus*, the great estates who for more than two centuries have devoted the greatest care to creating fine wines. All of the Bordeaux *premiers crus* are exceptional. Which can be considered the greatest of the great? Latour is often mentioned, Mouton even more so.

Following pages:
Baron Philippe de
Rothschild, owner
of Mouton Rothschild
and race car
enthusiast.

Organoleptic Description

The robe of this legendary wine has remained dark and opaque, though there is an imperceptible browning at the edge of the disk. The bouquet is typical of "flamboyant Mouton"—baroque, spicy, luxuriant, almost uncontrolled. After this, the body appears to be disciplined, but it is there, unfailingly. There is a balance between the alcohol (significant), acidity (important) and tannin (very concentrated), which appears to be "standard," though in fact it is much more than that—an archetypal Mouton, an archetypal 1945.

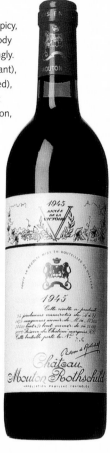

Secrets of Quality

Early flowering, great concentration and richness of the musts (very low yields), total maturity, excellent grape quality, highly skilled vinification.

Availability

The star attraction of numerous wine auctions.

Current Price

Around $10,000.

Apogee:
Around 1985?

Comparable or almost comparable vintages: 1961, 1949, then 1947.

Development:
To be drunk preferably before 2020.

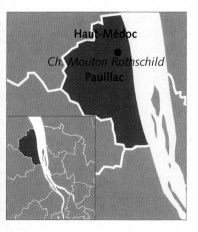

Weather Conditions

The fact that this was the first postwar harvest ought to have been enough to immortalize the vintage, but the freak weather conditions made it even more memorable. In the first few days of May, there was a sudden heavy frost, which blackened four-fifths of the vineyard. The Merlot vines, which flower earlier than the Cabernets, suffered most. Subsequent hot, dry weather soon restored the situation, but the harvest was extremely small.

Clos des Lambrays 1945 Burgundy

There is evidence that the historic, miraculous, enclosed vineyard of Clos des Lambrays goes back to the fourteenth century. The vineyard took its name from a Burgundian family that was very prominent in the Middle Ages. All trace of it disappeared after the French Revolution, when estates were broken up as a result of inheritances. Then along came an extraordinary man, Louis Joly, who embarked on an amazing reconstruction, buying up seventy-five plots of land, one by one, and succeeding in reconstituting the Clos de Lambrays as a *monopole* (where all the wine entitled to the name is made from the grapes on the estate). Or, rather, almost a *monopole*, because one-tenth of an acre eluded him, and that is the reason why about 200 bottles of Clos des Lambrays are labeled with the name of Jean Taupenot, winemaker of Morey-Saint-Denis. Since 1988, the other 35,000 bottles are the work of Albert-Sebastien Rodier and his descendants.

In 1938, Rodier sold the Clos des Lambrays to Renée Cosson, a woman of great character who was passionate about sculpture and guarded her wine jealously. While her husband continued working as a banker in Paris, she lived in the seventeenth-century mansion overlooking a park planted with magnificent rare trees. She considered her wine to be a work of art; commercial considerations were of no interest to her. She wanted minute yields, so she let the vineyard age, because old vines "make good but little." She allowed her wine to ferment longer than anyone else's and left it to age in the wood

Opposite: Wine cellar at the Clos des Lambrays.

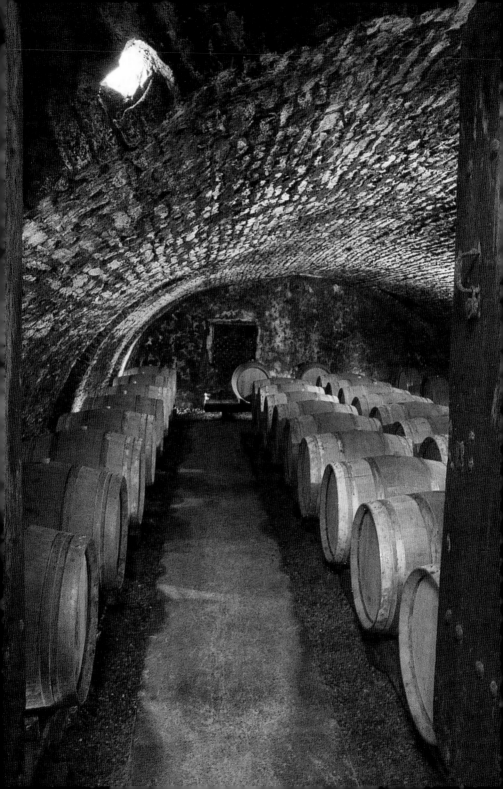

indefinitely. Such practices are dangerous and are not always successful, but if there is an element of luck, the resulting wine may be of exceptional quality. However, this attitude creates havoc in the modern world, where performance and profitability are the watchwords.

Renée Cosson had trouble with the authorities, who refused to classify all the plots of land that comprise the Clos des Lambrays as a *grand cru*. She would not abide this decision, however, and continued to put out bottles labeled with the two sacred words. The authorities, in the absence of an agreement, continued to classify them in the lower category of *premier cru*.

Madame Cosson died in the late 1970s, and although she had gone too far in some respects, she had made some interesting choices, as several of the vintages prove. The vineyard had become too old and contained several *manquants* (missing plants, dead vines); the fermentation was antique; wines past their prime were still stagnating

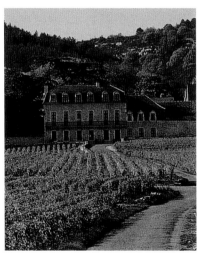

in the wood. The reserve of old vintages was impressive, however. Her son was unable to retain the property and the Saier brothers acquired it in 1979. The authorities classified 86,618 hectares (out of 86,975) as *grand cru*, and replanting began. In late 1996, a new proprietor took over, and Gunther Freud, a German, acquired a totally new Clos des Lambrays.

Mansion and vineyard at the Clos des Lambrays.

Organoleptic Description

A unique wine, the quintessence of this great soil. The robe is
legendary, so lasting that it has no age, and the spicy bouquet,
with its touch of bergamot and vanilla, is unique to Clos des
Lambrays. The mouth is even more extraordinary: in its concen-
tration; its syrupy, melting quality; its roundness; and the mildness
of the alcohol. Its supple smoothness is like that of no other wine.
It is easy to believe that neither at the Clos des Lambrays nor
anywhere else will such a wine ever be made again.

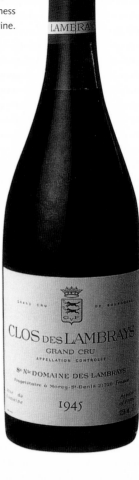

Secrets of Quality

Derisory yields, old vines.

Availability

Sometimes sold by
specialist wine merchants.

Current price

Around $3,000 a bottle.

Apogee:
1975.

**Comparable or
almost comparable
vintages:** None, but
1937, 1949 come
close.

Development:
Still excellent
to drink.

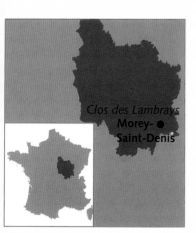

Weather Conditions

The year 1945 was the greatest for French wines. Early bad
weather sharply reduced yields, but the sun took care of
the rest later. The soil is low in potassium, a problem that
Burgundy would later suffer. The grapes were small,
concentrated, and perfect, especially at Clos des Lambrays,
with its very old vines. It is unlikely this set of circumstances
will ever occur again.

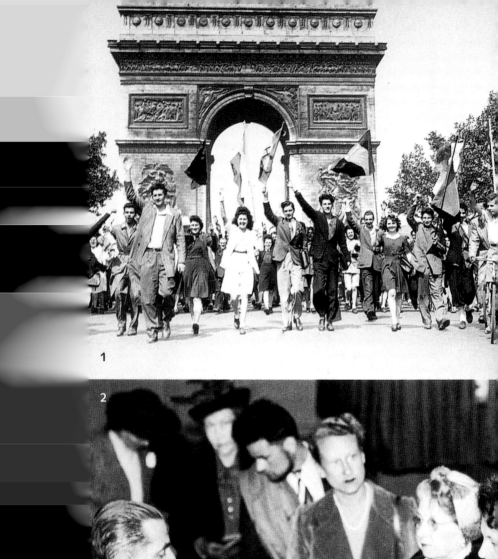

1

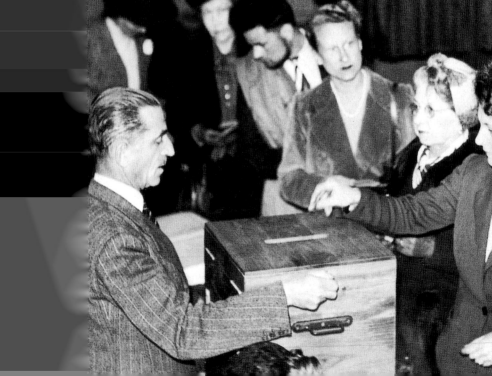

2

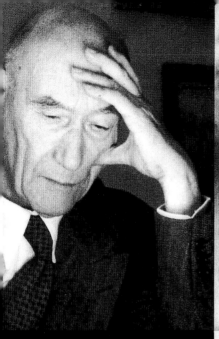

4

5

1. The Liberation
Liberated Paris celebrates joyfully.

2. Votes for women
Frenchwomen are finally granted the right to vote, which they exercise for the first time in 1946.

3. André Gide
The publication of his *Journal*, which he began in 1943, was completed in 1953.

4. Atom bombs dropped on Hiroshima and Nagasaki
After the bombing of Hiroshima on August 6, a second atomic bomb was exploded over Nagasaki on August 9. Japan surrendered.

5. Alexander Fleming
The British doctor discovered penicillin in 1928 and won the Nobel Prize for medicine for the discovery of another antibiotic in 1945. He was appointed rector of Edinburgh University in 1952.

1947

The aftermath of World War II hangs over Europe. France reorganizes slowly and painfully. Rationing of foods and commodities continues. General de Gaulle resigns and the Fourth Republic is founded. The first president, Vincent Auriol, is a socialist, and his colleague Paul Ramandier becomes prime minister. The year 1947 is the year of nationalization and major strikes in industry in France and Italy. It also sees the beginnings of the workings of the Marshall Plan.

In New York, the United Nations is preoccupied with the Palestine question, a prelude to the creation of the State of Israel. The British intercept the *Exodus*, a ship containing 4,000 Jewish refugees who intend to emigrate illegally to Palestine, and send them back to Hamburg, Germany. Colonial empires founder, and Nehru and Gandhi are instrumental in winning independence for India. Pakistan is created. There is rebellion in French Indochina. Communist dictatorships spread throughout Eastern Europe. King Michael of Romania abdicates. The Iron Curtain is not yet closed, but the Soviet Union is busy forging links in the chain mail. In Great Britain, Princess Elizabeth, the heir to the throne, marries Lieutenant Philip Mountbatten, who is made Duke of Edinburgh.

And while the world is entering a new phase, nature is bestowing her exceptional bounty…

Opposite: Château Cheval Blanc 1947.

Château CHEVAL BLANC

· 1947 ·

St Émilion

_{LONDRES 1892}
_{MÉDAILLE DE BRONZE}

_{PARIS 1878}
_{MÉDAILLE D'OR}

H^{iers} FOURCAUD-LAUSSAC

PROPRIÉTAIRES

Mis en bouteille au Château ⌐ FRANCE ⌐

APPELLATION SAINT-ÉMILION CONTROLÉE

6L

Château Cheval Blanc 1947
Bordeaux – Saint-Émilion

The Cheval Blanc estate consists of a single plot of 37 hectares east of the town of Saint-Émilion. Its gravel soil is planted with one-third Merlot vines and two-thirds Cabernet Franc vines (about 6,000 plants per hectare), a mixture unique to this vineyard. Château Cheval Blanc is the youngest of the *premiers crus*, since it has only existed since 1854. It remained in the family of the owner until fall 1998.

The climate that prevailed during the 1947 vintage can be summed up in one word: glorious. From April 1 through the end of October, that is to say during the vegetative cycle, it was extremely hot (reaching 95–100°F) and dry, and restrictions were imposed on the use of water in the Bordeaux district.

Opposite: Gaston Vaissière, cellar master at the time of the 1947 vintage.

When heat and dryness are excessive and persistent, the sap cannot play its part, the leaves wither and drop off the vine. Without leaves, without chlorophyll, the grapes themselves do not receive sugar. This phenomenon is known as growth blockage and is much feared by vine growers in dry regions. It is a calamity that rarely befalls the Bordeaux district, however, since the climate is almost always temperate due to the proximity of the Atlantic. If there is the sort of heat wave which occurs three or four times a century, there is almost certain to be a storm on August 15. But in 1947, the storm arrived a week late, on August 21, and while there was scattered rain in September, it did not fall until the 19th and 20th, when most of the grapes had been harvested. Under these conditions, it is not surprising that flowering was consistent and swift.

The heat was stifling from June onward and the good weather lasted right into the fall. Harvesting began on September 15 and ended on October 4. The Merlots were as fine as the Cabernets Francs. The grapes were healthy, sweet, and rich; all the musts exceeded an alcohol content of 14°. However, the scorching weather meant that the grape berries that reached the fermentation vats were very warm. This meant that there was a lot to worry about, especially overactive fermentation or a sudden cessation and appearance of volatile acidity. Many estates suffered from these problems, but for some mysterious reason, Cheval Blanc was fine. The explanation may be that the natural yeasts had been partially burned off by the exceptional heat and absence of humidity (not even dew), and this may have slowed the fermentation. Also, the cement vats, being good insulators, had lessened the effect of the heat, and their moderately small size increased the effect. Malolactic fermentation was complete and perfect, the aromas were extraordinary, so much so that Gaston

Above: Château Cheval Blanc.

Following pages: Grape harvesting in the old days on the Cheval Blanc estate.

Vaissière, the cellar master, claimed that the winestore was pervaded with the smell of bananas. Such a thing had never happened! The wine had more surprises. Traditionally, *premier cru* wines are aged in new casks, but in 1948, postwar austerity prevailed and there were not enough new casks. The wine had to be aged in casks that were five to ten years old. Even this did no harm. Cheval Blanc 1947 is invulnerable and defines the practices of modern oenology. Cheval Blanc 1947, though now mature and into its second half-century, is still a young wine. It probably reached its apogee in the late 1980s, but in the early decades of the third millennium, the best claret of 1947 is still the equal of itself, and it will remain excellent.

Organoleptic Description

The invulnerable 1947 Cheval Blanc defies the laws of the modern oenology. It resembles no other wine, though it comes closest to a vintage port. Generosity, suppleness, power, licorice, cedar, plum, velvety tannins, an unequaled smoothness, and an endless finale.

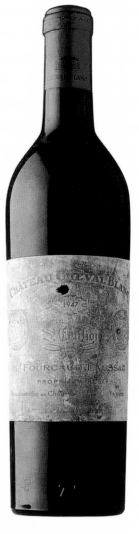

Secrets of Quality

Exceptional heat and dryness, producing a brief flowering; rain on August 21; successful vinification despite the obstacles.

Availability

Château Cheval Blanc 1947 is one of the attractions of wine auctions. It is not impossible to find, but very sought after.

Current Price

Around $5,000 a bottle.

Apogee:
1985 through 1990.

Comparable or almost comparable vintages:
1921, 1929.

Development:
Best drunk before 2020.

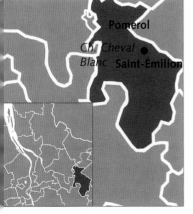

Weather Conditions

In the towns and cities of France, the streets were deserted and café terraces abandoned on account of the relentless heat. Only July and August 1976 come close to the extraordinary summer of 1947. But the comparison ends there, because in 1976, the weather broke in late summer and the Bordeaux grapes were harvested in the rain (in spite of the drought tax), whereas in 1947, the heat wave continued right into the fall.

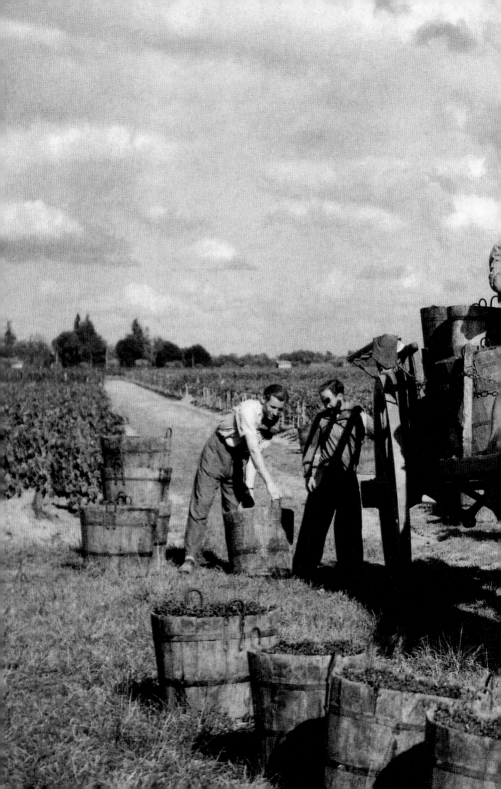

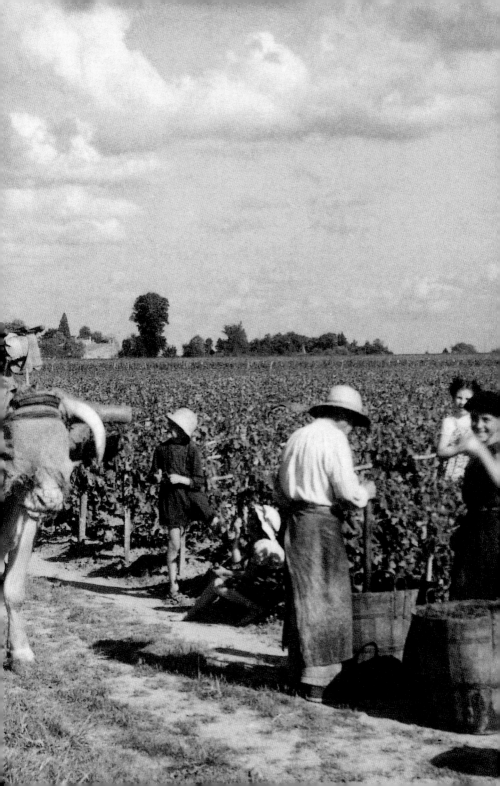

Château de Fesles 1947 Loire – Bonnezeaux

The name of this appellation is a reference to the iron-rich springs on the right bank of the Layon River. Theoretically, the vineyard could cover some 130 hectares, but that is not the case today. It extends over the commune of Thouarcé on slopes with a south-southwest exposure. Vines have been grown on the slopes of Bonnezeaux for nine centuries. Were they always the Chenin Blanc variety? Almost certainly. Also called Peneau de la Loire, this grape has been known in its region of origin—Touraine and Anjou—since the ninth century. Historians believe it to be a mutation of the Chenin Noir, a grape variety without much interest for wine makers. Chenin Blanc is a late-developing variety which takes noble rot very well. It has a very distinctive aroma and high degree of acidity, a characteristic that comes in handy if it is vinified as a sparkling wine, but also indispensable if it is to be made into a sweet dessert wine, such as a Quart de Chaume or a Bonnezeaux. The Château de Fesles is the largest producer of the Bonnezeaux A.O.C.; its Chenin Blanc vines are planted on schistic soils of a special type called phtanites.

The harvest is performed by successive pickings for the ripest grapes (*tries*), followed by separating the solid matter out (*débourbage*) in a cold room; a twelve-hour maceration; fermentation in 400-liter vats, and aging in the wood for a year. In the Loire, 1947 was a legendary year. There had been no comparable vintage since 1921. And despite some excellent recent vintages, 1947 remains an anomaly.

Organoleptic Description

The 1947 Château de Fesles is an unchanged and unchanging wine, even though the robe contains mahogany tints. The bouquet is as powerful as it is rich, smelling of citrus and candied apricots, honey, and wax. In the mouth, it is admirably balanced, the Chenin's acidity having resisted the torrid heat of the summer and fall of 1947. The syrupy consistency is not flat, despite the high sugar content, since it is counterbalanced by the still-present vigor and by a slightly bitter taste, perhaps due to the way in which the wine was aged. A millionaire wine.

Secrets of Quality

Exceptional Chenin Blanc vintage and the rarest possible weather conditions.

Availability

Rare.

Current Price

Few transactions.

Apogee: 1970.

Comparable or almost comparable vintages: None. Perhaps 1982 or 1989. 1990 may prove its equal.

Development: Best drunk by 2020, possibly later.

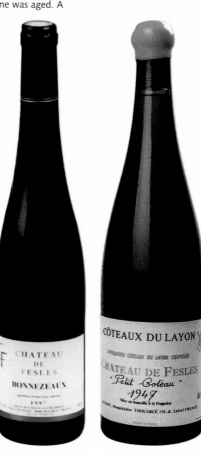

Weather Conditions

In this legendary year, many winemakers were unable to produce dry wines because the levels of sugar were so high that alcoholic fermentation ceased spontaneously at a moment when the wine still contained between 20 and 40 grams of sugar! One can imagine the richness of the grapes left on the vine until the noble rot did its work. The degree of alcohol crept up to 20°, 22°, 25°, and even more.

1. Establishment of the State of Israel
The United Nations studied the Palestine question as a prelude to the creation of the new state of Israel, which is established in 1948 by David Ben-Gurion.

2. Indian independence
Negotiations between the British government and Indian leaders, attended by Nehru and Gandhi, resulted in the independence of India and the creation of Pakistan.

3. Albert Camus
The French author won the coveted Grand Prix des Critiques for his last novel, The Plague.

4. Automotive industry
Death of Henry Ford, founder of one of the largest automotive companies in the world.

5. Royal marriage
Princess Elizabeth marries Lieutenant Philip Mountbatten, who becomes the Duke of Edinburgh.

1949

The world organizes and starts to take up stable positions. In France,
bread is de-rationed at the beginning of the year; other foods are no
longer subject to rationing in November. Mao Zedong proclaims the
People's Republic of China, expelling Chiang Kai-Shek, who installs his
government on the island of Formosa (Taiwan). The German Federal
Republic is born in May. Konrad Adenauer becomes chancellor, and
Bonn is the capital. Shortly thereafter, in September, East Germany
renames itself the German Democratic Republic. The city of Berlin,
occupied since the end of the war by the Allied Powers, is split in two.
West Berlin becomes a province of the German Federal Republic
(occupied by the Americans, the British, and the French), while East
Berlin is a part of the GDR. Austria remains under Soviet occupation.
The Comecon, an economic organization of all the Soviet Bloc
countries, none of whom benefit from the Marshall Plan, is formed.
The Cold War prompts the formation of the North Atlantic Treaty
Organization (NATO), and the USSR explodes its first atom bomb in
July. The world only learns about it in September from President
Truman. The Council of Europe is founded, with headquarters in
Strasbourg. The United Nations discuss colonial problems and demand
that the Dutch leave Indonesia. Sukarno becomes the first president of
the independent country. The U.N. also grants independence to the
former Italian colonies. France has its own colonial problems in

Opposite: Musigny
de Vogüé 1949.

Indochina, where the situation worsens. France grants Vietnam internal autonomy when President Auriol signs an agreement with the former Emperor of Annam, Bao Dai, a controversial figure who returns to Vietnam after incorporating Cochin-China into the Vietnamese state; the Viet Minh rebels subsequently declare war on the French. Egypt, which invaded Israel soon after it was established, still refuses to recognize the young state but signs an armistice with it. The proposal to internationalize Jerusalem continues to be a bone of contention for both Jews and Arabs.

War funds technological progress. An airplane breaks the sound barrier and flies at an altitude of more than 75,460 feet; the first passenger jet, the Comet, is built and goes into service in the United Kingdom. Three years later, the first electronic calculator will be revealed to the world. There are rumors that IBM intends to manufacture and sell these machines.

The great advance in medicine is the identification of the influenza virus, making vaccination against it a possibility. In France, there is an innovation in broadcasting whose impact cannot be underestimated. A journalist named Pierre Sabbagh presents a new type of programming, the television newsreel, three times a week. William Faulkner receives the Nobel Prize for literature, and the literary world is shaken by the publication of a book entitled *1984* by George Orwell, a politico-social work of science fiction written in 1948 (the author merely reversed the last two figures of the date) about daily life under a totalitarian regime. Orwell, a socialist, denounces Stalinism; he will die in January 1950. The composer Richard Strauss dies at the age of 85; the French violinist Ginette Neveu is killed in a plane crash on a flight from Paris to New York that also claims the life of the former French boxing champion Marcel Cerdan. In Belgium, two leading figures pass away: Maurice Maeterlink, winner of the Nobel Prize for literature, whose works include the libretto for *Pelleas et Melisande*, Debussy's only opera; and James Ensor, a great painter whose work is in some ways reminiscent of that of Hieronymus Bosch.

Opposite:
Harvesting baskets.

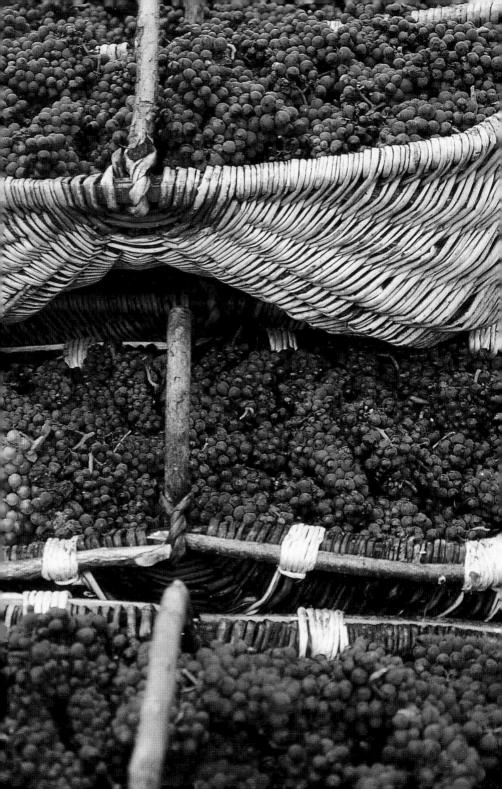

1949

Musigny de Vogüé 1949 Burgundy

There are periods in which exemplary vintages follow one after the other. In the case of Burgundy, such years are: 1928/1929, 1945/1947/1949, and 1988/1989/1990.

The weather in 1949 was not uninterruptedly fine—this may even be the reason for the classicism of the wines, for extremes of heat, cold, dryness, or moisture do not result in healthy, balanced grapes.

In Burgundy as in Bordeaux, the spring weather was stormy, especially during the flowering. This could be considered to be a good thing, as it reduced the yield per hectare. The harvest was thus smaller than average in both regions.

The de Vogüé estate covers 12 or so hectares in the commune of Chambolle-Musigny. It was founded in 1450 by Jean Moisson, who built a few buildings, some of which still survive. Since 1766, the Vogüé family has lavished great care on the estate, which includes 2.7 hectares of ponds and 7.2 hectares of Musigny, two-thirds of the *grand cru*, and all of the Petits Musigny.

Musigny de Vogüé is only made from old vines. In 1949, and perhaps even today, the vines were, on average, more than 40 years old. The vintage was vinified under the supervision of Count Georges de Vogüé (who died in 1987) and the manager, Roumier, in the most traditional manner, that is to say in the same way that wine had been made for the past century or two: the stalks not removed, fermentation in open wooden vats. The Baroness Bertrand de La Doucette has inherited the domain, but the results remain just as perfect.

Following pages: Count Georges de Vogüé, who owned the estate at the time of the 1949 vintage.

Organoleptic Description

The 1949 Musigny de Vogüé is the epitome of everything one expects from the climate of the Musigny vintages. The robe is not the brightest but the most beautiful, the most elegant, and the most joyful. As for the nose, the finest grape stocks also become the most harmonious. The famous red-berry flavors are there, closer to raspberry than cherry, closer to blackcurrant than to mulberry, with a hint of licorice and spice. All these flavors can be found in the mouth which is silky, melting, crowned by miraculously well-integrated, subtle tannins. It is not a question of length in the mouth, because the memory of such a wine does not disappear.

Secrets of Quality

A very specific growing area, old vines, limited yield.

Availability

Sometimes sold at auction, especially magnums.

Current Price

Around $6,000 a bottle.

Apogee:
1980.

Comparable or almost comparable vintages: 1959, 1945.

Development:
Still perfect in a magnum, but should be drunk soon.

Weather Conditions

Much has been written on the respective merits of the years 1945, 1947, and 1949. In 1945, there was an extreme concentration of juice, in 1947, extreme heat, but in 1949, there was extreme classicism. In all three years, the grapes were healthy and ripe. The summers were record-breaking—long, hot, dry. This dryness also caused 5,000 hectares of forests to burn in the Landes, causing the death of nearly 80 people. In early September, a little rain saved the grape harvest. At the end of the month, perfect grapes were poured into the vats, a truly wonderful crop.

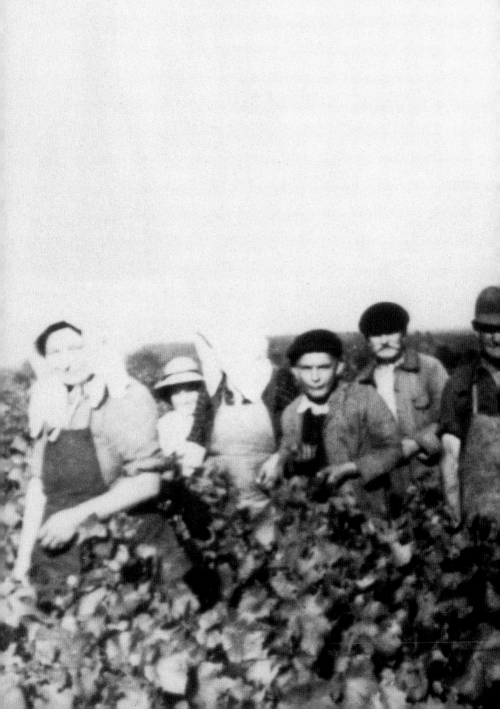

1

2

4

5

1. People's Republic of China
Mao Zedong proclaims the People's Republic of China after deposing Chiang Kai-shek and reinforces his links with the Soviet Union.

2. Television
Birth of the television newsreel in France, presented by Pierre Sabbagh and broadcast three times a week.

3. Marcel Cerdan
The former world boxing champion dies in a plane crash between Paris and New York.

4. Rita Hayworth
The American film star marries Prince Ali Khan.

5. William Faulkner
The American writer receives the Nobel Prize in literature.

1959

Charles de Gaulle takes office, having been elected president of the French Republic, and offers self-determination to Algeria. In Cuba, Fidel Castro ousts the dictator, Fulgencio Batista, at the very end of 1958. Castro becomes prime minister and nationalizes land. The break with the Unites States is complete. The Belgian Congo is granted independence. The Dalai Lama, the Buddhist spiritual leader, flees his native Tibet, which is under the brutal domination of the Chinese; he takes up residence in India. The space race between the Soviet Union and the United States continues to turn in favor of the Soviets, who have a rocket-launcher that is infinitely more powerful than the Americans'. The Soviet space probe *Lunik I* is the first object ever to escape from Earth's gravity. *Lunik II* reaches the moon, and *Lunik III* orbits the moon and transmits photos from the side that cannot be seen from Earth. The Americans send two monkeys into space. The Russians do the same with two dogs and a rabbit.

In the south of France, the Malpasset dam bursts and causes the death of more than 400 people at Fréjus. The world celebrates the weddings of the Shah of Iran to Farah Diba and of Jacques Charrier to Brigitte Bardot. The economist and sociologist André Siegfried dies, and the world of music mourns the passing of composer Hector Villa-Lobos and the jazz musicians Sidney Bechet, Billie Holiday, and Lester Young. The French heartthrob Gérard Philipe also dies.

Opposite: The circular winestore at Château Lafite Rothschild.

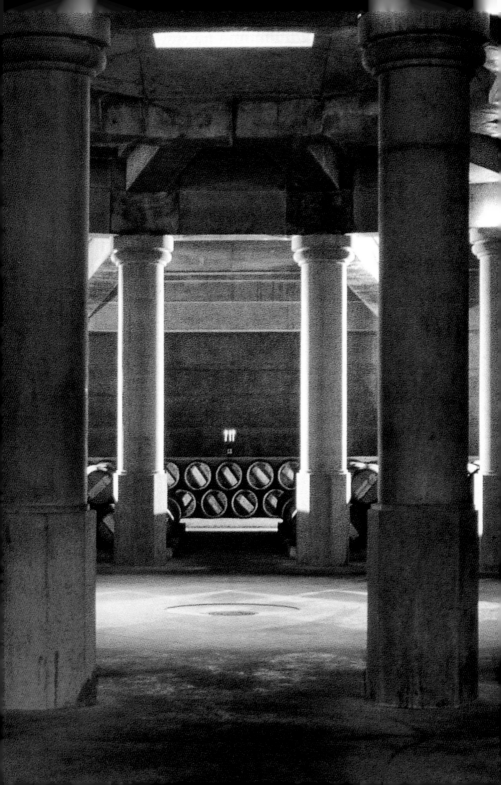

Château Lafite Rothschild 1959
Bordeaux – Pauillac

This is a vintage that has always been referred to with the greatest respect, though in certain places, there have been whispers of "It's too much, too much," muttered with downcast eyes, as if the speaker wanted to be excused for his ungratefulness. Wines of this year achieved such an unusually high sugar content that special dispensations were granted to Champagnes, whose degree of alcohol exceeded what was permitted under the rules of the appellation! The acidity level was low, closer to that of 1947 than to 1951, yet strangely, the wines are not heavy or flat, which might have happened under the circumstances.

With its hundred hectares, Lafite is the largest of the *premier cru* estates. It has a long history intermingled with that of the *parlement*, or council of nobles, of Bordeaux. Between the seventeenth century and the present, two famous names are connected with the estate, Ségur and Rothschild. The counts of Ségur made the wine's reputation and cosseted the vines for more than a century. James de Rothschild acquired the vineyard when it was auctioned off in 1868. He paid about 4.4 million francs for it, a record price at the time.

The vineyard has remained in the Rothschild family ever since. In 1959, the deep gravel soil of Lafite played its important part in ensuring that the vines were able to withstand the extremely hot summer without wilting. The result is a very great wine, no doubt the first among the year's best, though Lafite has often enjoyed the title of *premier des premiers*.

Organoleptic Description

The robe shows a certain development but the hue remains dark; the revelation comes when one sniffs a glass. The most subtle aromas of this Lafite approach those of cedar, emphasized here by a fruitiness of candied mulberries and cookies. In the mouth, the cedar turns to licorice and vanilla, smooth and dark. The richness of the 1959 harvest gave this wine an elegant but strong structure, melting and harmonious, an indication of its longevity.

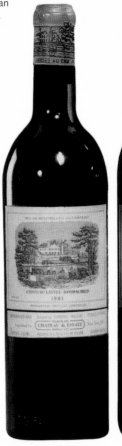

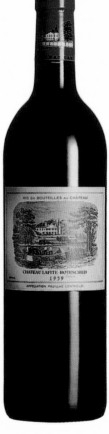

Secrets of Quality
Drought-resistant soil.

Availability
Sometimes sold at auction.

Current price
Around $4,000.

Apogee: 1985.

Comparable or almost comparable vintages: 1945, 1961.

Development: To be drunk before 2010 (the largest bottles will keep better, but must be laid down with care.

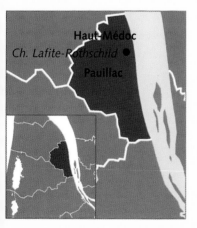

Weather Conditions

There was a near-disaster because July and August—especially the former—were months of drought, which caused a blockage in vegetation in the Bordeaux district, though rain fell in the end. In Burgundy, harvesting began in dry weather in the second half of September; it was one week later in Bordeaux.

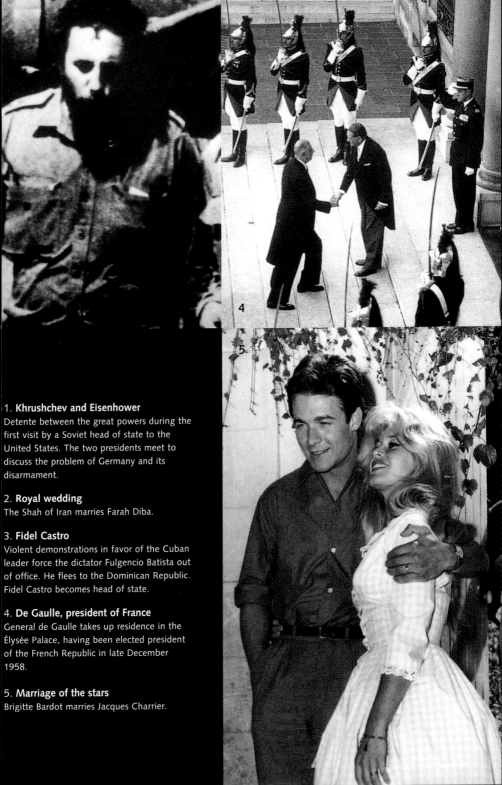

1. Khrushchev and Eisenhower
Detente between the great powers during the first visit by a Soviet head of state to the United States. The two presidents meet to discuss the problem of Germany and its disarmament.

2. Royal wedding
The Shah of Iran marries Farah Diba.

3. Fidel Castro
Violent demonstrations in favor of the Cuban leader force the dictator Fulgencio Batista out of office. He flees to the Dominican Republic. Fidel Castro becomes head of state.

4. De Gaulle, president of France
General de Gaulle takes up residence in the Élysée Palace, having been elected president of the French Republic in late December 1958.

5. Marriage of the stars
Brigitte Bardot marries Jacques Charrier.

1961

Man goes into outer space for the first time. On April 12, the Soviet cosmonaut Yuri Gagarin orbits the Earth on board the *Vostok I*. The American response is swift; on May 5, Alan Shepard takes up the challenge with the *Mercury III*. The Berlin Wall is erected by the East Germans, thereby preventing escape to the West. Hassan II becomes king of Morocco. Trouble erupts again in the former Belgian Congo when Patrice Lumumba, former Congolese prime minister, pressures the copper-rich province of Katanga to break away. Lumumba is arrested and assassinated. The U.N. blue berets are sent in to restore order. In Algiers four French generals hatch a plot to maintain French rule. Meanwhile, a conference is held in Evian, France, between the French government and the Algerian nationalists. General Raoul Salan, ringleader of the French rebel soldiers, takes over the loyalist OAS, created to keep Algeria French. There is an aborted attempt to assassinate de Gaulle.

In Israel, Adolf Eichmann is tried for masterminding the deportation of millions of Jews. He is condemned to death.

The British protectorate ends in Kuwait and Iraq makes the first of many attempts to claim the oil-rich state as a province. The Bay of Pigs incident, American attempt to assist anti-Castro Cubans to invade Cuba, ends in a standoff, thanks to Soviet threats. The writers Blaise Cendrars, Celine, and Ernest Hemingway die, as does the psychoanalyst Carl Jung.

Opposite: Cellar of the Paul Jaboulet Aîné estate.

Hermitage la Chapelle 1961 Rhône

In 1961, the weather followed a uniform pattern throughout France: There was bright sunshine throughout the whole summer and for a good part of the fall. In Bordeaux, a sharp frost that broke into a spell of fine spring weather, drastically reducing the yield (a qualitative factor). In the Rhone Valley, the spring was very wet, causing severe wilt of the buds, again ensuring that the volume was small.

The vineyards of Paul Jaboulet Aîné saw their average production of 40 hectoliters per hectare fall to 15 hectoliters per hectare. Syrah grapes (the only variety used to produce red Hermitage) were harvested on the only hill on the estate. "La Chapelle" is a brand name, as opposed to the name of a particular vineyard or plot of land. The grapes come from 5 hectares in the Bessards and 16 hectares in the Méals; the normal yield is 100,000 bottles (though not in 1961). Nowadays, the harvest is sorted and the stalks discarded, but that was not the case in 1961. The vinification was not particularly unusual—fermentation at less than 86°F for about ten days, and *rémontage* for three hours a day—but the aging process required the wine to be aged in casks of oak from the Jura region near the mountains, which produced more mellow tannins than those of the Allier oak. The wine is bottled without being filtered but is lightly clarified with bentonite.

Following pages:
View of the estate.

Organoleptic Description

The 1961 Hermitage la Chapelle is inky black and almost unaffected by age. The fruitiness is explosive, concentrated, and complex. There is a density that is also found in the mouth with the mellow scent of sugarplums. The tertiary aromas are of high quality, smelling of balsam with hints of tar. This mellow, fruity concentration is reminiscent of the port wine aromas of the 1947 Château Cheval Blanc.

Secrets of Quality
The concentration.

Apogee:
1990.

Availability
Scarce.

Current Price
Around $6,000 per bottle.

Comparable or almost comparable vintages: 1929, 1978, 1983.

Development:
To be drunk preferably before it is 50 years old.

Weather Conditions

There was a sharp frost in the spring that interrupted a spell of good weather, drastically reducing production in the Bordeaux region. In the Rhone Valley, the bad weather came in the form of rain, causing the young shoots to dampen off, guaranteeing a meager harvest.

Château Latour 1961 Bordeaux – Pauillac

The vintage was exemplary and is often quoted as "the" vintage of the twentieth century. Although the phrase tends to be overused, this Château Latour can at least claim to be the vintage of the second half of the century.

Everything went just right that year, as nature had all the luck on her side, with the dual results of seriously reducing the yield while obtaining perfect maturity and an ideal harvest.

A warm spell early in the year was followed by a late frost that damaged the vines. This was not the first such weather pattern: frost always reduces the yield, but hot summers ensure that the grape ripens perfectly.

Opposite: The legendary 1961 vintage.

The vintages of 1945 and 1961 are comparable, in that they were two record years of very small yields, amounting to ten and eight hectoliters per hectare, respectively.

At Latour, the harvest began on September 16 but lasted only ten days, due to the poor quality of the grape. The grapes were small, almost dried out.

Under these conditions, the volume produced was barely a third more than a normal harvest, just 63 barrels in 1961, compared with 166 in 1960.

In that year, some Bordeaux winemakers wanted to delay the harvest until October—not to overripen the grapes, which was not desirable, but in hope of providential rains, which might perhaps increase the size

of the few grapes that remained on the vine. But this was in vain, because even then the rains failed to come. Finally, morale was saved because the grapes might be of a better quality, even if the quantity was greatly diminished.

Everyone knew that the vintage would be exceptional if the excessively rich musts and the warmth of the grapes harvested did not cause fermentation to be prematurely arrested, always a threat under these conditions. A high degree of alcohol was to be expected, as well as very ripe tannins and an extraction rate. There might also have been too low a level of acidity, causing the wine to be flat and too long. None of this happened. The concentration and richness of the must could only lead to the production of one of the great wines suitable for keeping over a long period.

The vintage has not disappointed; the wines may have reached their apogee a few years ago, but they remain excellent.

Of all the year's vintages, Latour has had the slowest development. When all the other great wines of the century had long passed their apogees, Latour 1961 had barely reached the peak of its perfection.

Courtyard of the winestore.

Organoleptic Description

The robe is extremely dark and dense, while the weft and warp of the bouquet is so tight that it gives the impression of opacity. It is an extract of spices that is almost introverted. In the mouth, the wine imposes its stature and concentration, one could almost call it a "square roundness." It is full, spherical, but also straight and taut, and the finale is as harmonious as it is powerful, as complex as it is long.

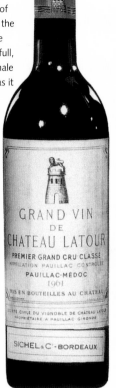

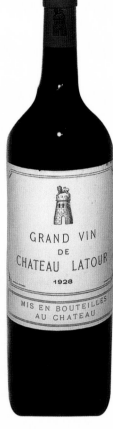

Secrets of Quality
Maturity and low yield.

Apogee:
2000.

Availability
The star of the French wine auctions.

Comparable or almost comparable vintages: 1928, 1945.

Current Price
Around $6,000 per bottle.

Development:
Should be drunk before 2025.

Weather Conditions

It was unusually warm at the beginning of the year, so the vines sprouted early. Then three frosts, between March 17 and 29, blackened and killed off the shoots. Sunny weather in May hastened flowering, but at the very moment of pollination, there was another cold spell, which caused the flowers to wilt. The harvest was bound to be very small. End of act one. The second act opened more traditionally, with the magnificent hot weather and harvesting in the sun. Yet despite all that has been written about it, the summer and heat of 1961 were not record-breaking; at least seven or eight summer were hotter, though it was one of the hottest of the twentieth century. The temperature was not that high, but on a few afternoons its exceeded 104°F! This concentrated the grape juice. The near total absence of rain (except on September 20) and the burning south wind further dried the grapes.

1. The Berlin Wall
The construction of a concrete wall dividing the city of Berlin was an attempt to keep East Germans from fleeing to the West.

2. Coup d'etat in Algiers
Three of the four French generals (from left: Zeller, Jouhaud, and Salan) responsible for the putsch in Algiers that caused worldwide consternation. They were condemned by the French president, Charles de Gaulle.

3. Ernest Hemingway
Death of the American writer, who won the Nobel Prize for literature in 1954.

4. John and Jackie Kennedy
The first Roman Catholic president of the United States took office in January 1961.

5. The conquest of space
The Russian cosmonaut Yuri Gagarin became the first man in space aboard the *Vostok I*.

1962

The war in Algeria ends. With the Evian agreements, Ben Bella becomes the first head of government of the independent Algeria. The exodus of the *pieds-noirs*, the French colonists, begins.

There is another attempt on the life of General de Gaulle and again he escapes. He holds a referendum on the direct election of a president of the French Republic by a 60% vote. War is narrowly avoided between the Soviets and the Americans when Khrushchev installs missile launchers in Cuba and President Kennedy threatens to sink the ships carrying the missiles. The Soviet ships turn back. But in space, the Soviets increase their lead. The Americans put John Glenn briefly into orbit (three trips around the earth), the Soviets orbit the earth almost fifty times in *Vostok II* and *IV*. The United States consoles itself with *Mariner*, the probe that passes 186 miles from Venus and transmits photographs of the planet. The Pope excommunicates Fidel Castro. The ocean liner *France* is launched and the tunnel under Mont Blanc is completed. A pop group from Liverpool makes a recording at Decca Records, which the company decides not to release because it doubts that it will be successful. That group was called The Beatles.

John Steinbeck wins the Nobel Prize for literature. Marilyn Monroe dies under suspicious circumstances, and the painter Yves Klein dies prematurely as well. The world of literature loses Bachelard, Nimier, Faulkner, and Hesse.

Opposite: Penfolds Grange Hermitage 1962.

enfolds

Max Schubert

e Hermitage

BIN 95

1961 BOTTLED 1962

Penfolds Grange 1962 Australia

A change of hemisphere means a change of world. This wine comes from Australia, a country where the grapes are harvested in March or April. Although the change of seasons is an oddity to which one soon acclimates, the "change of world" is very obvious in the viticulture, which is very different to anything that happens in the Old World. Australian custom is reminiscent of the Spanish *bodegas* (which produce their wines from many different varieties), but only somewhat, because the *bodegas* of Rioja, for example, procure their grapes only in Rioja, which gives the wine its appellation. In Australia, although growing areas, regions, and subregions have recently been established, the concept of estate-bottling and vineyards, as they are understood in Europe, does not exist. Grapes from distant regions can thus be combined and chosen on the basis of their properties or their compatibility. Furthermore, Australia is on the forefront of modern technology and has exported winemakers (oenologists) all over the world, and the country is unaffected by European prejudices against irrigation or the use of harvesting machines.

Penfolds is named for its creator, Christopher Rawson Penfold, who settled in Magill, near Adelaide, in the foothills of Mount Lofty, in 1844. This eccentric English doctor set himself up as a vine-grower and winemaker, and was the first to introduce the grape variety called Syrah in France and Shiraz in Australia into the Southern hemisphere. At the time his home was known as the Hermitage of Grange Cottage, which is why his wine is known as Grange Hermitage. It is now known

The winestores.

simply as "Grange" to distinguish it from the Hermitage A.O.C. in France, which is only made from one grape variety, the Syrah.

It is no accident that the red wines have a similar name. Max Schubert, who ran the Penfolds operation from 1950, set out to create a great wine following a study trip to Bordeaux. However, he used a completely original approach: rather than selecting a few outstanding plots of land, as was custom in Europe, he instead blended the best grapes, or the varieties that appeared to be the most compatible, to create his masterpiece.

The Shiraz grape, which is perfectly adapted to the clay and siliceous soil of the hills of Adelaide, the Morphett Vale, and the Barossa Valley, was the basis for the high-quality wine. Pragmatic and un-hindered by any formal training, Schubert discovered, adapted, and invented. The Australian vineyards began growing a large number of varieties, but Cabernet Sauvignon met with the most success. Schubert thus conceived the idea of blending Cabernet Sauvignon with Syrah in varying proportions, always with more of the Syrah. The Grange thus became a blended wine, like claret.

The vinification, which is perfect of course, adheres to the following principles: complete removal of stalks (*éraflage*), extraction by submerging the cap (*chapeau*) at unusually low temperatures (68°–77°F), and aging in American oak barrels for about two years, followed by storage in bottles for four. Like all pioneers and innovators, Schubert faced mounting criticism until his wine won a gold medal at a major event in Sydney in 1962, when it was pronounced the best wine in Australia. Not only did Penfolds Grange become the most expensive wine in Australia, but also one of the most expensive in the world, achieving prices somewhere between the *premier* and *deuxième crus classés* of Bordeaux. It is the only wine of its quality that does not come from a precisely defined location. Schubert managed to maintain quality by constantly changing the composition of his blends, eliminating certain grapes, such as those from Morphett Vale (a vineyard that fell into the hands of developers) and replacing them with some from Clare Valley 12,000 miles away (but grapes from vineyards at a distance of 300 miles have also been used).

Even though Penfolds Grange does not come from a specific plot of land, it is nevertheless the product of very carefully selected grapes, which certainly derive their quality from the land on which they were grown. We are once again back to of the concept of the indisputable merit of the land, but in a manner that Europeans would find it hard to accept, because it assumes the possibility of conceiving a wine made from, for example, a blend of Lafite, Cheval Blanc, and Hermitage. In fact, this is not as silly as it sounds—it is known that in the nineteenth century, the makers of Bordeaux "hermitaged" their wine.

Penfolds advertisement from the late 19th century.

Organoleptic Description

The robe is very dark and dense, turning brown at the edge of the disk. The tertiary aromas of Syrah are mixed with exotic, spicy, vanilla-scented bouquets, to which are added mild notes of licorice, some of which are surely contributed by the American oak hogsheads. There is a balance, full and fleshy, almost syrupy, with a roundness, power, and length in the mouth. This is a glory that has never been surpassed in production of about 80,000 bottles a year.

Secrets of Quality

Low yield (20 to 30 hectoliters).

Availability

Sold at auction in Australia and sometimes in the United Kingdom.

Current price

Around $1,300 in Australia.

Apogee:
Around 1976.

Comparable or almost comparable vintages: 1970, 1976.

Development:
To be drunk as soon as possible.

A Classic Wine?

Is Penfolds Grange a classic wine? No, according to leading French oenologist Émile Peynaud. During a French television broadcast, the famous English oenophile Jancis Robinson, author of best-selling books on wine, brought a bottle of Penfolds Grange Hermitage into the studio. Professor Peynaud smelled the bouquet and described it as "pharmaceutical," a term describing a category of aromas. Peynaud had never said such a thing about a Bordeaux—which is normal, of course, because Penfolds does not try to imitate claret. It's something to be said in its favor, when one considers how many imitators abound.

1

2

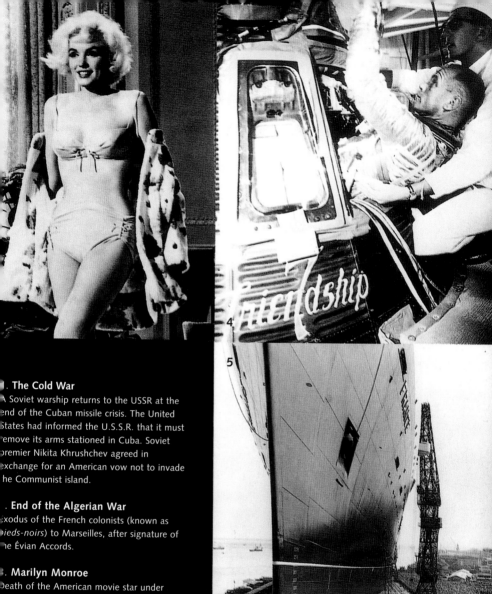

1. The Cold War
A Soviet warship returns to the USSR at the end of the Cuban missile crisis. The United States had informed the U.S.S.R. that it must remove its arms stationed in Cuba. Soviet premier Nikita Khrushchev agreed in exchange for an American vow not to invade the Communist island.

2. End of the Algerian War
Exodus of the French colonists (known as *pieds-noirs*) to Marseilles, after signature of the Évian Accords.

3. Marilyn Monroe
Death of the American movie star under circumstances that have never been fully explained.

4. NASA reaches space
The American John Glenn orbited the Earth three times in the *Mercury*, making him the second man in space, after the Russian cosmonaut Yuri Gagarin.

5. The *France*
Launch of the transatlantic liner *S.S. France*.

1964

1964 is the year in which The Beatles triumph, the year of the miniskirt, and the year when the Vatican comes out firmly against the contraceptive pill. It is also a year of transition and commitment to the future—a tunnel under the English Channel is planned, for example. American forces, present in Vietnam as "advisors," are attacked by the North Vietnamese. Egyptian president Gamal Abdel Nasser and the USSR's Nikita Khrushchev together inaugurate the Aswan High Dam. By the end of the year, Khrushchev would be replaced by Kosygin, while Brezhnev becomes head of the Soviet Communist Party. China explodes its first atom bomb. There is a surprising example of cooperation for the period when the Soviets and the Americans decide to collaborate on producing a satellite. The American rocket *Ranger 7* takes 4,316 photographs in space before crashing into the moon. The United Kingdom abolishes the death penalty. Soccer once again claims many lives when 320 fans are killed in a riot following a football match in Lima, Peru. Jean-Paul Sartre rejects the Nobel Prize for literature. Martin Luther King Jr. is awarded the Nobel Peace Prize in recognition of his nonviolent fight for black civil rights. Nevertheless, three civil rights workers are murdered in Mississippi. The killers escape justice. Jawarhalal Nehru, who had been prime minister of India since its independence, dies.

Opposite: Cellar of La Tenuta Greppo; old bottles of Brunello di Montalcino.

Brunello di Montalcino 1964 Italy – Tuscany

To comprehend just how extraordinary Ferrucio Biondi-Santi's methods were in the years 1870 through 1880, one needs to remember what the wine scene was like in Italy at the time.

Today, every wine-growing country is in search of the best soil and climatic conditions for cultivation of its vines, and the aim is to produce the best wine possible—so "best practices" are quite standardized.

This was not at all the case 130 years ago in Italy. Its status as the cradle of European viticulture notwithstanding (20 centuries ago it was producing such legendary wines as Falernian), for 1,500 years it had languished into the production of "plonk," and although cheap wine has its uses, it is no excuse for allowing the great wines to disappear.

In the late nineteenth century, Ferrucio Biondi-Santi, the owner of a vineyard in the little village of Montalcino, 50 miles south of Siena in Tuscany, got it into his head one day to focus on a particular variety of Sangiovese, the most popular vine stock in the region and the main ingredient in Chianti.

He eventually chose the smaller of the Sangiovese Grosso variety, dubbing it Brunello. He propagated the variety in his vineyard and began to produce very distinctive wine. All that he did was completely against the traditions of Italian winemaking. He vinified a wine that had excellent keeping qualities, which required very long aging and was not worth drinking until many years in the bottle, unlike most Italian wines, which were hardly ever aged before sale. In this context, Biondi-Santi's methods would seem to be commercial suicide. And yet, as can be seen

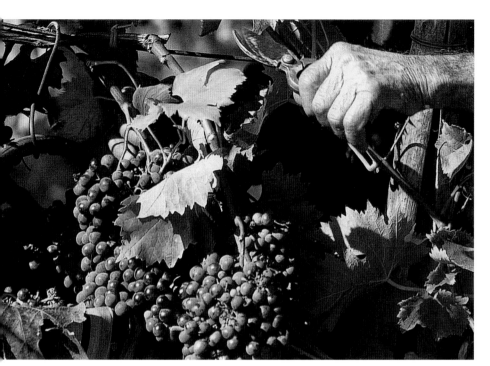

...rvest at
Tenuta.

more than a century later, he was on the right track. It was not until the 1970s that Italian viticulture once again invested in a quest for great wines. When this happened, Brunello de Montalcino naturally became one of the first to benefit from a D.O.C. and then a D.O.C.G.; that is to say, an appellation.

This distinctive wine has been produced since the late nineteenth century by the same family and is appreciated by connoisseurs throughout the world. Very sought-after and the most expensive wine in Italy, it took its place among the great vintages of the world. There is no doubt that the initiative of Ferrucio Biondi-Santi was responsible for the production of the first of the great Italian wines.

To introduce a wine that had been invented from scratch, the Biondi-Santi family stuck to rigorous rules of production. They grew only Sangiovese Grosso, which has a low yield per hectare, and aged in the wood for many years—four years for the Annata; five for the Riserva, the latter being made from old vines.

The rigor did not end there, because only the outstanding vintages had the right to be labeled Brunello di Montalcino Biondi-Santi, which

meant rejecting the resulting wines for three years out of ten!
The Biondi-Santi family is still at the helm today, although a lawyer had bought a share in the business. The archives of the estate, which are preserved in the winestore, are extraordinary. The registers are surprising in their modernity and provide a detailed description of all the vintages produced since 1880, with a detailed chemical analysis of each wine described. Brunello di Montalcino is certainly the only appellation of all the vintages, since the first, that has been described so precisely.

The estate.

Organoleptic Description

In 1964, Tancredi Biondi-Santi had the honor of vinifying the best-ever Brunello di Montalcino, a wine of an exceptional caliber, whose pomegranate-colored robe had barely developed, with a bouquet of complex tertiary aromas that includes violet and a hint of spice. The mouth remains strongly tannic (the presence of the tannins is emphasized by a slight acidity.) All this combines sumptuousness, virility, and elegance.

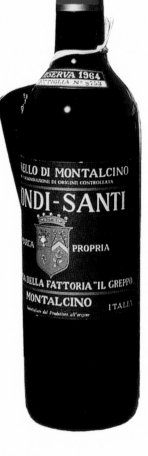

Secrets of Quality

Highly skilled vinification and perfect climatic conditions.

Availability

Rare (the estate has a well-stocked cellar; some of the bottles date back to 1890).

Current Price

Few transactions.

Apogee: 1990.

Comparable or almost comparable vintages: 1985, 1953, 1961.

Development: Preferably to be drunk before 2020.

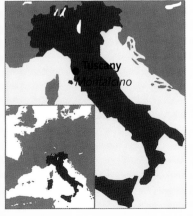

The Biondi-Santi Vineyard

Size: 15 hectares in the commune of Montalcino, south of Siena.
Grape variety: Sangiovese Grosso
Production: 500 hectoliters a year of Brunello de Montalcino
Alcohol level: 12.5° minimum.
Total acidity: 5.5 0/100.

1

2

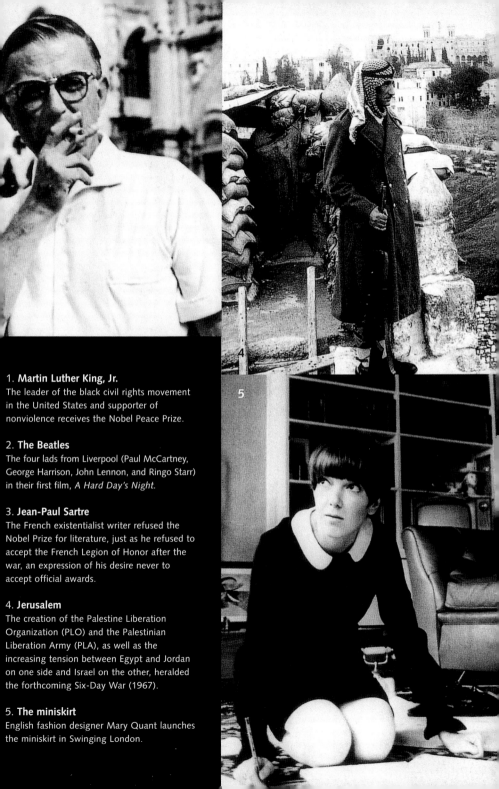

1. Martin Luther King, Jr.
The leader of the black civil rights movement in the United States and supporter of nonviolence receives the Nobel Peace Prize.

2. The Beatles
The four lads from Liverpool (Paul McCartney, George Harrison, John Lennon, and Ringo Starr) in their first film, *A Hard Day's Night*.

3. Jean-Paul Sartre
The French existentialist writer refused the Nobel Prize for literature, just as he refused to accept the French Legion of Honor after the war, an expression of his desire never to accept official awards.

4. Jerusalem
The creation of the Palestine Liberation Organization (PLO) and the Palestinian Liberation Army (PLA), as well as the increasing tension between Egypt and Jordan on one side and Israel on the other, heralded the forthcoming Six-Day War (1967).

5. The miniskirt
English fashion designer Mary Quant launches the miniskirt in Swinging London.

1967

On a political level, this is a year of crisis. Che Guevara is killed in Bolivia; Regis Debray, his French sidekick, is arrested and sentenced to a term of 30 years (he is released and expelled three years later). In Greece, the right-wing regime of the colonels takes over and King Constantine is sent into exile. The Vietnam War intensifies. Another, the Six-Day War, won resoundingly by Israel, is over quickly but has lasting consequences. Stalin's daughter Svetlana seeks asylum in the United States. Charles de Gaulle visits Québec and, encouraged by an enthusiastic crowd, shouts, "*Vive le Québec libre!*" (Long live free Québec!)

A mechanical digger is placed on the moon by *Surveyor III* to dig out some rock. France, the United Kingdom, and West Germany together design and build the Airbus. Dr. Christiaan Barnard, a South African surgeon, performs the first successful heart transplant, but the patient dies a month later from a pulmonary infection. The giant oil tanker *Torrey Canyon* founders, seriously polluting the English and Breton coastlines. French television broadcasts in color for the first time. Former German chancellor Konrad Adenauer, architect with de Gaulle of Franco-German reconciliation after World War II, dies, as does Clement Attlee, the first postwar British prime minister, and theoretical physicist J. Robert Oppenheimer, who invented the atom bomb. The arts lose the painter René Magritte and the writers André Maurois and Marel Aymé.

Opposite: Cellar of the Perrin estates.

Château de Beaucastel 1967
Rhone – Châteauneuf-du-Pape

The vineyard of the Château de Beaucastel covers 80 hectares. Traces of th estate can be found as early as 1549, but vines were not planted until the late eighteenth century. When the Perrin family took over the estate in the early twentieth, Beaucastel really began to flourish. In three generations, by combining tradition with judicious innovation, Beaucastel rose to the first ra of producers of the Châteauneuf-du-Pape appellation of wine.

The estate's soil is typical of the type in which the grapes for this wine grov best. There are polished pebbles deposited by the Rhone River in the Plioce era and from the Miocene era, and the soil has retained a red clay with sor sand content, as well as a less easily discernable subsoil of gray molasse. Th estate is innovative in the red varieties it uses, combining equal proportions (30%) of Grenache and Mourvedre. This is an exemplary combination, sine Grenache is an oxidating variety, which compensates for the antioxidizing power of the Mourvedre. The remaining 40% of the vineyard consists of t traditional varieties grown locally and accepted by the appellation. It shoulc be added that the white varieties are also unusual, because they include a large proportion of an unusual variety—Roussane (80%). This Châteauneu du-Pape estate is also innovative, even unique, in its system of vinification, which briefly heats the must (especially for Grenache). The method was invented to combat oxidases and limit the use of sulfur. On the other hanc traditional methods are used for aging, which takes place in 50-hectoliter vats. The wine is clarified with egg white before being bottled. The Châtea de Beaucastel 1967 benefited from the perfection of the grapes that year.

Organoleptic Description

The robe is dense though not unaffected by the passage of time. There is a slight browning and the edge tends toward orange in color. The bouquet is extremely complex and conjures up a cornucopia of candied fruits and spices. The Orient and the Mediterranean combine and strong tertiary aromas of tobacco and tar intervene. These aromas are perceptible again in the mouth, enhanced by the mild, almost mellow tannins, which are supple and melting. An example of accomplished elegance.

Secrets of Quality

Ideal blending, perfect grapes.

Availability

Very occasionally found at auctions.

Current Price

$240.

Apogee:
1985.

Comparable or almost comparable vintages: 1970, 1978, 1990.

Development:
The tannins do not dry out, but it ought to be drunk fairly soon.

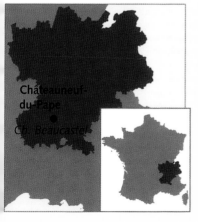

Châteauneuf-du-Pape

Ch. Beaucastel

Weather Conditions

It was an unlucky and disappointing year for most French wines, especially as hopes had been high as a result of good spring weather. Unfortunately, the fall ruined everything; the weather was so bad that in most places the grapes did not ripen properly, causing dilution. On average, the white wines fared best. Alsace was spared the rains and produced excellent wines, and the Sauternes survived through one of its famous Indian Summers. Château d'Yquem vinified a legendary wine. The Rhone Valley also managed to escape the fall rains and the grapes achieved ideal maturity, in a perfect state of health, with harvesters working in sunshine.

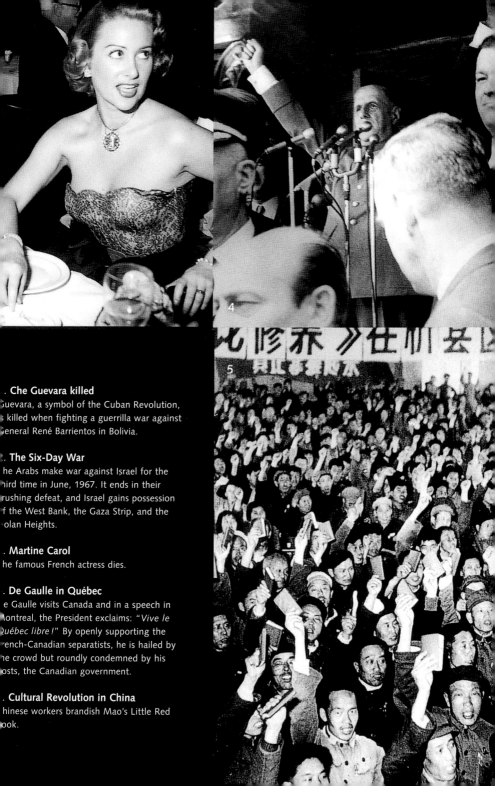

. Che Guevara killed

Guevara, a symbol of the Cuban Revolution, s killed when fighting a guerrilla war against eneral René Barrientos in Bolivia.

. The Six-Day War

he Arabs make war against Israel for the iird time in June, 1967. It ends in their rushing defeat, and Israel gains possession f the West Bank, the Gaza Strip, and the olan Heights.

. Martine Carol

he famous French actress dies.

. De Gaulle in Québec

e Gaulle visits Canada and in a speech in ontreal, the President exclaims: "*Vive le Québec libre!*" By openly supporting the rench-Canadian separatists, he is hailed by he crowd but roundly condemned by his osts, the Canadian government.

. Cultural Revolution in China

hinese workers brandish Mao's Little Red ook.

1970

For the first time, new cars in France must be fitted with seat belts, the wearing of which is compulsory. The French Communist Party elects a new assistant secretary-general, Georges Marchais. In Palestine, Yasser Arafat makes it known that he intends to liberate the territory by force. In India, maharajahs' privileges are abolished. After Gamal Abdel Nasser's sudden demise, Anwar Sadat becomes president of Egypt, and in Chile, the Marxist Salvador Allende is elected president. He goes on to introduce radical reforms, including nationalization of property.

In Italy, divorce is finally legalized. After all their chart and box-office hits, The Beatles split up. The incredible music festival at Woodstock in 1969 causes the hippie phenomenon to spread like wildfire. New pop stars seem to emerge on a daily basis—Joe Cocker, Bob Dylan, Jim Morrison and the Doors. The feminist movement is gaining ground. In Paris, women organize mass demonstrations.

France and the rest of the world are shattered by the death of General de Gaulle. The French Vichy politician Édouard Daladier and the Portuguese dictator Antonio Salazar follow him to the grave. Literary circles are plunged into mourning by the deaths of John Dos Passos, Jean Giono, François Mauriac, Elsa Triolet, Fernand Crommelynck, and Bertrand Russell. The singers Janis Joplin, Jimi Hendrix, and Luis Mariano, and the French comedian Bourvil, die in turn.

Opposite:
A Spanish *bodega*.

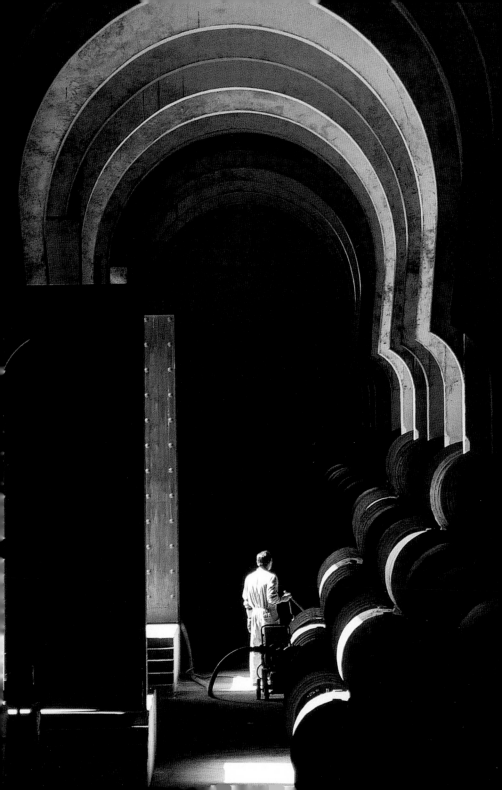

Vega Sicilia Unico 1970
Spain – Ribera del Duero

Opposite:
A bottle of
Vega Sicilia.

t is too often forgotten that the Spanish wine region is the largest in Europe. However, if Italy lost the tradition of great winemaking for a time, Spain shunned it for even longer, if fortified wines, such as sherry, are excluded. All this changed in 1864, when D. Elay Lecanda y Chaves purchased a strange, fertile plain from the Santos Cecilia family (Cecilia was changed to "Sicilia"; Vega means "fertile plain"), part of which was sloped. The property has also been called Pago de la Vega Santa Cecilia y Carrascul. Lecanda y Chaves was a pioneer. It wasn't until fifteen years later, after 1880, that the spread of phylloxera encouraged many wine growers from the Bordeaux area to settle in Rioja and the Duero, thereby introducing their vines to the region. Ignacio Herrero was succeeded by Dom Domingo Garramiola as owner of the estate. Gradually, the quality of the huge vineyard improved. However, it was not until 1970 that Vega Sicilia completed its rise and came to be recognized as Spain's greatest wine. Much to the joy of wine lovers, it opened the way for other Spanish wines. It now delights oenologists throughout the world and unselfconsciously asserts its claim to emulate the greatest of the great wines.

The story began on the left bank of the Duero River. The soils there are of great geological diversity; sometimes gravelly, sometimes a mixture of clay and limestone; sometimes consisting of red-stained clay. The initial 125 hectares of the property has been supplemented by about 60 more, which are closer to the river plain and therefore composed of richer alluvial soils. Most of the vines are of the local

Tempranillo variety, the most frequently grown in the D.O.C. Rioja. In fact, the Tempranillo (the name comes from its early ripening: *temprano* meaning "early" in Spanish) grown in Ribera del Duero appears to be the same variety that is called Tinto Fino locally. Some claims have been made, although there is no proof, that Tempranillo and Pinot Noir have a common origin. Whatever the case, Tinto Fino constitutes 60% of the vine stocks on the Vega Sicilia estate. It is complemented by 25% of Cabernet Sauvignon (a substitute for the Grenache usually grown in the Rioja), and there are also a few Merlot and Malbec stocks. All the grapes are harvested by hand.

The winemaking process is traditional; scraping, natural yeasting, and alcohol fermentation at under 86°F for 10 to 15 days. The wine is then stored in large vats for the malolactic fermentation. Then the blending begins. The methods used at Vega Sicilia are completely original, although, according to some, slightly old-fashioned.

After spending five years in large casks, followed by ten years in

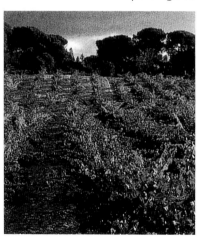

barrels, the wine continues to age in bottles for another ten years, sometimes longer. For instance, the 1970 magnums were not put on the market until 2001!

Vines of
Vega Sicilia.

Organoleptic Description

The wine was created from the following blend: 60% Tinto Fino, 25% Cabernet Sauvignon, 15% Merlot and Malbec. It was neither clarified nor filtered. Despite its age, and because the edges of the disk tend to turn an orange color, this mythical wine is robust. The bouquet is well-developed: melting, spicy, and woody, with undertones of tobacco and coffee. The mouth is impressive in its power and strong tannins, though it also has a lively, nervous touch—surprising in a wine of its age. The end of the mouth is long and complex, proving that a Vega Sicilia, even though aged fifteen years in wood, does not dry out. A mystery…or a miracle.

Secrets of quality
Old vineyard, small yield, variable climate.

Availability
Rare.

Current price
$750.

Apogee:
2000–2010.

Comparable or almost comparable vintage: 1964.

Development: Best drunk before 2025.

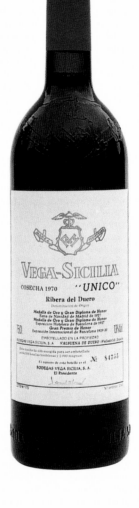

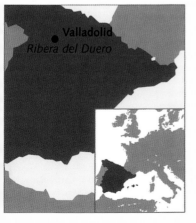

Weather Conditions

In 1970, the winter was cold and the summer very hot. But the heat of the day contrasted with the cool nights, an unbeatable combination for achieving the peak of quality. The grapes were thus able to attain complete ripeness early and were harvested in ideal weather. Outstanding quantity and quality were thus to be expected.

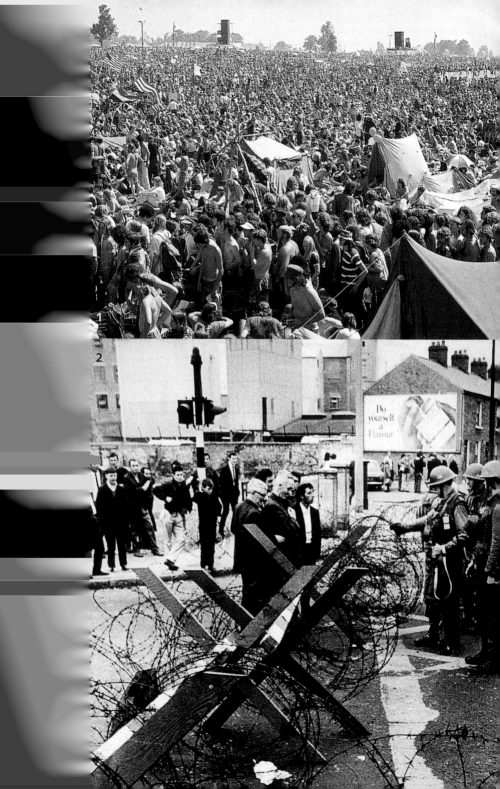

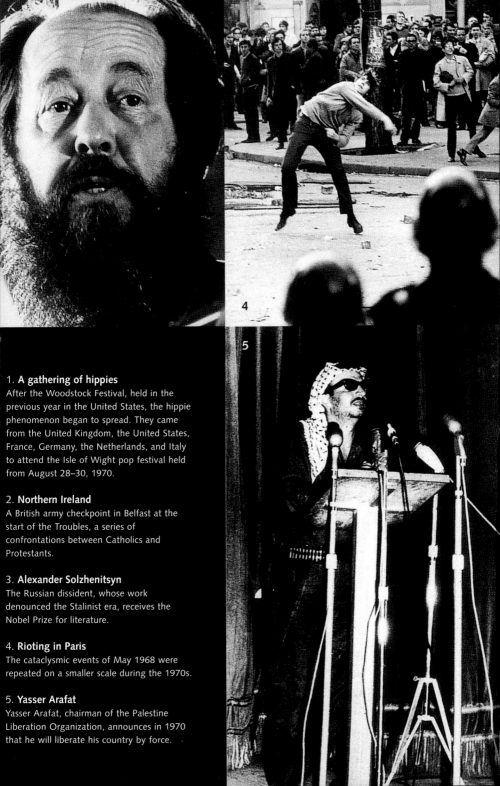

1. A gathering of hippies
After the Woodstock Festival, held in the previous year in the United States, the hippie phenomenon began to spread. They came from the United Kingdom, the United States, France, Germany, the Netherlands, and Italy to attend the Isle of Wight pop festival held from August 28–30, 1970.

2. Northern Ireland
A British army checkpoint in Belfast at the start of the Troubles, a series of confrontations between Catholics and Protestants.

3. Alexander Solzhenitsyn
The Russian dissident, whose work denounced the Stalinist era, receives the Nobel Prize for literature.

4. Rioting in Paris
The cataclysmic events of May 1968 were repeated on a smaller scale during the 1970s.

5. Yasser Arafat
Yasser Arafat, chairman of the Palestine Liberation Organization, announces in 1970 that he will liberate his country by force.

1971

Superstitious people do not miss the opportunity to attribute the *Apollo XIII* disaster to the number 13. It is followed by a perfect landing on the moon by *Apollo XIV*, or rather, by the lunar excursion module *Antares*, and then by the spectacular *Apollo XV* mission, which places the first electrically powered vehicle on the moon. Although the Soviets have lost the race for the moon, they are still in the space race. They are the first to build an orbiting space station. However, three Soviet cosmonauts die of asphyxiation during the year because an airlock fails on their spacecraft, causing it to depressurize. U.S.–U.S.S.R. rivalry moves to Mars. The American space probe *Mariner IX* orbits Mars as a satellite, while *Mars III* plants a Soviet flag on the Red Planet.

The Concorde supersonic passenger plane makes its first long-distance test flight between Toulouse, France, and Dakar, Senegal. The Shah of Iran holds a magnificent feast in Persepolis to commemorate 25 centuries of the monarchy. Switzerland finally grants women the right to vote. In Paris, the old market district of Les Halles is demolished and motorists are forced to pay for parking.

The Congo (formerly the Belgian Congo) is renamed Zaire; Bahrain and Qatar proclaim their independence as part of the creation of the United Arab Emirates. In Spain, Generalissimo Franco announces that King Juan Carlos will succeed him. Louis Armstrong, Igor Stravinsky, Jean Vilar, Coco Chanel, Khrushchev, and Fernandel die.

Opposite:
Snow-covered
vines in the Saar.

Scharzhofberg Trockenbeerenauslese 1971
Germany – Saar

Napoleon knew of this wine because, had it not been for him, the Scharzhofberg hill would still belong to the convent of St. Mary of Treves, founded in the sixth century. Napoleon's military and administrative jurisdiction applied French law to this northwestern part of Germany, which had two consequences for the land and its vineyards. First of all, the property of the clergy was seized and sold in the same way that it had been in Burgundy (and elsewhere), where ecclesiastical vineyards had been made public property and eventually sold to individuals. Secondly, the laws of succession, which led to subdivision of the land, were applied to this part of Germany in the same way as they were to Burgundy, and with the same results.

The Scharzhofberg hill was thus put up for auction on August 1, 1797, and acquired by Jean-Jacques Koch. He purchased only six of the 18 hectares for sale and created his vineyard on it. When he died, under Napoleonic law, the property was divided between his seven children. Fortunately, one of the sons bought the shares from his siblings and thus kept the estate intact.

Koch's great-great-grandson, Egon Müller, and his family now own seven hectares, but the total area of Scharzhofberg has been increased by nine hectares. This does not mean, however, that the whole vineyard is of uniform quality. Scharzhofberg enjoys a great reputation, due to the combination of the shale soil and the 45° angle of the slope, which offer great possibilities for Riesling grapes. The variety is at the edge of its area of cultivation, and it is always at this point that

the grape varieties produce their best crops. This characteristic of the vine has a disadvantage and an advantage. On one hand, it is very sensitive to weather conditions, meaning that the quality of the wine is not always good. On the other hand, the wines are of incomparable finesse when everything goes well. Müller's vines have certain unusual features. First of all, the stock is not grafted onto the root of a different, phylloxera-resistant variety: The vines of the Moselle are old because they were almost totally spared the plant-lice epidemic for reasons that have never been explained. It is known that phylloxera does not invade sandy soils, as it has difficulty in moving through the sand, but this does not apply to a shale soil.

Egon Müller's Rieslings are hard to cultivate because of the steep grade of the slope, and the density of the plantings (8,000 plants per hectare) do not leave much room for the grower to move about in. Despite these difficulties, Müller insists on working on his vineyard in the time-honored fashion and shuns chemical treatments. The pickers sort the grapes on the spot. In order to do so, they have two buckets; the first for grapes which have not been botrytised and the second for

bunches destined for the Spätlese. The harvest is lightly pressed, the must is filtered by gravity, then slowly fermented in wood for up to two months, when the sugar content is sufficiently high. As soon as the wine appears to have stabilized, it is bottled, without being clarified but after light filtration.

Egon Müller's Scharzhofberg Trockenbeerenauslese (TBA) is only vinified in very small quantities (200 or 300 bottles a year), and only when the vintage permits. This did not happen at all during the 1960s, only three times during the 1970s, and once during the 1980s.

Egon Müller makes the most expensive wine in the world, produced from grapes affected by noble rot, but he is not responsible for the incredible prices fetched by his wine—like the prices for most of the "special" German wines, they are fixed at the annual auction in Treves. This 1971 TBA was sold for about $1,669 in Germany in 1972. The record price attained by the 1971 Scharzhofberg TBA is perfectly justified, however, since this is a fabulous wine.

Vine plants during
the dead season.

Organoleptic Description

Anyone who has drunk this wine, if only once, can never forget it. Not only is its pale gold color unique, but so is its slightly candied citrus bouquet and floral freshness, which cannot be found in any other wine. There is also a balanced vigor in the mouth that is unequaled. The acidity is so strong that it feels as if it is scouring the teeth, but it is offset by the residual sugar and the bitterness of the citrusy flavor. There is nothing heavy, thick, or cloying in this dessert wine, but on the contrary a freshness and natural gaiety, the movement and rapidity of perpetual youth. A modern sweet white wine.

Secrets of quality

Soil type, old vines, severe pruning, tiny yield.

Availability

Extremely rare.

Current price

No transactions.

Apogee:
1995.

Comparable or almost comparable vintages: 1959, 1975.

Development: Slow. It will be excellent in 2015.

Weather Conditions

Most people in this part of the world can still remember the miraculous summer and fall weather in 1971. It could not have been better: warm, dry weather until the harvest, with fall's morning mists to promote the growth of noble rot on the berries, which were small, perfectly ripe, and concentrated. The great vintage promised by nature was indeed incomparable to the rest of the century for this type of wine.

1

2

1. Salvador Allende
The recently elected president of Chile, accompanied by his daughter.

2. Concorde
The Concorde leaves France for the first time on a test flight between Toulouse and Dakar.

3. Pablo Neruda
The Chilean poet receives the Nobel Prize for literature.

4. The moon and Mars
The first extraterrestrial vehicle is landed on the moon by NASA's *Apollo XV*—in the same year *Mars III* plants the Soviet flag on the Red Planet.

5. War between India and Pakistan
A civil war in the eastern part of Pakistan causes India to intervene on behalf of the rebels and sends a flood of refugees from East Pakistan into India.

1975

The year was fairly peaceful, with the exception of the continued violence in Vietnam and civil war in Lebanon. In November, Generalissimo Franco dies, after a 36-year despotic rule, and Juan Carlos de Bourbon becomes king of Spain, with plans to introduce democracy. In Germany, the Baader-Meinhof gang is brought to justice, marking the end of an era for the anarchist group. Angola is granted independence by Portugal and immediately plunges into a civil war between the government and the rebels supported by South Africa. The OPEC cartel raises the price of oil again, making the North Sea's oil and gas deposits financially viable, a boon for the economies of the United Kingdom and Norway. In Egypt, after eight years of blockage, the Suez Canal is reopened. The American and Russian spaceships *Apollo 18* and *Soyuz 19* meet up and lock together in space.

The Russian physicist and dissident Andrei Sakharov, who had helped to make the Soviet hydrogen bomb, receives the Nobel Peace Prize for his work on human rights. The Soviets consider this a provocation. A number of artists and performers pass away during the year, including Michel Simon, Pierre Fresnay, Oum Kalsoum, Josephine Baker, Pier Paolo Pasolini, Pierre Dac, Dimitri Shostakovitch, Saint-John Perse, and Gaston Gallimard. Other politicians, apart from Franco, to die that year are Chiang Kai-Shek, Guy Mollet, and King Faisal of Saudi Arabia, who is assassinated.

Opposite:
Turning the bottle.

1975

Clos des Goisses 1975 Philipponnat Champagne

The method used by the estate is similar to that employed by Salon Champagne (*page 130*), based mainly on five points. Only vintage Champagne is produced, so it is not made every year; only grapes of a single provenance are used; the champagne is aged for a long time—about ten years—on its lees (although the regulation minimum is three years); production is limited; and the Champagne is eventually bottled in a vessel with a distinctive design.

The Clos des Goisses is reflected in the waters of the Marne Canal, and if seen from a distance, the reflection is in the shape a Champagne bottle lying on its side, a phenomenon that has inspired many photographs.

Opposite:
Philipponnat
Champagne cellar.

The road leading from Mareuil-sur-Ay to Tour-sur-Marne separates the enclosed vineyard from the canal. The Clos occupies a very steep slope (about 40°), which was once cultivated using lifting gear, it is so difficult to work. Nowadays, miniature tractors with caterpillar tracks that have been specially designed for this type of vineyard are a useful piece of equipment for working the vines.

The Clos des Goisses, the largest estate in Champagne, was founded in 1935 by Pierre Philipponnat, who bought plots of vineyard from several different proprietors. It now covers an area of 5.5 hectares. The stock consists of 70% Pinot Noir and 30% Chardonnay. It has exceptional exposure to sunlight, especially as the sun reflects off the Marne Canal. The must is fermented in neutral vats and in the wood. The wine is then drawn off and stored in special bottles, which are

sealed not with a crown stopper (topped with a metal disk), but with one made purely of cork, which explains the expression *tiré sous liège* (drawn off under cork). This means that disgorgement, where the lees that have collected under the cork are drawn off, must be performed by hand, and only after a very long aging period on the fine lees (*dépôt*), a crucial period during which the wine can become more complex after the autolysis of the yeasts. The winemakers describe this phenomenon by saying that "the wine is eating its mother."

The Champagne produced by the Clos des Goisses is always made in small quantities. In 1975, the grape harvest was 9,082 kilograms per hectare; a generous yield, but not an excessive one. The acidity levels, so important in the balance of a Champagne, amounted to 8.5 grams a liter, which was excellent. At the Clos des Goisses, it is usually not necessary to sort the grapes because all the berries ripen better than average every year, even at the beginning of the harvest. In 1975,

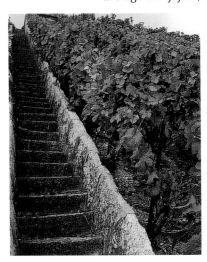

however, the grapes had to be sorted because the rains came, even at the beginning of the harvest. The Pinot Noir grapes were exceptional and the Chardonnays added their finesse to the blends.

Above:
Vines of the Clos des Goisses.

Following pages:
Cellar of the Clos (*left*); Rotating the champagne bottles to make the sediment collect below the cork (*right*).

Organoleptic Description

Clos des Goisses 1975 seems to be unchanging. Its robe is a uniform gold that hardly changes with age—in fact, it actually looks younger that the 1976 or 1979 vintages. This resistance to the ravages of time is even more remarkable because the acidity level is not particularly high. Not only is the 1975 young in appearance, the nose and mouth confirm this impression. The tiny bubbles contribute to the bouquet of burnt toast and dried fruit, and it has a masterful balance in the mouth. The whole is melting and harmonious; a pure, smooth minerality extends the memory of a full, round Champagne without a trace of heaviness.

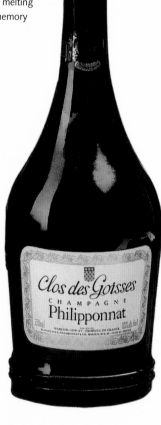

Secret of quality

Early maturity due to the exposure of the vineyard.

Availability

Over a hundred bottles are still aging in the winemaker's cellars.

Current price

Not available.

Apogee:
1990.

Comparable or almost comparable vintages: 1952, 1985, 1988.

Development:
Drink now.

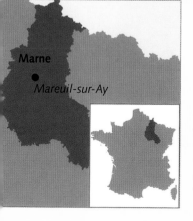

Marne

Mareuil-sur-Ay

Weather Conditions

In 1975, the winter was long and the vegetative cycle began late, with full flowering not occurring until around June 25. A very hot, sunny summer made it possible to harvest grapes that were perfectly ripe, however, and 90% of them exceeded 11° of potential alcohol. But in late September, it began to rain, and unfortunately the rain lasted through the harvest, encouraging gray mold and requiring the sorting of the grapes to remove any that had rotted.

. Conflict in Northern Ireland

∎mb explodes in Dublin. Since direct rule by
∎e United Kingdom began in 1972, the Irish
∎epublican Army (IRA) had escalated its
∎erations.

. Cooperation in space

∎e American astronaut Thomas Stafford and
∎e Soviet cosmonaut Aleksei Leonov meet
∎en the spaceships *Apollo* and *Soyuz* lock
∎gether.

. King Faisal of Saudi Arabia

∎ng Faisal, strongman of the Arab world and
∎e of the masters of the international oil
∎pply game, is assassinated.

. The Baader-Meinhof Gang

∎e German terrorist Andreas Baader
∎d his accomplices are caught. The trial
∎arks the end of their anarchist terrorism.

. Andrei Sakharov

∎e dissident Soviet physicist receives
∎e Nobel Peace Prize for his work defending
∎man rights.

1976

There are two important advances in space exploration. The *Viking I* probe lands on Mars and *Soyuz XXII* becomes the first manned spy satellite. Jimmy Carter is elected president of the United States. Jean-Bédel Bokassa proclaims himself Bokassa I, emperor of the Central African Republic. Two earthquakes in northern China leave 700,000 dead. In France, prime minister Jacques Chirac hands in his resignation to President Valéry Giscard d'Estaing. Raymond Barre takes over. There is a similar event in the United Kingdom with the unexpected resignation of Harold Wilson as prime minister.

In the United States, Patty Hearst, the granddaughter of newspaper magnate William Randolph Hearst who had been captured by the Symbionese Liberation Army, is convinced by the charms of her jailers and becomes a militant herself. As a result, she is sentenced to 35 years imprisonment, with the right of appeal.

In 1976, the Frenchman Éric Tabarly wins the Transatlantic lone yacht race on *Pen Duick VI*, and Björn Borg wins Wimbledon at the age of 20. Mao Zedong dies, having led the Chinese Communist Party since 1921. Other deaths during the year are novelist Agatha Christie and physicist Werner Heisenberg, as well as Martin Heidegger, Paul Morand, André Malraux, Raymond Queneau, the composer Benjamin Britten, Max Ernst, Fritz Lang, Luchino Visconti, and Jean Gabin.

Opposite:
Rheingau cellar, Germany.

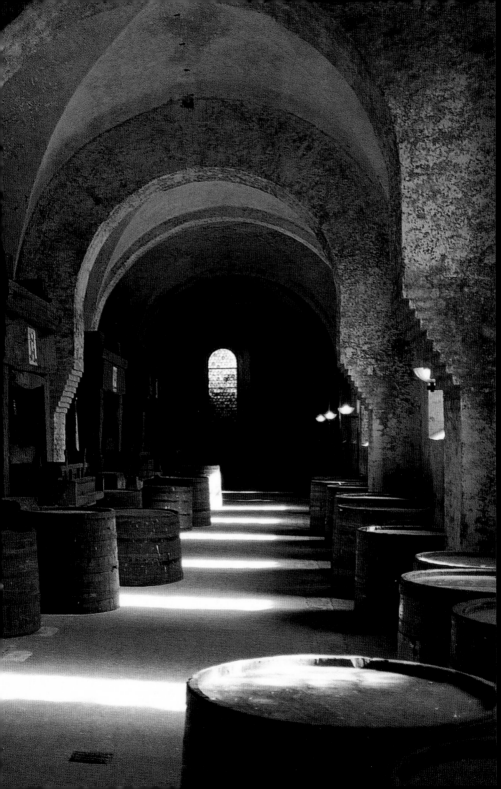

Hattenheimer Pfaffenberg Trockenbeerenauslese 1976
Germany – Rheingau

Schönborn castle, in the Rheingau, has been owned by the same family since 1349, but it needed more than tradition for the estate to be preserved, since the parcels of land were not contiguous. Today, it covers 75 hectares, the current owner being Karl von Schönborn-Wiesentheid. There are some advantages to being the owner of a winery that dates back to the fourteenth century: being able to go down into the cellar and choose a bottle of 1735 in order to auction it at the famous Kloster Eberbach wine auctions. The result is a record price of DM 53,000! The wines of the Schloss Schönborn are numerous, with no fewer than fifty varieties produced by several climates and plots of land. Most of the grapes are Riesling, followed by Pinot Blanc and then Pinot Noir, the latter resulting in a remarkable dark red wine. In addition, harvests that are split or delayed produce special vintages such as the Spätlese and Eiswein. The most valuable wines are harvested from grapes affected by noble rot, and are labeled Beerenauslese and Trockenbeerenauslese (BA and TBA).

Small teams of experts sort the grapes and only pick those affected by the noble rot. Grapes remaining on the vine will eventually be picked, and the grapes that are healthy produce a Spätlese, and even, in some cases, an Eiswein. The harvest is sorted a second time before the grapes are put in a vat and lightly pressed. The juice is fermented at less than 68°F. The wine rests on the fine lees for about 20 days, then it's stored in vats for a few more months before being bottled. It's neither clarified nor filtered.

Following pages:
Wall around the Schloss Schönborn estate.

Organoleptic Description

The 1976 Hattenheimer Pfaffenberg TBA is slightly orange in color, and thick without being oily. The bouquet is very complex, consisting of lemony candied citrus and very ripe apricots, with a hint of vanilla. The aromatic complexity is reproduced in the mouth. The wine also has a rare freshness and vigor, which is unexpected in a wine that has attained its apogee. The supreme elegance of a rich wine.

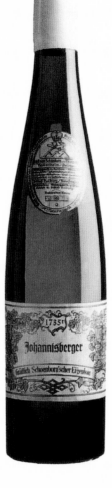

Secrets of quality

Minute yield; draconian selection of botrytised grapes.

Availability

Virtually unavailable (300 bottles made).

Current Price

Not on the market.

Apogee:
1990 to 2000.

Comparable or almost comparable vintages: 1971, then 1979 and 1986.

Development:
Drink now, preferably before 2025.

Schloss Schönborn
● **Rheingau**

Weather Conditions

In around three years in ten, the weather conditions are good enough to be able to vinify a TBA. *Botrytis cinerea*, the noble rot required to create this wine, must develop on the grapes, which need to be perfectly ripe as the result of a hot summer. Early autumn mists need to dampen the vineyard until the sun breaks through at midday and dries out the grapes.

1

2

4

5

1. Jimmy Carter
After eight years of Republican rule, a Democratic president enters the White House.

2. Éric Tabarly
The French yachtsman wins the Transatlantic Race for the second time, having first won it in 1964.

3. Björn Borg
The young Swede wins Wimbledon at the age of 20. He would go on to win the French Open six times and Wimbledon five times.

4. André Malraux
Death of the great French writer and former minister of culture.

5. Martin Heidegger
The German philosopher dies.

1978

Aldo Moro, former prime minister of Italy and chairman of the Christian Democrat party, is kidnapped and assassinated by the Brigate Rosse (Red Brigades). President Jimmy Carter unites Anwar Sadat and Menahem Begin at his country estate, Camp David, for the purpose of signing a peace agreement between Egypt and Israel. There are violent demonstrations in Iran. The Ayatollah Khomeini is expelled from Iraq and welcomed as a refugee into France. Pope Paul VI dies and is succeeded by John Paul I, whose pontificate lasts just 33 days. After his death, John Paul II is elected, the first non-Italian pope in four-and-a-half centuries. In the United Kingdom, the first "test-tube baby," Louise Brown, is born, the product of *in vitro* fertilization. The year 1978 is notorious for the worst case of oil pollution in French history, when the tanker *Amoco Cadiz* runs aground loaded with 230,000 tons of crude oil. A cyclist called Pollentier is disqualified from the Tour de France for drug-taking; the race is won by Bernard Hinault. Other important events are the kidnapping of Baron Empain, chairman and managing director of the firm of Schneider, who is released after having his left earlobe cut off, and the appalling mass suicide at Jonestown, Guyana, of 400 members of the cult headed by Jim Jones, an American preacher. Jacques Brel and Claude François die; the world of art loses Giorgio De Chirico. Golda Meir, Israel's first woman prime minister, dies in Jerusalem.

Opposite:
A vine starting
to sprout.

Château Rayas 1978
Rhône – Châteauneuf-du-Pape

The French are strong traditionalists in most areas of food and drink, and wine is a classic example of this attitude, especially as vineyards are handed down from father to son. However, a few pioneers have flouted the time-honored rules and shown that truisms can lie. These "self-taught" winemakers include Philippe de Rothschild in Bordeaux, patron of the Pigalle theater, race car driver, and lover of French literature; Jacques Seysse, a newcomer to the Burgundy region who invented his Morey-Saint-Denis and his Clos de la Roche; and Jean Grivot, the pharmacist who improved the wines of Vosne-Romanée and Gardin and who left Marseilles to be able to make a better Givry. These are just a few of the outstanding figures who bought vineyards with a certain concept of winemaking in their minds and who were untrammeled by the financial and other considerations that can interfere with making wine of the highest quality.

Opposite: Château Rayas 1978.

Commander Reynaud, inventor of Rayas, belongs to this category of amateurs and enthusiasts because he is in love with wine, and when love and intelligence are combined, the impossible becomes possible. He is the second generation of Reynauds to own the estate. His father acquired it by chance, having been advised to "live in the country" for health reasons. Rayas was not bought for its vines, which had been ravaged by phylloxera. It was Reynaud's son who created Château Rayas. No tradition, no special knowledge, no aesthetic rules had been inherited from his father. In 1920, Commander Reynaud took over the estate and for the next twenty to thirty years completely overhauled

CHATEAU RAYA

CHÂTEAUNEUF-DU-PAPE

...ELLATION CHÂTEAUNEUF-DU-PAPE CONTRÔLÉ...

CHÂTEAUNEUF...
VAUCLU...
FRANCE

MIS EN BOUTEILLE AU CHÂTEAU

the entire vineyard. He must have had a clear plan of what he intended to do and had been very confident of success, because he chose the most difficult and constraining methods, which resulted in derisory yields per hectare. He might have compensated for the small harvest by extending the area planted with vines because he had quite a few hectares, but he did nothing, and the woods that surround the small plots of vines help create a microclimate that attenuates the burning summer heat of Châteauneuf-du-Pape. He had sought to do this already by choosing north-facing slopes on which to grow the vines. His ultimate aim was to create a fine wine, a wine whose finesse was partly due to the sandy soil in which the vines grew (as opposed to the classic gravel and limestone or clay).

Commander Reynaud bet everything on the vineyard—or rather, on the grapes—and won. This is surprising, because the winestore was very mediocre, especially when compared to his ambitions for the wine.

Landscape around Châteauneuf-du-Pape.

Unlike most varieties of Châteauneuf-du-Pape, the red Château Rayas (there is a rare white of which only 2,000 bottles a year are produced) comes from a single variety, Grenache Noir. The Grenache vines are heavily pruned and harvested "green" in the summer, producing no more than 15 hectoliters per hectare. The stalks are not removed and are only moderately fermented, because at Rayas there is no desire to produce a competition product, only a distinguished wine. For the same reason, Château Rayas does not owe its qualities to the wizardry of blending, since the woodiness, vanilla, and tannins contributed by the wood are not sought after.

Is Château Rayas a typical Châteauneuf-du-Pape? Of course not, but the diversity of the soil types and grape varieties used might qualify such a hasty reply. At all events, what is quite clear is that this is one of the greatest wines in the world.

Organoleptic Description

The robe does not hide its age, and a slight browning is perceptible in the mass. The finesse and harmony of the aromas are exemplary. The blackcurrant fruitiness is not totally overwhelmed by the tertiary aromas of balsam, reminiscent of Russian leather. In the mouth, the concentration, power, and finesse melt into a supple, almost syrupy, roundness. A wonderfully unique wine.

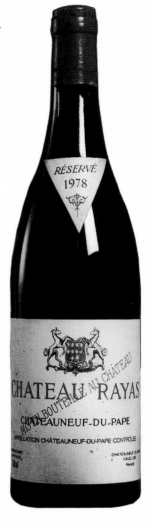

Secrets of Quality
Design of the vineyard, rigorous quality control.

Availability
Rare. The wine has mostly been exported.

Current Price
Few transactions, but around $1,050.

Apogee:
2000.

Comparable or almost comparable vintages: 1967, 1961.

Development:
Why wait?

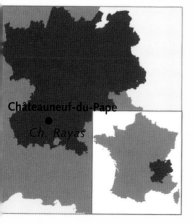

Châteauneuf-du-Pape

Ch. Rayas

Weather Conditions

In the case of the 1978 vintage, the further south and east one goes, the better the quality of the wines. They are very acceptable in Bordeaux, excellent in Burgundy, and exceptional in the Rhone Valley. Exceptional, because summer and fall were perfect. The grapes were as healthy as they were ripe and produced one of the best Châteauneuf-du-Pape vintages and an exemplary Château Rayas.

1

2

1. Jean-Paul II, a Polish pope
For the first time in four-and-a-half centuries, the pope is not an Italian. The Polish archbishop Karol Wojtyla is elected to succeed John Paul I by the 111 cardinals meeting in conclave on October 16.

2. Black tide
When the *Amoco Cadiz* oil tanker ran aground, it created another black tide of pollution, this time off Belle-Ile off the Brittany coast. The previous disaster to hit the French coast, the oil spillage from the *Torrey Canyon,* did terrible damage to Finistère, also in Brittany.

3. Bernard Hinault
Winner of the Tour de France cycling race.

4. Anwar Sadat and Menahem Begin
The two leaders signed a peace agreement between Egypt and Israel at Camp David and jointly received the Nobel Peace Prize that year.

1982

The Iran-Iraq War continues, and from April through June war is waged in another part of the globe. The Falklands War is started and lost by Argentina, which was bent on wresting the islands from the British. Despite the objections of settlers, Israel returns the Sinai peninsula to Egypt, and then invades South Lebanon with the aid of the Christian Phalangists. This leads to the massacre of refugees in the Sabra and Shatila camps near Beirut by Phalangist soldiers. Two further terrorist acts arouse universal indignation and horror. In Italy, General Della Chiesa, prefect of Palermo, Sicily, is murdered in a car-bomb explosion perpetrated by the Mafia. In France, an anti-Semitic attack in the Jewish quarter of Paris, the Rue des Rosiers, results in six deaths. Also in France, the 39-hour working week is voted in and the franc is devalued, while the West German mark surges. France abolishes the law making homosexuality illegal. Gabriel Garcia Márquez receives the Nobel Prize for literature.

Two leading politicians die: Leonid Brezhnev in the Soviet Union and Pierre Mendès France in France. The world of music loses Glenn Gould, Arthur Rubinstein, and Thelonious Monk, and the writers Louis Aragon, Pierre Gaxotte, and Georges Pérec are no more. Princess Grace of Monaco, Romy Schneider, Henry Fonda, Ingrid Bergman, Jacques Tati, and Rainer Werner Fassbinder also die that year.

Opposite: A bottle of Pétrus against the map of the region.

Pétrus 1982 Bordeaux – Pomerol

The reputation of this vintage is well-known. It is also an example of
how a vintage can be both great and abundant, although 1982 was
no 1961. The grapes were superb, completely ripe, and there was no
disparity between alcoholic maturity (sugar) and phenolic maturity
(tannins). There was only one blot on the horizon, and it involved
white Sauternes grapes—the weather was too fine to enable the noble
rot to develop on grapes that were nevertheless fully ripe. But for the
red grapes, sugar, ripe tannins, and low acidity all combined to create a
supple and excellent wine. Critics assumed that the results would be
"too good, when young, to have keeping qualities." Pétrus 1982 has
given them the lie by its richness in alcohol and tannins.
The Château Pétrus vineyard is one of the most famous in the world.
It consists of 11.4 hectares, to which 5 hectares from the neighboring
vineyard, the Château Gazin, have been added. The soil type is unique,
nothing like that on which other Pomerols are grown. The soil of Pétrus
sits like a clay cap or island on an ironstone plinth. The soil would appear
to be too compact but it is saved by good drainage and by a stream
which is retained only by the small area of the vineyard. The average age
of the vines, of which there are about 6,500 plants per hectare, is about
40 years, among the oldest in the Bordeaux district. They are severely
pruned and the date of harvesting is pondered at length. The grapes are
only picked in the afternoon to avoid the dew, and it is performed
at great speed, thanks to an army of experienced pickers and carriers.
The wine is aged for 22 months in new vats. It is clarified but not filtered.

Organoleptic Description

Despite some of the things that have been said about it, Pétrus 1982 is a powerful, full-bodied, tannic wine whose development is slow, contrary to that of many other vintages of this type. At the heart of an explosive fruitiness there is a strange touch of hardness, which is surprising in a wine made exclusively from Merlot. There are successive aromas of the smoothness of plums, mulberries, and a bouquet of spices. The strength and length in the mouth are characteristic.

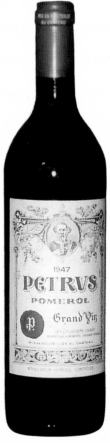

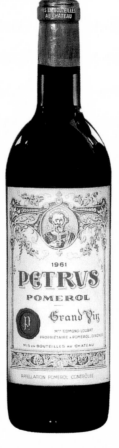

Secrets of quality
Old vines, soil type, perfectionism.

Availability
The most sought-after vintage after the 1961.

Current price
$5,000.

Apogee:
From 1995 through 2000.

Comparable or almost comparable vintages: 1947, 1961, 1989.

Development:
Preferably to be drunk before 2015.

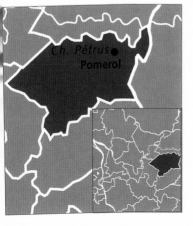

Ch. Pétrus
Pomerol

Weather Conditions

The spring was radiant, with early flowering and a beautiful, hot summer, with a few small showers that promoted growth. At harvesting time, temperatures were very much in excess of the average, more than 83°F.

Pesquera Cuvée Janus Reserva 1982
Spain – Ribera del Duero

It is noticeable that the great achievements in contemporary winemaking—and probably winemaking in the past—are always due to the efforts of a single, strong-minded individual, someone who obstinately imposes his own principles on practices that are too often the result of tradition rather than pragmatism. The creation of a great wine also involves heavy investment, implying that there is a lot of money available. There are numerous examples in the history of the Bordeaux vineyards. Only members of the *parlement*, the assembly of local nobility, had the resources to create the *grands crus*, the greatest

Opposite: Winestore of the Alejandro Fernandez bodega.

wines. The same is true on the other side of the Pyrenees, in Spain's Duero Valley, called the Douro where it extends into Portugal.

The man behind this great Spanish wine is called Alejandro Fernandez. After making his money as an industrialist, he realized that his modest family vineyard faced the famous Vega Sicilia estate (*page 240*).

He consequently devised a daring and imprudent plan to compete with the very best Spanish wine without imitating it.

In 1972, Fernandez created a 65-hectare vineyard, divided into two geologically different plots of land. The first was beside the Duero, on gravelly, alluvial soil. The second was on high ground (2,460 feet above sea level) on a pebbly clay soil, where there was a sharp contrast between day and night temperatures, designed to bring out the aroma of the wine.

He only planted the local variety of grape, Tempranillo, at a very low density (2,500 plants per hectare) to make it easy to cultivate the

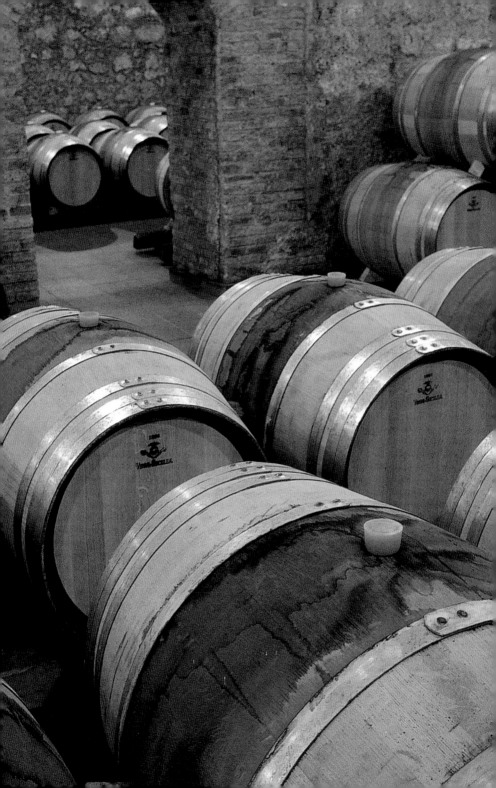

plots. He has also imposed draconian restrictions on the yield per hectare, something that is not easy in a young vineyard.

Vinification left nothing to chance. Although the stalks are normally removed for wines classified as Reserva, in the case of Janus fermentation, the stalks are not discarded but the grapes are picked without their stalks, staight from the vine, in the old-fashioned way. Fermantation is regulated at the exceptionally low temperature of 72°F to 77°F and maceration is very short, less than ten days.

Aging is also unusual, not for the amount of time, which is two years, but for the choice of woods, which consists of 90% American oak, 10% French oak. Although the Vega Sicilia and Pesquera estates are so close to each other, it would be hard to imagine more opposing approaches to vine stocks, vinification, and aging. It is as if Alejandro Fernandez, realizing that he could not compete with Vega Sicilia on his own ground, deliberately chose to take a totally different route with the aim of producing wines that were just as great. The ploy was a

complete success. Janus, his prestige wine—which he has been vinifying for more than 20 years, and only when the quality of the vintage so permits—graces the table of the great and the good.

Entrance to the
bodega.

Organoleptic Description

Cuvée Janus 1982 has a wonderful robe. The edge of the disk shows signs of moderate development. The very ripe fruitiness is partially masked by tertiary aromas of tar and leather. The structure in the mouth is imposing and full-bodied but mitigated by an almost syrupy vanilla flavor, contributed by the American wood in which it is aged. A very interesting composition, combining roundness and virility.

Secrets of quality

Limited yield, careful choice of soil type, and vinification.

Availability

Almost nonexistent (about 6,000 bottles, three or four times every ten years).

Current price

$200.

Apogee: 2000.

Comparable or almost comparable vintages: 1985, 1986.

Development: To be drunk after 2010 (perhaps in 2020).

A "competition wine"?

The wine is said to belong to the category of "competition wines," which implies a wine made from overextraction that ages poorly. Yet if the vintner had sought maximum extraction, he would have opted for long maceration at a high temperature (86–92°F). Under such conditions, and in view of the high tannin content of the Pesquera, the only conclusion is that the Tempranillo varieties, severely pruned, have found their ideal territory.

1

2

1. **Iran-Iraq War**
Iran launches an offensive against Iraq. The Iraqi president, Saddam Hussein, is shown here visiting the front lines.

2. **Gabriel García Márquez**
The Colombian writer receiving the Nobel Prize for literature.

3. **Romy Schneider**
The Austrian actress died on May 31.

4. **Pierre Mendès France**
Death of one of France's greatest political figures.

5. **Princess Grace**
The former Grace Kelly is killed in an automobile accident.

1985

A new, modernizing influence enters the Kremlin with Mikhail Gorbachev, champion of *perestroika* and *glasnost*. In the United States, Ronald Reagan begins his second term in office. The Iran-Iraq War shows no signs of ending. Nor does the Lebanese civil war, in which kidnapping of foreigners has now become a feature. The Greenpeace ship *Rainbow Warrior*, on its way to Mururoa to protest against French nuclear testing, is sunk in the port of Auckland, New Zealand, sabotaged by French secret agents who are caught and sentenced to ten years in prison. The French minister of defense, Charles Hernu, is forced to resign and is replaced by Paul Quilès. Many important projects are in the pipeline in France, including a tunnel under the English Channel and a glass pyramid at the Louvre. Following Germany and the Netherlands, French premier Laurent Fabius orders AIDS tests to be introduced for blood donors. In the United Kingdom, the coal miners are finally beaten by Margaret Thatcher and her government after striking for a year against pit closures. There is another soccer massacre when 38 people are killed and 450 wounded at the European Cup Final at the Heysel Stadium in Belgium. The wreck of the *Titanic* is located. Marc Chagall, Jean Dubuffet, Orson Welles, Simone Signoret, Louise Brooks, Henri Flammarion, James Hadley Chase, Jacques de Lacretelle, René Barjavel, and Michel Audiard die during the year.

Opposite: Moët et Chandon cellar.

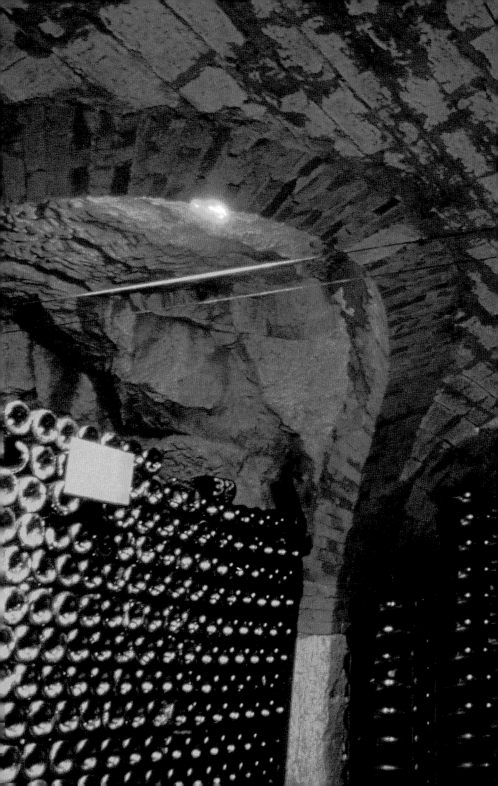

Dom Pérignon 1985 Champagne

The nineteenth century was a time of great enthusiasm for enhancing th
reputations of long-ago legends. There was Charlemagne with his long
beard, Henri IV of France and his "chicken in every pot"; Joan of Arc,
who personified French nationalism—and Dom Pérignon, who
"invented" Champagne.

Opposite: Bottles
of Champagne
being aged in the
traditional upside
down position, so
that the lees
collect on the cork.

Following pages:
Harvesting basket
for Champagne
grapes.

When historians come to examine the facts, however, they find a dearth
of information. Dom Pérignon is known to have been born in 1638, the
same year as Louis XIV, and to have died in 1715, the year in which the
Sun King died. Apart from that, there is a little information—a few let-
ters, a few signatures of some standard contracts. Nothing had been
written about him by his contemporaries, at least until he died. Dom
Pérignon was a monk at the Abbey of Hautvillers, near Épernay in the
heart of Champagne, and from 1668 he was its cellarer and purchasing
agent. The abbey owned a large 25-hectare vineyard and he was
perfectly satisfied with its wine and the money it made. Dom Pérignon
had a large cellar built that could hold up to 500 bottles of wine, but we
do not know what wine it was. According to one of Champagne's best
historians, Colonel François Bonal, Dom Pérignon never vinified spark-
ling wines.

Fernand Woutaz suspects that the treatise entitled *Manière de cultiver la
vigne et de faire le vin en Champagne* (Manner of cultivating the vine
and making wine in Champagne), published in 1718 by Cannon Godino
was really written by Dom Pérignon (or at least based on his notes).
One thing is certain, it was the English who first used the *méthode*

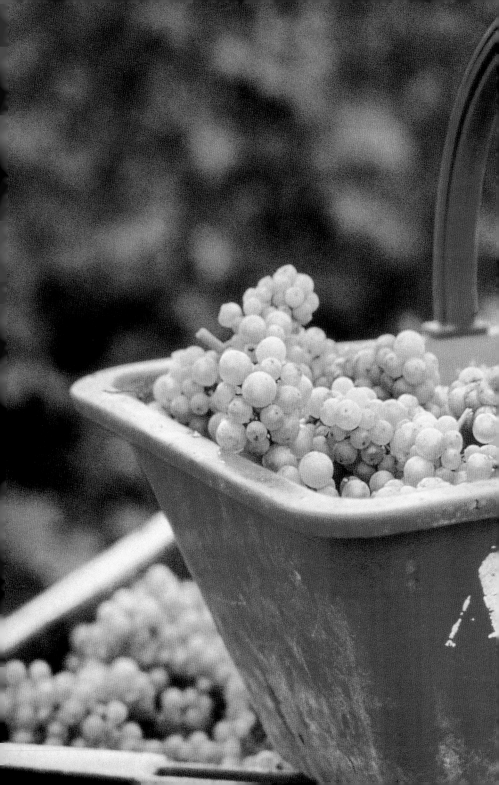

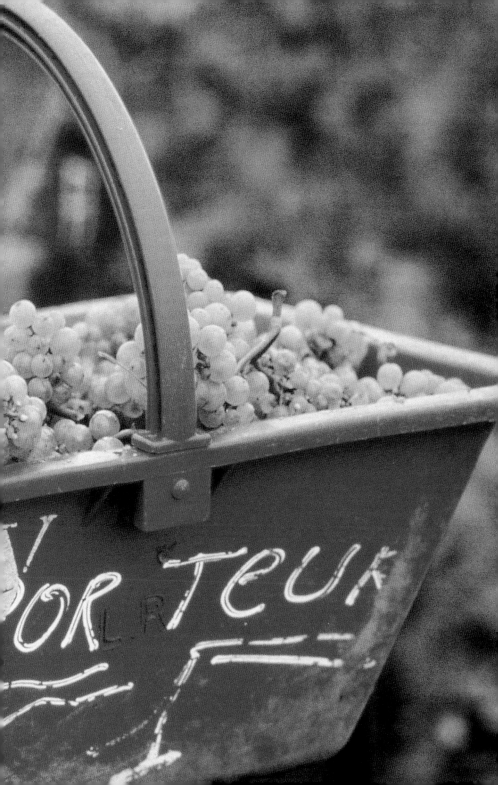

champenoise. A publication dated 1662 describes the method thus: "Add sugar and molasses to make the wine effervesce." This method was not adopted in Champagne until around 1800. Prior to this date, the fizziness was achieved in Champagne by bottling it too early (a method known as the *méthode rurale*). In 1732, Bertin du Rocheret, the biggest wine-merchant of the period, wrote in his notebook: "I do not know if we will (make it) foam."

The first official permission to sell the wine in bottles dates from 1728. This explains why the oldest Champagne firm (Ruinart) was not founded until 1729, 14 years after Dom Pérignon's death.

The uncertainties of history, however, do nothing to spoil the merits of Dom Pérignon Champagne, which was recognized in his day for white wines of exceptional clarity.

A century later, Eugène Mercier, a prominent figure in the region who died in 1904, registered the Dom Pérignon trademark and presented it as a gift to Moët et Chandon on the occasion of a marriage. It was not actually used until 1936, when it was launched for the inaugural voyage of the ocean liner, the *Normandie*.

The Moët et Chandon estate.

The first Dom Pérignon was the 1921 vintage, one that is so legendary that many œnophiles claim it to be the vintage of the century. In 1985, the grapes were in perfect health and maturity was ideal. The very mild fall permitted an exceptional second harvest at the end of the month. While it is rare that second generation grapes attain full maturity, this happened in 1985. The natural level of alcohol in the musts attained an average of 10°, which is excellent; the level of acidity was 8 to 9.5 grams per liter, an indication of balance and longevity. At the time, the vintners recognized that the potential of the 1985 was similar to that of 1975. Dom Pérignon is the result of a blend of two noble Champagne grapes, Pinot Noir and Chardonnay. The 1985 vintage, like the 1982 and the 1976, used more white grapes, 60% Chardonnay and 40% Pinot Noir. The wines are always made by malolactic fermentation.

Organoleptic Description

The 1985 Dom Pérignon has a very pale straw-colored robe. The nose consists of a basic burnt toast, with floral overtones tending toward acacia with a hint of ivy. In the mouth there is liveliness and vigor, perfect balance, great length, and above all, an admirable finesse, perhaps at the price of a slight lack of roundness. The finesse is accentuated by the extreme youth of this wine, which was first marketed in 1992.

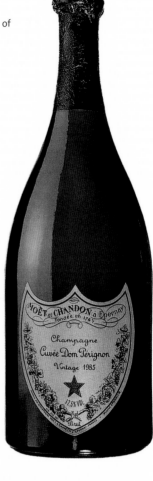

Secrets of Quality

Grapes selected from among the *grands crus*.

Availability

Sometimes sold at auction.

Current Price

$500.

Apogee:
1995.

Comparable or almost comparable vintages: 1982, 1971, 1964–1961.

Development:
Drink now.

Marne

Épernay

Weather Conditions

In 1985, only half the normal volume of grapes were harvested. The winter temperatures had been the lowest recorded for 150 years (down to 13°F) and frosts in the spring aggravated the situation. But the summer was particularly warm and sunny and in September records were broken. The grapes were harvested between September 30 and October 11.

Sassicaia 1985 Italy – Bolgheri

When the renaissance of the great Italian wines, forgotten for more than fifteen centuries, is mentioned, the Sassicaia is generally talked about immediately after the Brunello di Montalcino *(page 226)*. Chance, circumstance, and intuition all combined to give birth to this great wine.

During his student days in the 1920s, the Marquis Mario Incisa della Rochetta planted some French grape varieties in the Asti region. This man of taste appreciated fine French wines and loved horse racing.

Upon marriage, his wife brought him a huge estate of 2,700 hectares in the Bolgheri region, near Livorno. During World War II, when it was impossible to get wine from France, the marquis remembered the Cabernet vines he had planted near Asti. He had them carefully packed and planted 1.5 hectares at Bolgheri with them. The vines were severely pruned.

Opposite:
Winestore of
Tenuta San Guido.

The local soil is gravel and the vineyards are at an altitude of 1,150 feet, guaranteeing some cool weather. Yet the first thousand bottles produced from the transplanted vines were disappointing. The wine was very tannic and hard, the more so because it had been aged in casks of Slovenian oak. The wine was bottled and stored in the cellar where it was forgotten for a few years. One day, no one knows why, it was tasted again. To everyone's surprise, it was excellent. The wine had "made it"—digested its tannins and humanized.

As a result, the marquis decided to plant some more parcels of land with the grape varieties (more than 25 hectares, planted at a density c

4,000 vines to the hectare) and trained in the French way over short stakes and wires. Giacomo Tachis, the great oenologist who worked for the firm Antinori, supervised the vinification. The winemaking equipment was perfect; the temperature was regulated at 86°F and the fermentation vats were stainless steel. The wine was then aged in French oak barrels.

The wine was given the name of *Sassicaia*, which means "poor, stony soil," and from 1986, oenophiles throughout the world were eager to taste the wine.

The marquis's initiative was highly criticized in Italy, however, partly because the vineyard was located in a region which was not known for its wines, but mainly because he had planted foreign vines rather than the local Sangiovese variety. The product was a wine that had nothing in common with Tuscan wines, nor even any of the other Italian wines called, with a degree of contempt, "international wines." Many other countries have since followed suit. Although Sassicaia had become a

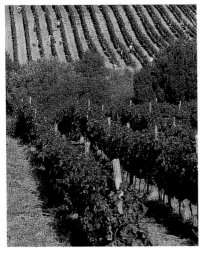

famous wine, it could not be classified as anything other than a mere *vino da tavola* (table wine), both for the location where it was made and the grape variety it used.

When his father died in 1983, the Marquis Nicolo Incisa della Rochetta more than met the challenge—to such an extent that the Sassicaia 1985 has been awarded the prize of best wine in the Cabernet claret category, even when competing against *premier cru* wines from Bordeaux! Fortunately, the Italian authorities are less rigid than their French counterparts and have introduced a Bolgheri appellation, a move

Above: Vines of Tenuta.

Following pages: Vega Sicilia, the great Spanish wine *(page 240).*

justified by the proximity to Sassicaia of another wine that is causing a sensation, Ornellaia, which deserves to be watched as closely as its cousin Sassicaia.

Organoleptic Description

The 1985 Sassicaia remains the best wine produced by this controversial vineyard. It is deep ruby in color and has just reached its apogee. It is warm, well-built, ample, and complex. The tannins are perfectly ripe and expressed in a bouquet of blackcurrant with a hint of licorice, emphasized by tarry and leathery aromas. A woody vanilla binds this harmonious symphony together. In the mouth, there is a supple architecture that does not impose on the melting and complex aromas, and it has a unique aftertaste.

Secret of quality

Combination of climate and soil type.

Availability

Very sought after at auctions in the United States and the United Kingdom.

Current price

$2,500.

Apogee:
2000.

Comparable or almost comparable vintage: 1985 is indisputably the best vintage.

Development:
To be drunk before 2010.

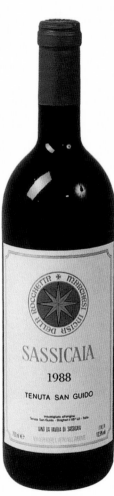

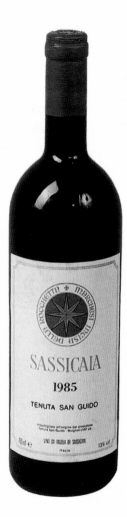

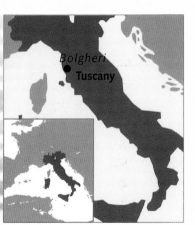

VINO FINO

VEGA-SI

FECHA 1941

BODEGAS y VIÑEDOS
VEGA SICILIA

TINTO "VALBUENA"

EMBOTELLADO EN SU 5º AÑO

VALBUENA DE DUERO (Valladolid)

BODEGAS y VIÑEDOS
VEGA-SICILIA

TINTO "VALBUENA"

EMBOTELLADO EN SU 3.ª AÑO

BODEGAS y VIÑEDOS
VEGA-SICILIA

TINTO "VALBUENA"

EMBOTELLADO EN SU 3.ª AÑO

REGISTRADA

PM

ARCA

VEGA-SICILIA

"UNICO"

COSECHA 1962

Ribera del Duero
Denominación de Origen

Medalla de Oro y Gran Diploma de Honor
Feria de Navidad de Madrid de 1927
Medalla de Oro y Gran Diploma de Honor
Exposición Hotelera de Barcelona de 1927
Gran Premio de Honor
Exposición Internacional de Barcelona 1929-30

EMBOTELLADO EN LA PROPIEDAD

...IA, S.A. VALBUENA DE DUERO (Valladolid) España

75Cl.

13,5% Vol.

Nº 0954

...a ser embotellada
...agnum.

VINO DE M...

...n uvas: Cabernet Sauvign...

ARCA

...EGA...

...H...

1

2

4

5

1. The Greenpeace Affair
The Greenpeace ship *Rainbow Warrior* is sunk while preparing to sail to Mururoa Atoll to protest against French nuclear testing. Two French special agents are arrested, and the French defense minister resigns.

2. Louvre Pyramid
Start of construction on the project designed by the architect I. M. Pei.

3. Claude Simon
The French writer receives the Nobel Prize for literature.

4. Mikhail Gorbachev
The new master of the Kremlin is a modernizer. Gorbachev becomes general secretary of the Soviet Communist Party.

5. Simone Signoret and Orson Welles
The French actress and the American director and actor, seen here together, both die this

1989

In 1989, the Berlin Wall, erected in 1961, is destroyed forever. The collapse of the Communist world had not been forecast even by the greatest experts. Among those it catches by surprise are the Romanian dictator, Nicolae Ceausescu, and his wife, who try to flee. They are caught, summarily tried, and executed. The situation is very different in China, where television stations the world over broadcast an image of a single student blocking the way of a tank during the massacre in Tiananmen Square. In Iran, the Ayatollah Khomeini and the Shi'ite clergy pronounce a fatwa, or death sentence, on the British author Salman Rushdie for the "blasphemous" content of his book *The Satanic Verses*. A few months later Khomeini dies at the age of eighty-nine. In his lifetime, he has been responsible for the execution of 50,000 opponents of the regime and a million killed in the Iran-Iraq War. Soccer is still a killer: At the Hillsborough Stadium in Sheffield, England, police misdirect the crowd, and as a result 96 are crushed to death and hundreds are wounded. In France, new anti-smoking measures are introduced. In Paris, two major new buildings, the Opéra-Bastille and the Arche de la Défense, are inaugurated and the bicentennial of the French Revolution is an excuse for lavish celebrations. There are plenty of celebrity deaths in 1989, including the Emperor of Japan, Hirohito; the artist Salvador Dalí; and the writers Georges Simenon and Samuel Beckett. Bette Davis, the zoologist Konrad Lorenz, and the boxer Sugar Ray Robinson also die this year.

Opposite: Case of Château Haut-Brion.

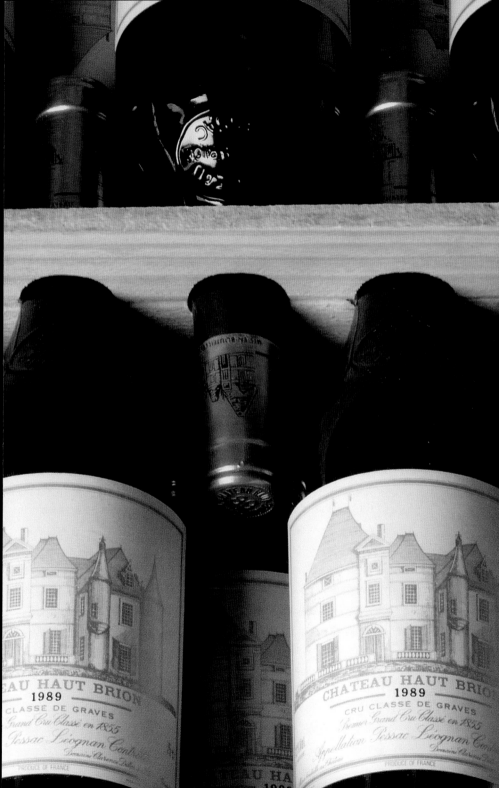

Château Haut-Brion 1989
Bordeaux – Pessac-Léognan

This is a symbolic estate, and one that is unique, because it is the birth-place of claret. In 1525, Jean de Pontac married Jeanne de Bellon. Her dowry included a vineyard at Haut-Brion on the site of the present vine-yard, which is now surrounded by the town, and whose grapes are har-vested by students from the nearby university campus. The Pontac family took more than two centuries to invent the claret we know today, a long time before the estates of Margaux, Latour, or Lafite, which also produce great Bordeaux wines and whose owners were once members of the assembly of lords in Bordeaux known as the *parlement*.

The Pontacs introduced two innovations. First, the practice of *triage au fin*, or drawing off the wine above the lees, meant that the wine was blended and refined. Second, by personalizing the wine which they offered under the name of Haut-Brion, they emphasized its origin and its uniqueness. Shortly after 1600, the Pontacs are said to have invented the concept of a *cru*, often mistranslated into English as "growth," which has become an indication of quality. They may have intended it merely to mean a brand name. Haut-Brion's fame soon spread to England, because in April, 1663, Samuel Pepys, bon vivant and diarist, wrote that he spent the evening at the Royal Oak Tavern, "where I partook of a variety of French wine called Ho-Bryan which had an especially good and unusual flavor the like of which I had never before encountered." This is the first time a claret is specifically mentioned by its brand name or *cru*. Wines had hitherto been identified only by the region from which they came—Graves, Médoc, etc. The Pontacs were clearly adopting this as a marketing strategy because, in

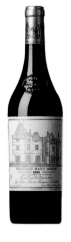

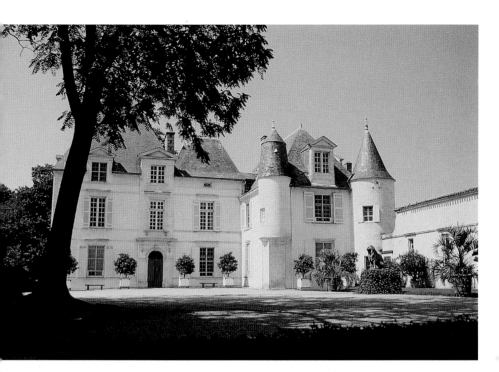

1666, they opened a luxury tavern-cum-grocery-store called The Pontac Head, at which they sold Haut-Brion. It became the haunt of London high society. Haut-Brion thus had a 30- or 40-year head start on the other *premiers crus* and sold its wine easily and very expensively. Even the French taxation authorities noted that the price of *vin Pontac* was 20–30% higher than that of the next most expensive wine. The fame of the Pontac family in England and the sensation caused by the wine were such that in 1677 the philosopher John Locke decided to go and visit the vineyard at Haut-Brion. Here he observed: "A west-facing rounded hill. The soil looks as though it were incapable of producing anything, consisting as it does of white sand mixed with a little gravel." This is an excellent description of Pyrenean Graves soil, which covers a large winegrowing area but does not alone account for the singularity and supremacy of Haut-Brion at the time. From the early eighteenth century, the best vineyards copied the Haut-Brion method and were known by their own names.

Subsequently, through marriage, Château Haut-Brion became the property of the Fumel family. The statesman Talleyrand bought it in 1801, then the estate

changed hands three times before it was acquired by American banker Clarence Dillon in 1935, at a time when winemakers were in crisis due to the Depression. Dillon's granddaughter, the Duchess de Mouchy, now owns this jewel, as well as the neighboring Château la Mission Haut-Brion. The 42 hectares are planted with Cabernet Sauvignon (55%), Merlot (25%), and Cabernet Franc (20%) at a density of 6,000 plants per hectare. Jean-Bernard Delmas, manager of the estate, equipped Haut-Brion with computerized vinification equipment and stainless steel vats and pipes, at the cutting edge of progress. The wine is fermented in vats for 40 days, and is then aged in new wood (like all the *premier cru* wines). It is then clarified, lightly filtered, and bottled in old-style flagon-type bottles. The year 1989 was a great one for all the wines of Bordeaux, even the dessert wines. This was the result of perfect harvests, which lasted from late September through late October. The red grapes needed more care than the whites, however, because the makers had to deal with three problems. Alcoholic maturity (due to the proportion of sugar) occurred

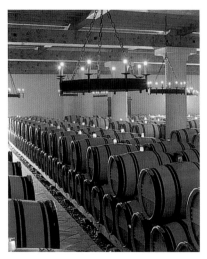

The winestores of the estate.

earlier than the phenolic maturity (tannins), so those who harvested too early missed the opportunity of creating a great wine. Furthermore, optimum conditions and late flowering without any damping off meant the harvest was abundant, almost untouched by the summer drought. Consequently, if harvesting was not performed early, the great potential of the 1989 vintage would be diluted. On the other hand, if the grapes were harvested too late, they suffered from one of the failings of which 1989 wines are often accused, namely too low an acidity level. One winemaker realized he had too many grapes and tried to concentrate the wine, but all he obtained was a diluted wine with low acidity. Haut-Brion's Jean-Bernard Delmas committed no such error. His early harvest was exemplary and he left the tannins to mature perfectly. The result was soon obvious. Long before it was bottled, the 1989 Haut-Brion was considered to be the best wine to have been vinified on the estate since 1961.

Organoleptic Description

How can such a perfect wine be described? 100% concentrated, 100% balanced, 100% harmonious, and 100% complex, with the addition of characteristics unique to Haut-Brion: a hint of smokiness and the balsamic touch contributed by masterful blending.

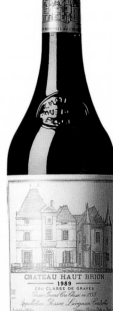

Secrets of Quality

Perfect grapes, yield problems overcome.

Availability

Star of the wine auctions and resellers.

Current Price

$1,300.

Apogee: 2000.

Comparable or almost comparable vintages: 1961, 1990.

Development: Drink within the next 20 years.

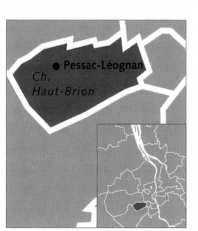

Weather Conditions

In 1989, the hot weather started early. The wine lovers who attended the Vinexpo trade show in Paris in June that year remember the unbearable heat (100°F), which led to the installation of air-conditioning in the Palais des Expositions. The white grapes were harvested before the end of August and the first red grapes were picked in early September. A few showers fell around September 10.

Barbaresco Sori San Lorenzo 1989
Italy – Piedmont

Italian viticulture has several distinctive features. The tradition is a long one and wines have been produced whose reputation has lasted over the centuries. Italy is the birthplace of European (and thus world) viticulture, but curiously, for nearly 2,000 years, there was no apparent desire to create great wines. It was not until the late nineteenth century that a grower first revived the production of quality wines. In practice, however, it was not until after World War II that Italian winemakers revived their dormant lands. The resurrection is due to a few prominent personalities with boundless energy, of which Angelo Gaja is the archetype.

Opposite: Bottles of Gaja.

The Gaja family left Spain and settled in Piedmont in the seventeenth century. In 1859, they began making and trading in wine, buying vineyards in the Barbaresco region and, according to custom, also buying grapes. In 1961, Angelo Gaja decided to move the family enterprise forward in a new direction. A few years later, he took the crucial decision to sell his wine only in bottles. In 1973, he tried unsuccessfully to sell his wine to the United States. Yet since 1970 he had had an important asset, a very skilled oenologist (chief cellarer), Guido Rivella, a winemaker whose talent was proved by the sequel. What is wrong with a Barolo and a Barbaresco? They are too hard, they contain too much tannin and too much acidity, and the end of the mouth is dry. Angelo Gaja, who was well-traveled and had tasted wines from all over the world, drew solutions that might seem paradoxical: namely, that yield per hectare should be halved and the

GAJA

BAROLO
ZIONE DI ORIGINE CONTROLLATA E GA

SPERSS
1990

%BY VOL., BOTTLED BY GAJA, BA
RED WINE, PRODUCT OF ITALY

GAJA

BARBARESCO
INAZIONE DI ORIGINE CONTROLLATA E GARANTITA

SORÌ TILDÌN
1990

harvest should be late, when the grapes were fully ripe. The fermentation and aging periods should be shorter, and the vats should be replaced by casks. It is no surprise to learn that in Piedmont, Angelo Gaja was taken for a madman, a criminal revolutionary who would ruin the region by imposing green harvests. Gaja took no notice and persevered.

His approach may seem to be illogical because reducing the yield would concentrate tannins; but in fact, reducing the yield per hectare balances the must, increasing the aromas without increasing the tannins, and improving the quality. Furthermore, he heavily scalded his casks to reduce their tannic contribution. (The water that poured out was very brown.) Aging in casks produced measured oxidation, something that is needed to make the wine "rounded."

Today, in addition to his Barbaresco vineyard, he has acquired a property in Barolo, and another at Montalcino, with a view to producing Brunello, as well as 70 hectares in the Bolgheri appellation—right beside the famous vineyards of Sassicaia and Ornellaia.

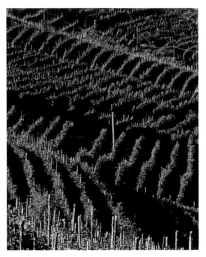

Vines on the estate.

Great wines are only achieved by discovering how best to use the land for vineyards. In the Barbaresco D.O.C.G., Angelo Gaja isolated three plots and vinified them separately. In 1967, it was the Sori San Lorenzo; in 1970, the Sori Tildin; and in 1973, the Costa Russi. All these wines were made from Nebbiolo, a very old and great grape variety native to Piedmont, which was used for making Barolo wines in the sixteenth century and even as early as the fourteenth century. Some claim it was even used by the Romans.

Organoleptic Description

Barbaresco Sori San Lorenzo 1989 of Gaja is a work of art. The robe is impressive and almost unmarked by the passage of time; the complex bouquet of very ripe—almost cooked—red berries marries with a touch of violet, smoke, and leather and tends to the dark and somber. The woodiness is not invasive and contributes a light, balsamic binding note to the aromatic components. The structure in the mouth is strong, the tannins being both thick and vigorous, ensuring that this slow-developing wine will have wonderful keeping qualities.

Secrets of quality

Limited yield, maturity, and vinification suited to the wine.

Availability

Variable, depends on the country. Not easy to find outside Italy.

Current price

$575.

Apogee: 2010.

Comparable or almost comparable vintages: 1961 (old style), 1988, and 1990.

Development: Should be drunk before 2030.

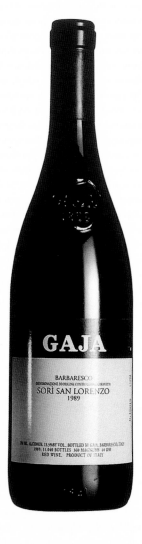

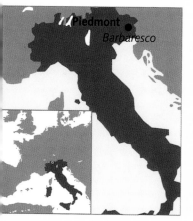

Weather Conditions

This type of wine deserves more in-depth study because it accumulates the greatest amount of tannins and maximum acidity, hence the importance of the exposure of the vines. Furthermore, it should be noted that Nebbiolo is a late-maturing variety, so it is vital that the fall weather is clement, even hot and sunny. This was the case with the 1988, 1989, and 1990 vintages.

Montrachet 1989 Burgundy

"Montrachet! Divine Montrachet! The first and finest among white wines …" Thus wrote the Marquis de Cussy in the nineteenth century. Montrachet, like Corton-Charlemagne, is one of the greatest dry white Burgundies. The two wines are historically—or legendarily—very different. Corton-Charlemagne took the name of the Holy Roman Emperor in 775, when the "clos Charlemagne" vineyard was donated to the collegiate church of Saulieu at Aloxe. According to legend, the vineyard also owes its white grape varieties to Charlemagne, because his wife, Barbe, hated seeing her husband stain his magnificent beard

Opposite: Entrance to the Château de Beaune estate.

with red wine! The history of Montrachet is not nearly so glorious or ancient. It was not until 1728 that the Abbé Arnoux, one of the greatest œnophiles of the period, noted its existence, claiming with complete justification that is was the "most unusual and delicate wine in France." Clermont-Montoison, who was a member of a family of noble lineage related to the Clermont-Tonnerres, realized the importance of the estate when he married the heiress to the barony of Boutière in 1710, and thus became lord of Chassagne and owner of the castle of Chagny. He added to his holdings by acquiring more land until he owned half of Montrachet. In 1776, a Clermont-Montoison married Charles de la Guiche, and half of Montrachet thus passed to that family. During the French Revolution, Charles de la Guiche was guillotined and his lands sold as national property, but the family eventually managed to buy it back. The family changed its name to de Laguiche after the revolution and still owns the entire estate, with

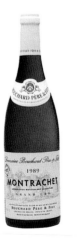

the exception of two hectares that were sold to Bernard and Adolphe Bouchard in 1838. This jealously preserved plot of land offers production conditions that are as perfect as they are rare, if not unique. But anyone looking for a picturesque hill at Montrachet will be disappointed. The word *rache* means "scurvy" or "bare," and the estate is indeed a bare hillock topped with one or two ragged trees. The vines grow lower down the hill. First there is the vineyard of Chevalier-Montrachet, then just below it the royal vineyard of Montrachet. It is in a balanced position; not too high and not too low. Bâtard-Montrachet is right next to it, covering the opposite side of the hill. As for the soil, the whole mystery of the wine is here. It is hard to explain because so many factors are at play that it would be impossible to list them all, especially as the way in which they interact increases the difficulty of doing so. The layer of topsoil is very thin. Just below it there are gravel and limestone alluvial deposits, and it is these that are of prime importance. There is much more active limestone (13%) here

Above: Cellar in the château.

Following pages: Montrachet *(left)*; Corton-Charlemagne *(right).*

than anywhere else in Burgundy. The stony soil ensures good drainage, reduces erosion, and stores the heat.

The Montrachet vineyard is split up and always was. The de Laguiche family owned half of it and they currently own a quarter, making them the largest landowners. Today, the firm of Bouchard owns less than a hectare because, in 1845, Adolphe, in a fit of generosity, donated his share of Montrachet to a female friend; this part now belongs to the Ramonet and de Laguiche families and the Boillerault heirs. The parcel of Montrachet which belongs to the firm of Bouchard is in the commune of Puligny-Montrachet, in the heart of Montrachet, between the Chevalier and the Bâtard. Harvesting is performed by hand and vinification in the traditional way: fermentation and aging, then racking in bottles.

Organoleptic Description

Visually, Montrachet 1989 is uniform in color. Aromatically, there are fragrances of honey and almond, with a woody aroma that is eventually predominant. The woodiness is also elegantly present in the mouth with power and suppleness. The construction is rigorous, with a measured nervosity that ensures balance and does not prevent the development of this wine as it reaches its apogee. It has a measured sagacity.

ecret of Quality

aturity of the grapes.

vailability

m cellars and wine
ctions.

rrent Price

t available in the
ited States.

Apogee:
2004.

**Comparable or
almost comparable
vintages:** 1983,
1985, 1992.

Development:
To be drunk before
2025.

Puligny-
Montrachet
Montrachet●

Weather Conditions

Heat may also be one of the secrets of Montrachet. There is a perfect south-southeastern exposure so that not a calorie is lost, from the first to the last rays of the sun. The vine is grown on a gentle slope whose wild flora are of a type found elsewhere only much further south. March 1989 was a particularly mild month, so the vegetative cycle began early. A cold spell in April slowed it down but the fine weather returned and flowering was early though prolonged. July was hot and stormy, but August was dry and the heat resulted in early harvesting (around September 15) under excellent conditions, producing a crop of healthy, ripe grapes.

1

2

1. Grande Arche de la Défense
Inauguration of the massive arch designed by Johan-Otto von Spreckelsen to house the Ministry of Defense in Paris.

2. Bicentennial of the French Revolution
A lavish parade is organized along the Champs-Élysées in Paris to mark the occasion.

3. Samuel Beckett
Death of the Irish poet and playwright, who wrote in both English and French.

4. Fall of the Berlin Wall
The demolition of the wall erected in 1961, symbolizes the collapse of the Communist bloc.

5. The Bejing Spring
In May, thousands of students demonstrated on Tiananmen Square, demanding freedom and democracy. On June 4, the military stepped in. The official death toll was reported to be 1,400, though there were nearly 3,000 casualities.

1990

Three major political events make 1990 a year to remember: the reunification of Germany, the Iraqi invasion of Kuwait, and the resignation of British prime minister Margaret Thatcher.

The first elections for the whole of Germany are held at the end of the year, which are won by Helmut Kohl and his Christian Democrat Party. Proof emerges that the alleged massacre at Timisoara, in Romania, was a ploy invented for television news purposes.

Lech Walesa, charismatic leader of Solidarity, is elected Polish head of state by an unsurprising 75% of voters.

Since the death of Tito ten years prior, Yugoslavia has become increasingly unstable. Serbia orders the dissolution of parliament and of the regional government of Kosovo, whose ethnic Albanian population has rebelled against Belgrade's authority.

Iraq's invasion of Kuwait in early August will unleash the Gulf War at the beginning of the following year. The United Kingdom and Argentina restore diplomatic relations, broken off during the Falklands War. Mikhail Gorbachev wins the Nobel Peace Prize.

The last of the subcompact 2 CV cars roll off the Citroën production line in France. Literature loses Alberto Moravia. In the United States, the psychologist Bruno Bettelheim dies, as do "the Barefoot Contessa," Ava Gardner, and the divine and mysterious Greta Garbo, who had not made a film since 1941.

Opposite: Bottles of Veuve Clicquot Champagne.

Veuve Clicquot Grande Dame 1990
Champagne

Opposite: Bottles of Champagne maturing.

Following pages: The Veuve Clicquot cellar.

The Widow Clicquot must be the most famous Frenchwoman in the world, after Joan of Arc. Her Champagne has won her great renown, amplified and sustained by her powerful personality, which was much ahead of her time. Her husband provided her with her first innovation by making her a widow—a distinction in Champagne. This gave her total autonomy over the estate, something that was extremely rare in 1805. At the age of 21, she married François Clicquot-Muiron, who worked with her father, a banker and draper who also dabbled in selling some of the wine produced at his vineyard in Bouzy. She had only been a widow for a few months when, at the age of 27, she founded the Veuve Clicquot-Ponsardin company, combining her maiden name with that of her late husband. She rehired Bohne, the cellarer, who had worked in the previous company and sold about 50,000 bottles a year. Veuve Clicquot ran her enterprise with great authority. She is alleged to have invented a type of table on which to shake the Champagne, forerunner of the triangular "school desks" (*pupitres*) that are now used. In fact, the tables had been invented about forty years earlier, but she is probably the first to have used them for "mass" production. It is even claimed that she "invented" pink Champagne, which she made a speciality of the house, a tradition that continues. However, it appears that in 1777 (a year before the future Madame Clicquot was born), Philippe Clicquot-Muiron, her future father-in-law, was selling pink champagne to his customers. After her husband's death, Nicole Clicquot continued to buy vine-

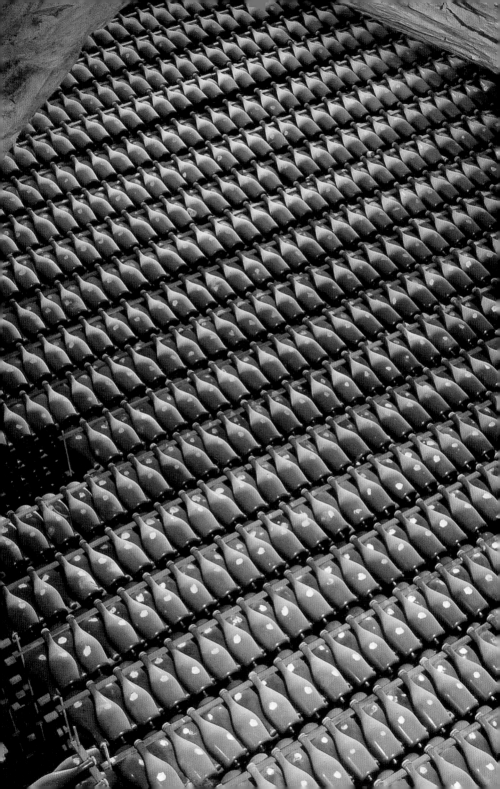

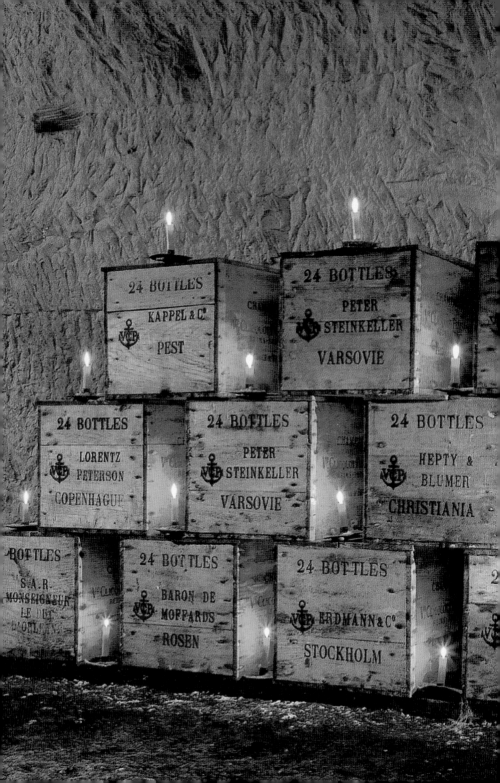

yards with astonishing discernment, and her holdings finally con-
stituted a huge vineyard as interesting in the diversity of its vines
as in their quality.

Her daughter married the Count de Chevigné, a charming man of
letters, who was sophisticated and delightful but a poor businessman,
and tried to involve his mother-in-law in various other enterprises, such
as banking and drapery, at the risk of compromising the prosperity of
the company. Fortunately, Madame Clicquot employed Edouard Werlé
as a business manager, who proved (unlike her son-in-law) to be an
excellent manager.

The estate prospered and was soon producing more than 500,000
bottles a year. The Widow Clicquot was very fond of her son-in-law,
and it was no doubt it was he who persuaded her to acquire the old
Château de Boursault and restore it into a magnificent castle
overlooking the Marne River. It is here that Madame Nicole Clicquot
died at the age of eighty-eight, after making all the arrangements
necessary to protect the interests of her
daughter and enable her firm to go to the
heirs of the Werlé family, with which she was
associated. For a century, the Werlés ran the
Veuve Clicquot-Ponsardin company with
great success, until it was acquired by the
LVMH group.

The year 1990 was an early one, and the
harvest was abundant. The musts were
surprisingly rich (10.7°) and nicely acidic (8
grams per liter), a sign of excellent Champagnes
to come. This was confirmed by the Cuvée
Grande Dame 1990, the result of a blend of the

Grapes used to
produce Veuve
Clicquot
Champagne.

eight best *grands crus*. Verzenay, Verzy, Ambonnay, Bouzy, and Ay
contributed the black grapes (61%); Avize, Oger, and Mesnil-sur-Oger
contributed the white grapes (39%). Obviously, it would have been
hard to do better. The Cuvée Grande Dame is a luxury champagne.

Organoleptic Description

The winemaker's maxim, "Give me good grapes and I will make you good wine," is amply proved by the quality of La Grande Dame 1990. The acidity stimulates the aromatic richness, and the carbon dioxide is perfectly integrated. The Champagne has a generosity, roundness, suppleness, and length in the mouth that contribute to its versatility. It can be drunk alone or with food, and it is full-bodied enough to blend well with numerous dishes.

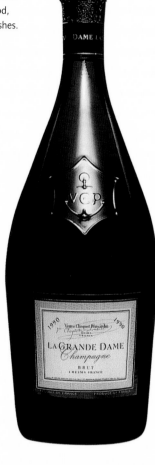

Secret of quality
Record amounts of sunshine.

Availability
Still being sold.

Current price
$225.

Apogee:
2000.

Comparable or almost comparable vintages:
1955, 1959, 1985.

Development:
Preferably to be drunk before 2005.

Weather Conditions

The year 1990 can be considered an early one. Budding began in late March and flowering in early June. The harvest began on September 11. Although there had been a frost in early April, the harvest was abundant (12,000 kilograms). The weather in July, August, and the first three weeks of September was ideal—to such an extent that the sunshine records for the previous 30 years were beaten!

1

2

1. Lech Walesa
The leader of the Solidarity trade union and winner of the Nobel Peace Prize in 1983 is elected President of Poland with 75% of the votes.

2. Channel Tunnel
On December 1, the French and British segments join up, marking the "end" of Great Britain's isolation as an island.

3. Greta Garbo
Death of the famous Swedish-born actress, nicknamed "the Divine."

4. Opéra Bastille
The new Paris opera house was opened to mark the 200th anniversary of Carlos Ott.

5. The Gulf War
Iraq invaded Kuwait and seized key positions on August 3. On November 30, the United Nations Security Council decides to intervene militarily to stop the Iraqi dictator Saddam Hussein and drive him out.

1994

1994

A severe earthquake hits the western suburbs of Los Angeles. Former president Richard Nixon dies. President Bill Clinton brokers peace in the Middle East by getting Israeli prime minister Yitzhak Rabin and PLO chairman Yasser Arafat to shake hands and sign an agreement. Rabin and Arafat share the Nobel Peace Prize with former Israeli prime minister Shimon Peres. In South Africa, Nelson Mandela is elected president, but genocide erupts in Rwanda. In Italy, media mogul Silvio Berlusconi becomes prime minister after his party, Forza Italia, wins an absolute majority in the lower house in late March. By the end of December, he is handing in his resignation to the Italian president when it looks as if his party will lose their parliamentary majority. Robert Hue is elected secretary-general of the French Communist Party. The Channel Tunnel is opened to passenger traffic, and France celebrates the 50th anniversary of the Normandy Landings, which liberated the country from German occupation. Playwright Eugène Ionesco, actor Jean-Louis Barrault, and singers Jean Sablon and Cab Calloway die, as do the painter Paul Delvaux, the medical researcher Linus Pauling, Jackie Kennedy-Onassis, and Pierre Boulle (author of *The Bridge over the River Kwai* and *Planet of the Apes*). American viticulture loses André Tchelistcheff, one of its founding fathers.

Opposite: A case
of Diamond Creek.

Diamond Creek Lake 1994 California – Calistoga

Mention American wines to a Frenchman and you are likely to provoke all kinds of contradictory, unpredictable, and often irrational reactions. Certain points should therefore be remembered in order to avoid false assumptions. America is like Italy, in that wine is made in 90 percent of the states. The oenology department of the University of California at Davis may not be the top in the world, but it is one of the best. Strangely, the United States is not among the so-called "new" producers of wines; American wines were winning medals in Paris exhibitions as long ago as 1900.

Prohibition—that great victory of American women, who were sick and tired of seeing their housekeeping money disappear into the saloons and of being beaten senseless by drunkards—gave rise to smuggling and speakeasies, and although it lasted for "only" 14 years (1919 through 1933) it was followed by the Depression that began in 1929, after which came World War II. For the United States, the caesura can thus be said to have extended for almost three decades. The true enemy of American viticulture, however, was phylloxera, a plague that no one knew anything about at the time. Without these plant-lice, the *Vitis vinifera* vines would have prospered as soon as Thomas Jefferson returned with them from France in the nineteenth century. The United States might then have explored what land was suitable for grape-growing and started producing quality wines. So it was not until after World War II that the vineyards of the United States came into their own.

Diamond
ek estate.

There is no point in dwelling at length on the pre-eminence accorded
to the grape variety: The subject is of marginal importance because a
wine is the product of a combination of the vine stock and the
territory. The proof is in the way that Al Brounstein worked his Napa
Valley vineyard, where the land has been divided into small, individual
parcels, with the aim of producing different wines in each, a policy he
pursued diligently. Brounstein, who died in 2006, was a gentleman
farmer and an aesthete. He embraced viticulture like some people
embrace religion, acquiring 16 hectares at the foot of Diamond
Mountain. He observed the geological diversity of the terrain and
decided to take advantage of it to produce a variety of wines, a very
Burgundian reflex. Diamond Creek produces four different wines:
Volcanic Hill, on 3.2 hectares of volcanic rock soil (full southern
exposure); Red Rock Terrace, on 2.8 hectares of iron-rich red earth
(north-facing); Gravelly Meadow, a vineyard located between the
previous two; and last but not least, Lake, so called because the vines
grow near a small lake. This parcel (32,300 square feet) is only one-
sixth the size of the Romanée-Conti vineyard. The grapes are only

vinified separately if the year is exceptional (as happened in 1978, 1984, 1987, and 1994). The yield is thus about 1,500 bottles, which are only produced once or twice a decade and it is the reason why Diamond Creek Lake is one of the rarest and most expensive wines in the United States.

Despite his Burgundian disposition, Brounstein did not choose to make Burgundy. He did not plant Pinot, which is only at home farther north, in Oregon. He has opted for Bordeaux vines, 88% Cabernet Sauvignon, 8% Merlot, 4% Cabernet Franc. The Lake parcel consists purely of Cabernet Sauvignon.

Unlike in the other vineyards, irrigation stops as soon as the new growing season begins, on April 25. Harvesting is by hand, permitting an initial grading process, and supervision continues because the stalks are also removed by hand. Vinification is Burgundy-style in wooden vats (though, unlike in Burgundy, the wood used is the local sequoia, or redwood).

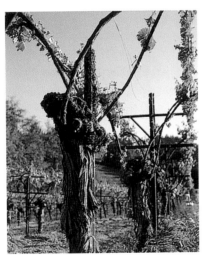

Vines growing near Calistoga, California.

Testing and measuring are performed every ten days. The liquid that runs off from the vats and the pressed wine are then mixed in wooden French hogsheads (new in the case of Lake, 50% new wood in the case of the other wines) and the wine is aged for almost two years and is drawn off four times. The final bottling is performed with complete respect for the wine, which is neither clarified nor filtered.

Organoleptic Description

Lake is all harmony and finesse. It has "grain" and its tannins are perfectly ripe, not harsh or astringent. It is complex, long, silky, supple, and totally civilized.

Secrets of quality

37.5 hectoliters per hectare, selection, soil.

Availability

Anyone who has bottles keeps them (production is limited to 1,500 bottles).

Current price

Not on the market.

Apogee:
Possibly 2006.

Comparable or almost comparable vintages: 1984, 1987.

Development: Slow.

Napa Valley
● Diamond Creek

Does it match up to the greatest of the great?

When Diamond Creek Lake 1994 was tasted and compared with a 1983 Château Lafite, Lake was found to be as good as a wine that has often been dubbed *premier des premiers*.

1

2

1. The Channel Tunnel
The Channel Tunnel was inaugurated on May 6 by French President François Mitterand and Queen Elizabeth II. The Eurostar now makes it possible to travel by train from London to Paris in two and a half hours. The trip through the tunnel takes 20 minutes.

2. Peace in the Near East
Signatories to the peace treaty brokered by President Bill Clinton, including Yitzhak Rabin (Israel), Hosni Mubarak (Egypt), and Yasser Arafat (Palestine).

3. Nelson Mandela
Nelson Mandela wins nearly 63 percent of the vote in South Africa's first postapartheid elections.

4. Conflict in Bosnia
Intervention of the U.N. blue berets.

5. Ayrton Senna
Ayrton Senna wins the Formula One Grand Prix in São Paulo. The Brazilian race car driver was killed in the same year on the Imola circuit, in Italy.

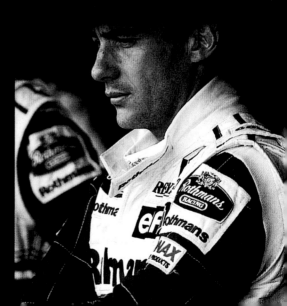

1995

Jacques Chirac, who had been defeated for the presidency of France in 1981 and 1988, finally succeeds François Mitterrand in the Élysée Palace. In Paris, a bomb explodes in the Saint-Michel subway station; the death toll is 7 and there are 110 injured. The government devises an anti-terrorist plan. In Japan, there is terrifying attack on the Tokyo subway by a religious cult using asphyxiating gas. There are 20 dead and 5,500 gas victims. Ukraine agrees to close down the Chernobyl nuclear power plant in return for $600 million in aid from the West. In Zurich, drug addicts are "expelled" from a park where they were tolerated hitherto. The Ebola virus ravages Zaire. Ireland holds a referendum to legalize divorce. In Poland, President Lech Walesa loses the election and is replaced by Aleksander Kwasniewski, an ex-Communist. Princess Diana gives a television interview in which she admits to having had extramarital affairs. The Queen expresses a wish that the royal couple divorce. Speculation by one of its agents in Singapore causes the venerable 200-year-old Barings Bank to liquidate. Emir Kusturica wins the Palme d'Or at the 48th Cannes Film Festival for his film *Underground*. The father of *musique concrète*, Pierre Schaeffer, dies, as do actress Lana Turner, pianist Arturo Benedetti Michelangeli, movie director Louis Malle, explorer Paul-Émile Victor, and veteran Formula One driver Juan Manuel Fangio of Argentina. Israeli premier Yitzhak Rabin is assassinated.

Opposite: Old bottles of Tokay in a cellar.

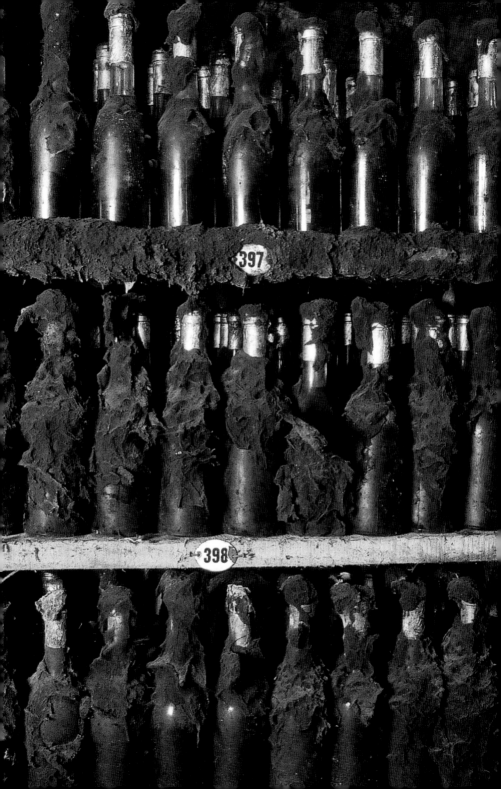

Tokay Aszü Oremus 1995 Hungary – Tokay

The mere name of this wine, which was the court wine par excellence, is worthy of respect. The Tsars of Russia and the House of Hapsburg owned vineyards on the slopes beside the Bodrog River. The river made a vital contribution because without it, *Botrytis cinerea*, the mold whose presence is indispensable for the vinification of a sweet dessert wine, cannot develop.

Tokay Aszü is one of the oldest dessert wines in the world (do not confuse dessert wines with sweet wines). It is made in a very special way which was described as long ago as 1631. The complex vinification has something in common with the methods employed in Rust to vinify the Ausbruch *(page 144)*, though the latter may have been devised earlier, and the process is reversed. The practice of vinifying botrytised grapes caused a religious dispute, since the Roman Catholic world refused to use "impure" rotten grapes, which were perfectly acceptable to the Lutherans. The process begins during the harvest. The Sauternes system of going along the rows several times, picking only the grapes that are rotten, is not practiced. Harvesting is late and the grapes are sorted at the end of each row using the "two-bucket" method used in Germany. The first bucket is reserved for completely rotten grapes, the second for the others. In the fermentation plant, the rotten grapes are loaded into an upright half-hogshead that has a hole at the bottom from which a very sweet juice flows. This juice is not the result of pressing, but of the weight of the grapes pressing on each other. This is called the *eszencia*. This very sweet liquid hardly ferments

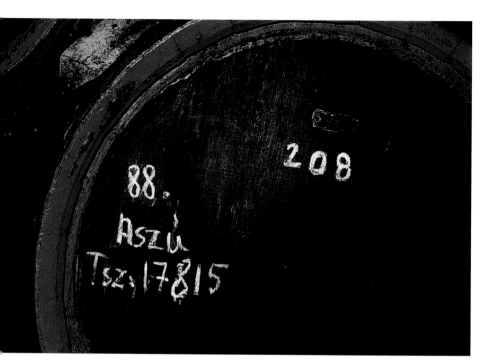

ks of Tokay
d.

at all, the degree of alcohol never exceeding 2 or 3°. It is thus not a wine, but rather a sugary, acidic liquid that can only be drunk in very small quantities (1 to 3 centiliters). Bottles of this nectar, this quintessence, are rare and very expensive. Tokay Aszü and Tokay Eszencia are the origin of the reputation of the wines of Tokay, which are vinified when the *eszencia* has run off. The grapes in the half-hogshead are pressed and worked until a paste is obtained, whose volume is measured in *puttonyos,* 25-liter containers. For a Tokay Aszü, the contents of between three and six *puttonyos* is added to the wine (the quantity is stated on the label); while if seven to nine *puttonyos* are used, the result is a Tokay Aszü Eszencia, the finest-quality wine.

Once vinified, the wine is aged in small wooden casks in tunnel-cellars dug into various parts of the countryside. The style of aging is quite unique and has been the subject of numerous discussions. For traditional aging, maximum oxidation is required. In order to achieve this effect, a little wine is removed from each cask so as to increase contact with the air. After three or four months, the casks are topped

up and aging continues for as long as 10 to 15 years. In the past, the half-liter bottles were stacked up and became covered in mold because the damp atmosphere of these underground tunnels favors their development. Nowadays, however, contemporary taste does not favor oxidation, so the oxidative phase has been abolished, as has the very long aging.

This historic wine and its vineyard had its share of problems during the second half of the twentieth century. Communist rule for more than 40 years left the cellars and vineyards in poor condition. The estates were nationalized, the vineyards produced on a single type of wine, and the cellars were completely emptied. Yet two great vintages emerged from this period, 1956 (ironically, since it was the year of the Hungarian uprising) and 1972. The wines were of very large provenance, however (probably too large), and excellent as they were, they could not reap the benefits of the very best soils. The 1956 was marketed by the Magyar Állami Pincegazdaság, as was the 1972, under

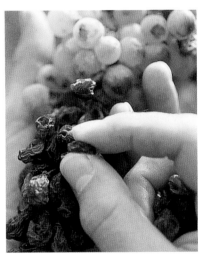

the name of Tokaj-Hegyalijai AG Borkombinát. Two other vintages, 1924 and 1931, also left an indelible memory. Unfortunately, all the genuine bottles of those years have disappeared, due to wars and aforementioned events.

The vineyards were denationalized in 1991, and European capital was plowed into reconstituting the estates, each of which once vinified their own wine.

These include the historic Oremus estate. It is from its vineyards that Tokay Aszü was born. This has nothing to do with the legends that explain the "invention" of Johannesburg dessert

Grapes affected by
Botrytis cinerea
(noble rot).

wines and Sauternes, which are fairly similar. In the case of Oremus, the story is well-documented. In 1630, Princess Zsuzsanna Lórántffy of Transylvania married György Rákóczy, crown prince of Upper Hungary. Among her vast properties was the Oremus estate, whose wines had the distinction of being labeled *prima classis*. The family pastor, Szepsy Laczkó Máte, of the University of Wittenberg, introduced the "aszü"

Organoleptic Description

This Tokay Aszü is the result of a traditional blend of 80 percent Furmint grapes and 20 percent Harslevelu, but it was vinified in the modern manner. The golden robe shows no signs of oxidation. This is confirmed in the nose by lively apricot aromas, which are not too sugary and are faintly spicy. In the mouth, the sugar-acid balance is exemplary. There is elegance, no hint of heaviness, and a long finale of very ripe citrus. A beautiful interpretation of an historic wine.

Secrets of Quality
Soil type and climate.

Availability
From specialist wine-sellers.

Current Price
$60.

Apogee:
From 2005 through 2010.

Comparable or almost comparable vintages: 1972 (old style), 1993.

Development:
Excellent when 30 years old and almost certainly beyond.

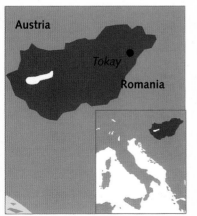

Austria

Tokay

Romania

Weather Conditions
May 1995 was a very sunny month, accelerating the vegetative cycle. The summer was hot and dry. In late September, a few gentle showers hastened the development of *Botrytis cinerea*. October was still sunny and dry, and the nights were particularly chilly. The first snows fell on November 17, while the vines were still green.

vinification method in 1612, and there is proof of production in 1631. The current vineyard was replanted after it was attacked by phylloxera, and again in 1964. To increase the density of plantation and improve the quality of drainage, it was replaced again in 1999 and the first harvest of these new grapes was in 2003.

In 1995, a large quantity of Aszü was harvested. The 1995 Tokay was made by adding six *puttonyos* to the basic wine of overripe grapes, meaning that there are six times 150 kilograms of Aszü grapes in six times 136 liters of must. After a ten-hour maceration, the Aszü paste is pressed. The must ferments for two months, then the wine is aged for 26 months in small oak barrels from Gonci with a 136-liter capacity. The wine is clarified by being drawn off two or three times, and it continues to mature in half-liter bottles. The syrup measures 11° on the Baumé density scale and contains 67 grams per liter of sugar (expressed as about "11 + 4").

Above: Tokay Aszü.

Opposite: A bottle of Tokay Aszü covered in mold.

1. Jacques Chirac
On May 7, Jacques Chirac was elected president of France. The prime minister, Édouard Balladur, another candidate for the office from the same political party, resigned.

2. Funeral of Yitzhak Rabin
The funeral of the prime minister of Israel, who was assassinated on November 4 by a young Jewish extremist, is held in Jerusalem.

3. Marie-José Pérec
On August 9, this athlete wins France's first gold medal at the World Athletics Championship in Gothenburg, Sweden, running the 400 meters in 48.028 seconds. She is seen here at the Atlanta Olympics in 1996, where she won two gold medals.

4. Terrorist attacks in the Paris Metro
A terrorist explosion at the St.-Michel commuter station kills seven and injures scores more.

5. Bibliothèque Nationale de France
France's new National Library is inaugurated on March 30 by President François Mitterrand.

1996

Boris Yeltsin is returned to office in Russia and Bill Clinton in the United States. NASA launches the *Pathfinder* probe of Mars with little fanfare. Claudie André-Deshays, the first Frenchwoman in space, completes a 16-day flight, 14 of them on board the *Mir* space station. Jacques Chirac suggests abolishing the draft in France. The United Kingdom in particular and the European Union in general are confronted with the problem of bovine spongiform encephalopathy ("mad cow disease"). Iraq barters oil for food in a U.N. agreement. A Boeing 747, flying between New York and Paris, explodes mysteriously over the Atlantic. In Afghanistan, after a two-year siege, the Taliban enters the capital, Kabul, and immediately introduces Muslim *sharia* law. In the United Kingdom, the divorce between the Prince and Princess of Wales becomes final. Belgium is traumatized by the Dutroux affair, in which a pedophile tortured and murdered countless children without being caught. Atlanta hosts the centennial Olympic Games of modern times. France wins the Davis Cup.

François Mitterrand dies at the age of 79. Michel Debré, who had been prime minister under de Gaulle and one of the founders of the Fifth Republic, dies in August. Marguerite Duras, Claude Mauriac, Maria Casarès, Marcello Mastroianni, Ella Fitzgerald, Marcel Carné, and René Lacoste also die that year.

Opposite: An ancient bottle of Krug Champagne with a stapled cork.

Krug 1996 Champagne

Krug is not the oldest nor the most powerful brand of Champagne, but it has immense prestige. The firm was founded in 1843 by Johann-Joseph Krug, who came from Mainz in Germany and had learned the art of running a cellar at one of the most prestigious firms of the time, Jacquesson of Châlons. He worked there for six years, married his boss's sister-in-law, and went to live in Reims, where he took over a wine merchant. Two years later, he decided to start making his own Champagne. He was skilled and his blends were so successful that he was asked to blend the Champagnes for other firms. Even today, the Krug vintage Champagnes are blended using the techniques established by him. The formula is 20% Cramant, 20% Vertus-Pierry, 20% Montagne de Reims, and 40% Ay-Bouzy.

Johann-Joseph Krug's talents have been inherited by his descendants. Henri Krug—the fifth generation—also excels in blending grapes from a variety of different sources in the Champagne region. Vinification in the traditional way in very small 206-liter casks contributes to the inimitable character of Krug, whose vintages are always awaited with excitement. The 1996 was made from rare grapes created in the happiest of conditions, because they benefited from 66 hours more sunshine than average (4% more).

Organoleptic Description

Here, as an example, are the data for two of the wines from which the Krug Cuvée 1996 has been made:
Verzy: 10.5° (alcohol) – 10.9 g per liter (acidity).
Ay: 11.2° (alcohol) – 10.3 g per liter (acidity).
Only the 1955 and 1928 vintages had such an extreme alcohol (sugar)/acid ratio. A tasting of the "clear wines," from which the Champagne is made before it effervesces, confirms the analytic data. These wines are as lively as they are powerful and presage a Champagne of great character that will age exceptionally well.

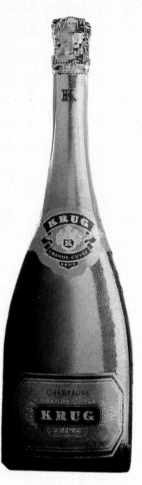

Secrets of Quality
Contrasting climate, richness, and acidity.

Apogee:
From 2003 through 2013.

Availability
Widely available.

Comparable or almost comparable vintage: 1928.

Current Price
$400.

Development:
Slow, drink before 2030?

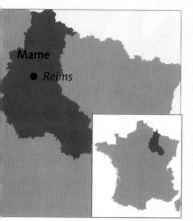

Weather Conditions

After a normal spring in which there was no frost, flowering began on the first day of the summer solstice. The weather was cool, followed by a long hot spell, which lasted from July 10 through August 15. A few showers prevented a drought. The first ten days of September were radiant. The grapes ripened. An unusual chill pervaded the vineyard, and the grapes were harvested in the second week of the month. Rain for the season showed a shortfall of just over four fluid ounces when compared with the mean. Only the years 1959, 1976, and 1985 were drier. Another important feature that creates great Champagne is the strong contrast between daytime and nighttime temperatures. This might explain why the grapes of 1996 were very ripe when harvested but were also highly acidic.

Ca' del Bosco Franciarcorta 1996
Italy – Lombardy

The French Champagne makers' representative bodies are excellent and extremely effective and they mercilessly hound anyone who attempts to use the magic term "Champagne" without having the right to do so. (There is no question that Champagne is the archetypal effervescent wine, a unique combination of finesse permeated with carbon dioxide.)

At the same time, the term "sparkling wine" has been so greatly abused that some makers have replaced it with the term *crémant*. Maurizio Zanella became interested in winemaking after visiting the Romanée-Conti estate. He immediately realized how important it was to make a fine wine. Taking Burgundy as a model, he planted a vineyard with a high density of Chardonnay and Pinot Blanc and Noir varieties in Lombardy.

In 1977, he decided to employ André Dubois, who for a while had been chief cellarer at Lanson, a Champagne maker, and proved to be of great help to Ca' del Bosco. A great adventure then began, which lead to the creation of a sparkling wine by applying the Champagne method to grapes from northern Italy.

Maurizio Zanella is an avowed perfectionist. He has his own analytical laboratory at which data for each wine, at all stages of vinification, are carefully recorded and compared.

Ca' del Bosco Franciacorta sparkling wine soon became one of the best Italian wines made by the *metodo classico*, which for several years now, no longer has the right to be called *méthode champenoise*.

Following pages: In the cellar.

Organoleptic Description

This blend consists of 45% Chardonnay, 25% Pinot Blanc, and 30% Pinot Noir. The soil is very porous, consisting of a glacial moraine of limestone, sand, and gravel. Vinification is performed in exactly the same way as in Champagne, including long aging on the lees, removing the deposit from the neck of the bottle, and replacing lost liquid. Never had the clear (still) wines attained such a degree of balance and concentration. The 1996 Ca' del Bosco Franciacorta finally went on the market in 2002. The prestige *cuvée*, Cuvée Anamaria Clementi, is presented in a special bottle. The wine is of great finesse and avoids the heaviness that can affect non-Champagne sparkling wines.

Vinification was particularly careful. While the wine was still in the process of alcoholic fermentation it was transferred to casks. Malolactic fermentation was followed by aging in wood for six months. When the wine was drawn off into bottles, it was left in cellars to age at a constant temperature of 54°F for five years. This long autolysis of the yeasts adds complexity to a wine already rich in spicy characteristics acquired during aging. This *cuvée* of Ca' del Bosco raises it to the first rank of sparkling wines in the world.

Secrets of Quality
Cool climate and perfect maturity.

Apogee:
From 2003 through 2005.

Availability
Not available in the United States.

Comparable or almost comparable vintage: 1991.

Current Price
No transactions.

Development:
Preferably to be drunk before 2010.

Weather Conditions
In 1996, flowering was uniform and rapid. Two hailstorms and a few thunderstorms in the summer made it a cool one, but the grapes were completely ripened and their juice very concentrated.

1. Bill Clinton
The president of the United States is reelected for a second four-year term. He is the first Democrat to be reelected president since Franklin Roosevelt (elected in 1932, 1936, 1940, and 1944).

2. Funeral of François Mitterrand
The former French president died on January 9. The funeral was held at Jarnac (Charentes), while a memorial service was held at Notre Dame Cathedral in Paris.

3. The British royal family
The Prince and Princess of Wales divorce.

4. Boris Yeltsin
The Russian president is reelected for four years on August 9.

5. Marcello Mastroianni
Death of the Italian film star.

Part Three

Vintages
from 2000 to 2008

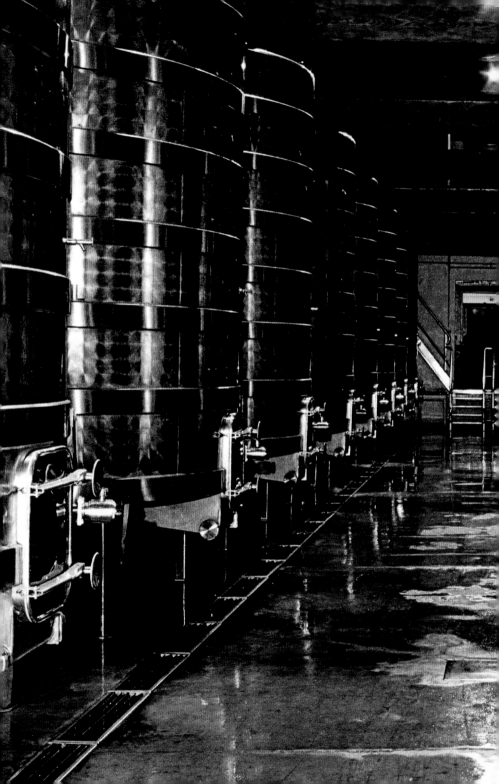

How does the twenty-first century differ from the twentieth?

In terms of its wines, the twenty-first century can be said to have begun around 1980. While previous centuries were exclusively European—apart from the great wines of Constancia in South Africa—the twenty-first century is global in terms of both production and consumption. Not only do five continents now produce good wine, they all seek to make great wines, and succeed in doing so. The myth of the great *terroirs* confined to Europe is no longer credible. Today's most dynamic oenological universities are in Australia (Adelaide) and California (Davis), and oenologists from the "new" wine-producing countries now work all over the world, including in Europe.

The European archetype is losing its edge for two reasons: Consumers outside of Europe are both greater in number and free of preconceived ideas about what wine should be like; and producers in the "new" countries work with local soil and climate conditions, which are often hotter than in Europe, resulting in wines that are fuller, more exuberant, and higher in alcohol content.

Does this mean we should speak of "new consumers"? The public tires quickly of flash and excess. After the success of over-woody, "pumped-up" wines with more strength than finesse, the expansion of producing areas toward cooler climes in both hemispheres (to the north and south, and also to higher altitudes), as well as a reduction in woodiness, does seem to indicate a new trend in consumer taste.

The following pages, which cover the early twenty-first century, feature classic wines, wines from far away, and wines from new soils (e.g. Toro) noteworthy for their type, they way they are made, and their quality.

2000

Although the year 2000 is not technically the first year of the twenty-first century, but rather the last of the twentieth, this does not dampen the planned festivities: Champagne flows, and the orders placed by wine traders turn out to be too large, resulting in surplus stock that takes all year to shift. At least the fears of a "Y2K" worldwide computer meltdown go unrealized.

Released from house arrest on medical grounds, General Augusto Pinochet leaves London for Chile. José María Aznar triumphs in the Spanish elections, and Vladimir Putin becomes president of Russia, as does Hugo Chávez of Venezuela, while George W. Bush, after a recount, is named the 43rd president of the United States. A Concorde airplane, pride of the Anglo-French aeronautical industry, catches fire and crashes shortly after taking off from Paris, killing 113. Damaged by an explosion, the Russian nuclear submarine *K-141 Kursk* is unable to resurface, and its crew dies of suffocation. The summer Olympic Games are held in Sydney. Obituaries for the year include; from the world of politics, former Italian prime minister Bruno Craxi, former Tunisian president Habib Bourguiba, and former French prime minister Jacques Chaban-Delmas; the literary world loses Pierre Bordas, José Cabanis, Michel Droit, Roger Peyrefitte, Jules Roy, and Barbara Cartland; and the film industry says good-bye to Austro-American actress Hedy Lamarr, French directors Claude Autant-Lara, Claude Sautet, and Roger Vadim, and British actor Sir Alec Guinness.

Preceding pages: Modern fermentation vats at Château de Pontet-Canet, Pauillac. *Opposite:* Stephan Von Neipperg tasting one of his wines—a Château Canon-la-Gaffelière from Saint-Émilion.

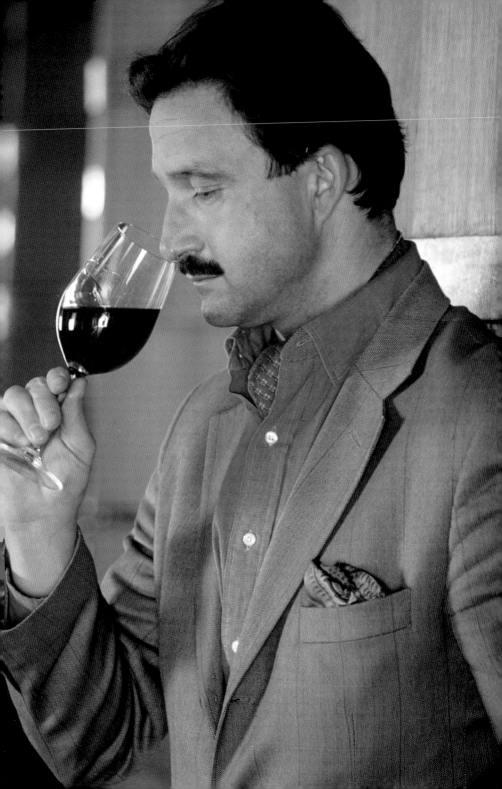

La Mondotte 2000 Bordeaux – Saint-Émilion

La Mondotte is the most recent addition to the *grand vin* category; its
first bottle bears the date 1996. It was an astounding success—the
American wine guru Robert Parker immediately gave it a score that
came close to top marks. Although this small vineyard is very new, it
already has quite a history. It was bought by Stephan von Neipperg,
the perfectionist owner of the Saint-Émilion *grand cru* Canon-la-
Gaffelière. Unable to incorporate his new vineyard into Canon-
la-Gaffelière for administrative reasons (they would not have been so
particular in the Médoc!), Neipperg decided to lavish special attention
on La Mondotte. With the help of consultant Stéphane Derenoncourt,
he drastically limited the yield (15–25 hectoliters per hectare), aged the
wine in new wood, and did not filter or clarify it. The result was that
his new Saint-Émilion actually outclassed his Saint-Émilion *grand cru.*
Owing to the young age of its vines, La Mondotte is not a *grand cru,*
but it sells for considerably higher prices. So can it be considered a
microchâteau, producing a *vin de garage?* The answer is no, for two
reasons: on the one hand the vineyard's size—four hectares—is on the
large side for "garage" production (an entirely unofficial designation);
and on the other, the vogue for garage wines has proved ephemeral,
whereas interest in La Mondotte has never waned.

Following pages:
View of La
Mondotte.

Organoleptic Description

A true Saint-Émilion, but a superlative one. Its 80% Merlot plus 20% Cabernet Franc brings gracious fullness and sensuality, with great aromatic complexity. The fine, delicate, but nonetheless plentiful tannins—without a hint of roughness—ought to inspire many producers. The drinker is delighted, and does not have to wait too long to enjoy a wine that will nevertheless keep for a lengthy period.

Secrets of Quality

Consummate cultivation of the vines, model vinification methods.

Apogee:
2010.

Availability

Rare: 12,000 bottles.

Comparable or almost comparable vintages:
1998, 2005.

Current Price

$370–550.

Development:
Can be drunk for up to 20 years.

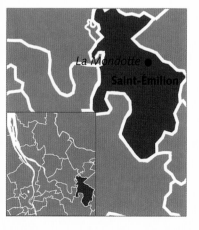

Weather Conditions

The growers had their work cut out for them, since it rained from February to May, which encouraged fungal diseases. Luckily June was dry and hot, which helped fight them. After more rain, the sun shone every day from July 20 to September 20. The harvest was carried out under good conditions in the second fortnight of September. The skins were thick (a sign of quality) but the merlots had fattened. Only vines that had been severely pruned maintained a high quality potential—which was the case at La Mondotte (25 hectoliters per hectare)—and a high sugar level.

1

2

1.100th birthday of the Queen Mother
On August 4, Queen Elizabeth the Queen Mother celebrated her centenary from the balcony of Buckingham Palace. Thousands of people came to salute her; at the time, she was the longest-lived member of the royal family in the monarchy's history (she was surpassed by Princess Alice, who died at 102 in 2004).

2. John Paul II's pilgrimage to Israel
In March, the pope begged Jews for pardon for persecution perpetrated by Christians.

3. Election of Vladimir Putin
Russia's new president, Vladimir Putin, arrives at the Kremlin May 7.

4. The year 2000
Minutes after a New Year's Eve fireworks display in Paris, the Eiffel Tower's counter flashed to 2000, ushering in the new millennium.

2001

For the first time ever, a probe—Near Earth Asteroid Rendezvous Shoemaker—lands on an asteroid, 433 Eros—at a distance of 300 million kilometers from the Earth. Another world first occurs in April: the legalization of marriage between persons of the same sex (in the Netherlands). In Belgrade, Slobodan Miloseviç is arrested. Blasting off from the Baikonur Cosmodrome in Kazakhstan, Denis Tito becomes the world's first space tourist. On September 9, Ahmad Shah Massoud, opponent of the Taliban regime in Kabul, Afghanistan, is killed by suicide bombers. But 2001's biggest event occurs on September 11, when four U.S. airliners are hijacked by terrorists. Two planes are flown into New York's World Trade Center, whose twin towers catch fire and collapse; another strikes the Pentagon; while the fourth—perhaps aiming for the White House?—crashes in Pennsylvania following heroic resistance from its passengers. Osama bin Laden and al Qaeda are rapidly declared responsible for the 3,000 deaths and $25 billion worth of destruction. Shortly afterward, the USA Patriot Act is passed. Nothing would ever be the same.

Obituaries include, at the beginning of the year, Greek composer Iannis Xenakis, as well as the French painter Balthus and singer Charles Trénet. In the United States, John Lewis, pianist and founder of the Modern Jazz Quartet, passes away, as does photographer Alberto Korda—best known for his iconic image of Che Guevara—in Paris. The year's end sees the death of the poet and first president of Senegal, Léopold Sédar Senghor.

Opposite:
View of Barbaresco
in Piedmont.

Barbaresco Rabajà Riserva 2001 Bruno Giacosa
Italy – Piedmont

Bruno Giacosa is the most highly esteemed producer in Piedmont.
Everyone who produces wine from Nebbiolo grapes—used for
Barolo and Barbaresco—knows he does it better than anyone.
When he buys grapes from a particular place, the wine he makes
from them is the best ever produced from that spot, earning him
the nickname "Professor of Nebbiolo."
His experience is deep: His father's trade was in grapes,
and on succeeding him Giacosa himself bought grapes from
which he made incomparable wines. After 60 years in the business,
Giacosa now owns two high-quality vineyards, Asili (Barbaresco)
and Falletto (Barolo). He makes wine the traditional way,
although his vats are stainless steel—an excellent material
for aging wine when properly handled, which is evidently the case.
He also ages his wine in casks called tuns, an old regional practice.
Like all great winemakers, Bruno Giacosa aims to "make the soil
speak," which in this wine he consummately achieves.

Following pages:
The vineyards and
village of
Barbaresco.

Organoleptic Description

Deep color, very spicy aroma, roasted touches, concentrated on the palate, tannins and acidity balanced but present. The roasted aromas become tarry, almost meaty flavors. Long, full finish with veiled bitterness.

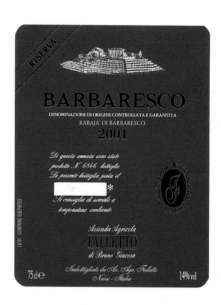

Secrets of Quality

Very high-quality vines, ideal vinification methods.

Availability

Internationally.

Current Price

$240–280.

Apogee: 2015.

Comparable or almost comparable vintages: 2000.

Development: Slow, can be drunk for up to 30 years.

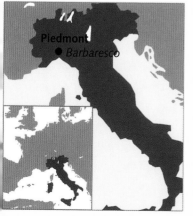

Weather Conditions

The conditions were average during the first half of the growing period. But, as the adage goes, *Août fait le moût* (August makes the must). Good weather arrived in August; the further the season advanced, the clearer it became that the 2001 Piedmont would be very good—even excellent—depending on the vines and microclimates.

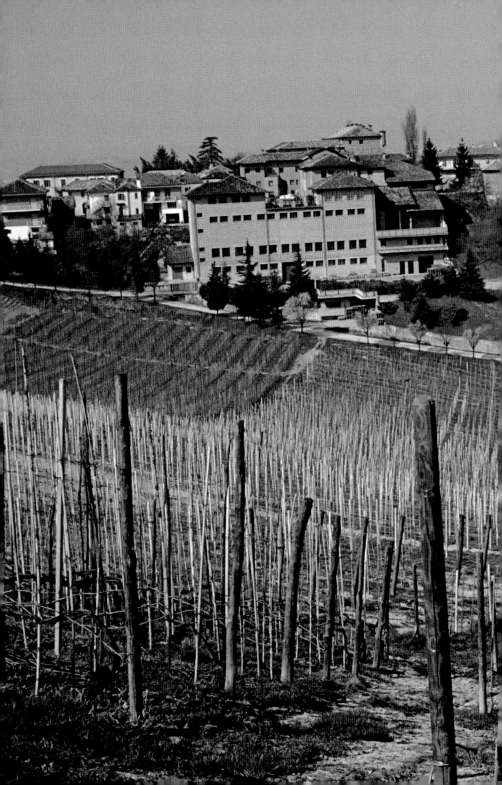

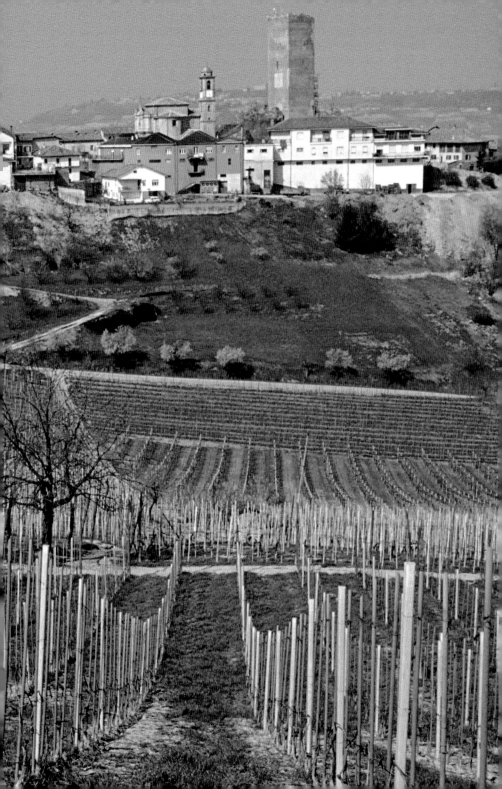

Te Awa Boundary 2001
New Zealand – Hawkes Bay

New Zealand comprises North Island and South Island, which are separated by the 30-mile-wide Cook Strait. The two islands' climates differ because they span, from north to south, a bit more than 900 miles, but both are home to vineyards. The 50-hectare Te Awa vineyard is located in the east of North Island in the Hawkes Bay area. Its precise locality is known as Gimblett Gravels because the land is composed of gravelly alluvium deposited by the old Ngaruroro River, thus providing well-drained soil conditions not unlike those of the Médoc. And as at the great European chateâux, each plot of land is harvested and vinified separately.

The winemaker at Te Awa is Jenny Dobson, who learned her trade in Burgundy under Jacques Seysse before becoming cellar master at Château Sénéjac, where she created Blanc de Sénéjac. Dobson spent 16 years in France and makes wine in the European way, creating elegant libations that are a far cry from those made in the powerful, concentrated Australian model. Her Boundary is very Bordeaux, both in its grape composition (82% Merlot, 15% Cabernet Sauvignon, and 3% Cabernet Franc) and in its spirit.

Vines at Te Awa,
Hawkes Bay, New
Zealand.

Organoleptic Description

No over-maturation, no over-extraction, no excessive alcohol, no indiscreet, attention-grabbing woodiness—Jenny Dobson seeks above all a wise balance and avoids easy enticements. Her Boundary takes total advantage of the fruity fullness of Merlot grapes, and the wine's finesse is due to a subtle tannin/acidity ratio that favors freshness over the softness that its body might have presaged.

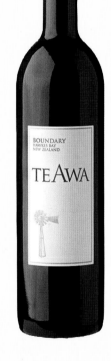

Secrets of Quality
Special soil conditions, vinification methods.

Availability
Widespread in the United States and the United Kingdom.

Current Price
$20–25.

Apogee:
2010.

Comparable or almost comparable vintages: 2000.

Development:
Drink now.

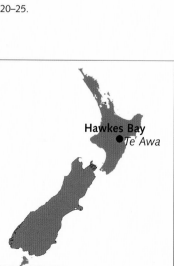

Weather Conditions

Frost can strike in the Hawkes Bay area, but is luckily limited by the ocean's proximity. The climate conditions are very similar to those in the Bordeaux region, although the soil-moisture regime differs, with the well-drained ground requiring drip irrigation. The 2000 and 2001 vintages escaped both frost and water shortages, and the alternating day/night temperatures contributed to the aromatic complexity.

1

2

1. Spacecraft lands on asteroid
NASA's NEAR Shoemaker spacecraft lands on asteroid 433 Eros on February 12 after a year in orbit, transmitting photos and data back to Earth.

2. Arrest of Slobodan Miloseviç
On March 31, the former president of Serbia and Yugoslavia surrenders to his country's special forces. This photo captures policeman arresting a demonstrator under the slogan, "Who is responsible?" outside a rally in Belgrade the next day.

3. World Trade Center attacks
A commercial airplane hijacked by terrorists crashes into one of the World Trade Center's Twin Towers in New York's financial district.

4. Same-sex marriage legalized
The Netherlands becomes the first country in the world to grant equal legal recognition to same-sex marriage. Sweden followed suit in January 2008. Here, Yvette Ramirez and Christina Branting at their June 30 wedding at a Lutheran church in Gothenburg.

2002

On January 1, the euro becomes the official currency in the principal countries of the European Union (with the exception of the United Kingdom). In Argentina, at the height of the financial crisis, Eduardo Duhalde is appointed president following his predecessor's resignation. January also sees the arrival of the first Taliban prisoner at Guantánamo Bay prison. On March 3, the U.N. welcomes its 190th member: Switzerland. April is eventful: the Netherlands legalizes euthanasia; Venezuelan president Hugo Chávez is arrested and imprisoned, but released two days later and restored to office; France is shaken by the results of the first round of its presidential elections— 19.86% for the Gaullist Jacques Chirac, 16.86% for far right leader Jean-Marie Le Pen, and 16.18% for Socialist Lionel Jospin. A fortnight later, Chirac is elected with 82.21% of the vote. In October, Jimmy Carter is awarded the Nobel Peace Prize, while Saddam Hussein wins a "landslide" referendum in Iraq. In Brazil, Socialist politician Luiz Inácio Lula da Silva is elected president. The French literary world loses Pierre Bourdieu, Pierre de Boisdeffre, René Étiemble, Jacques Fauvet, and Zoé Oldenbourg; show business says goodbye to François Périer, Henri Verneuil, and Billy Wilder; the art world sees the deaths of Jean-Paul Riopelle, Niki de Saint Phalle, and Roberto Matta; and the jazz world of Ray Brown and Lionel Hampton. In Britain, two members of the royal family die: Princess Margaret and the Queen Mother, at the age of 101. In addition, 2002 also sees the deaths of French general Jacques Massu and extremist Palestinian leader Abu Nidal.

Opposite:
The red barn at Frog's Leap, Rutherford, California.

Dr. Bürklin-Wolf
Kirchenstück Riesling Trocken 2002
Germany – Palatinate

The Palatinate is Germany's largest wine-producing region, located to the north of the vineyards of Alsace. In the late nineteenth century its reputation was greater than that of Rheingau and Mosel, but this is no longer the case. Following the recent increase in production of German reds, its renown is once more on the rise. Highly sought after for more than a century, Palatinate dry white Rieslings are generally produced

on small plots, and consequently in limited quantities. They differ from Rheingau or Mosel Rieslings in their rich, generous flavoring and their higher alcohol content, similar to Alsatian wines. Although Dr. Bürklin-Wolf's vineyards are large, the Kirchenstück plot covers a mere 3.5 hectares, in which the current owners possess only a few rows of vines! The vineyard's ideal orientation and clay soil bring unrivaled balance to the Rieslings produced there.

Above:
Vines at
Kirchenstück.

Following pages:
The rows are still
tilled by horse
(Lene, a mare).

Organoleptic Description

If ever the expression "golden wine" could be applied to a Riesling, it would be to Kirchenstück. Its color makes one think of rich, yellow gold, as does its full-bodied flavor. On both the nose and the palate it gives the impression of a perfect, classic balance, in contrast to the "nervous" inclination one expects from the region. Full fruitiness without sluggishness, a fine, fresh texture, and dryness without dominant acidity fully justify the oft-repeated slogan "the Montrachet of the Palatinate."

Secrets of Quality
Clay soil, ideal orientation.

Availability
Very rare.

Current Price
Few sales.

Apogee:
2010.

Comparable or almost comparable vintages: 2001, 2004.

Development:
Should be drunk before 2018.

Weather Conditions
The year was not an especially good vintage in Alsace, since undesirable precipitation harmed the ripening process. The Palatinate region, however, is protected by the Haardt Mountains, and is consequently dry and hot. In 2002 the grapes grown there were ripe and perfectly healthy, and the vintage excellent.

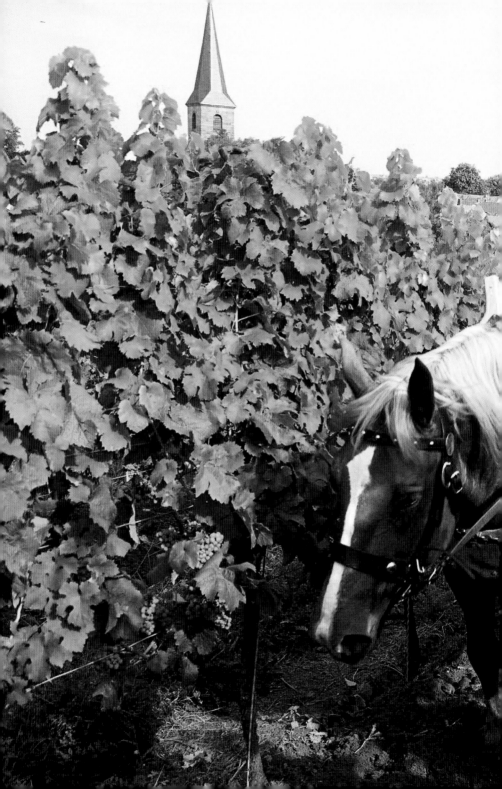

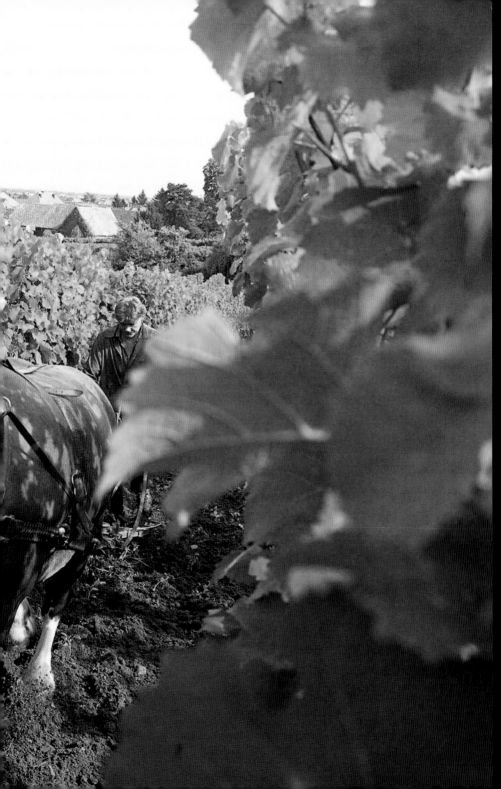

Frog's Leap 2002
California – Rutherford

Rutherford is a small American Viticultural Area (AVA) in Napa Valley, California. Only a couple miles square, it is located in the valley's heart and crossed by the Napa River, as well as by California's Highway 29. The first vineyards were planted here in the mid-to-late-nineteenth century, among them Gustave Niebaum's Inglenook winery, which now belongs to Francis Ford Coppola (who renamed it Rubicon in 2006). The area is also home to other old, illustrious vineyards, including Beaulieu and Caymus. This is no accident, of course; the quality of Rutherford's soil has long been recognized. Indeed, it is often said that the best Cabernet Sauvignons in the United States—and perhaps even in the world—find expression here. The parallels between Rutherford and the Médoc are striking, with both soils featuring alluvial gravel deposited by the rivers Napa and Garonne, respectively. In Bordeaux, the climate is tempered by the Atlantic, while Rutherford enjoys a median location between the coolness of Los Carneros and the baking heat of Calistoga. One of the founders of American oenology, André Tchelistcheff, defined the area's exceptional and characteristic Cabernet Sauvignons as being marked by "Rutherford dust," by which he meant a velvety, slightly mineral texture.

Frog's Leap is neither the largest nor the best-known vineyard in the region, but its origins stretch back more than a century. More important, it avoids the powerful, concentrated style of which the generous Cabernet Sauvignon grape is capable, favoring instead an elegant, fruity suppleness.

Organoleptic Description

Frog's Leap is a sensual wine that avoids the trap of slick woodiness. Its fruity fullness seeps into the fine texture, which is underlaid with red fruit. The paradoxical marriage of suppleness with veiled tannins contributes to the elegance of this most civilized wine.

Secrets of Quality

The soil, combined with solid but stylish vinification.

Availability

Limited.

Current Price

About $112.

Apogee: 2010.

Comparable or almost comparable vintages: 2001.

Development: Should be drunk now.

Weather Conditions

The summer was hot, but less so than the previous year. Frog's Leap's style does not suit extremes or over-ripeness.

1

1. Hugo Chávez imprisoned
The Venezuelan president is arrested and imprisoned on April 21 following a coup d'etat led by Pedro Carmona. He is freed two days later with popular support and the assistance of the presidential guard. This mural in Caracas was painted during his reelection bid against opposition leader Manuel Rosales in 2006.

2. Release of Ingrid Betancourt
Colombia's Revolutionary Armed Forces (FARC) kidnaps presidential candidate Ingrid Betancourt on February 23; her whereabouts are confirmed by television-news channel Noticias Uno in July 2008 and she is finally released after 2,321 days as a hostage.

3. Death of Niki de Saint Phalle
The French painter, sculptor, and film producer Catherine Marie-Angès Fal de Saint Phalle, photographed here in 1987 with her sculpture *Nana*, part of a series depicting domineering mothers.

4. New currency for Europe
In January, the European Union debuts its new currency, the euro, in its principal member countries—save for the United Kingdom, which maintains its pounds sterling. On January 3, this immense blue logo appears outside the European Central Bank in Frankfurt.

EXCLUSIVO

4

2003

The third World Water Forum is held in Kyoto, while in Iran the government confirms its cooperation with the International Atomic Energy Agency (IAEA) and announces its suspension of uranium enrichment. At the beginning of February, the space shuttle *Columbia* breaks up on its return journey through the Earth's atmosphere.

On March 20, the United States and United Kingdom air forces attack Iraq. Conquest is rapid; Saddam Hussein flees and disappears. By April 9, his 43 years of dictatorship are over. The end of May sees the last-ever New York–Paris Concorde flight. August is marked by a deadly heat wave that affects the entire European continent. Temperatures soar to record heights and 2003 is now remembered as the year of the heat wave. In Pakistan, Khalid Sheikh Mohammed, the "brain" behind the World Trade Center attack, is arrested. For the sixth time, Michael Schumacher becomes Formula One world champion. Former French president Valéry Giscard d'Estaing is elected to the Académie Française; two days later, Saddam Hussein is captured at Tikrit in Iraq.

Opposite:
The Mendoza wine region in Argentina. Snow covers the Andes Mountains, which slope down to the Catena Zapata winery.

Show business is hit by the deaths of Katharine Hepburn, Elia Kazan, Gregory Peck, and Leni Riefenstahl; likewise, musicians Benny Carter and Nina Simone exit the stage. The world of politics says good-bye to Pierre Poujade and the Ubu-esque Ugandan dictator Idi Amin Dada, while the father of the hydrogen bomb, Edward Teller, also dies this year.

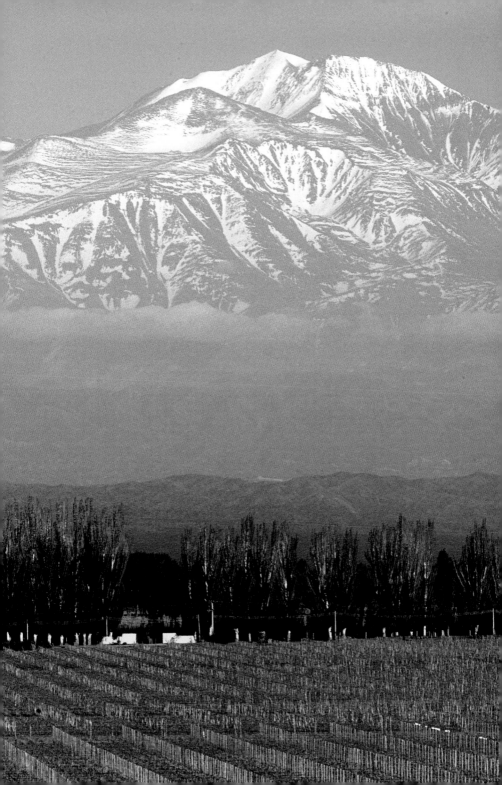

Nicolás Catena Zapata 2003
Argentina – Mendoza

The Catena family left Italy at the end of the nineteenth century and settled in Argentina. Practiced vintners, they made a good decision in choosing Mendoza, since the area was already known for its vineyards. They planted their first vines in 1906 and made wine "for thirst," like everyone at the time. But their business was a success, and by the late twentieth century had come to own several vineyards covering several hundred hectares. In the 1980s, while teaching agricultural economics at the University of California, Berkeley, Nicolás Catena met Robert Mondavi, from whom he learned specialized, modern, and very high-quality cultivation and vinification techniques. Back in Mendoza, he helped reform Argentine viticulture. As well as researching the root-stocks most suited to the different soils, he realized the harm caused by excess heat and consequently planted his Bordeaux, Burgundy, and Italian grape varieties at altitudes of 3,280 feet, 3,937 feet, and even 4,921 feet. His predilection was for Malbec and aging in French oak. Success was instant.

Catena's vineyards cover nearly 500 hectares, his ultramodern winery resembling an Aztec stepped pyramid. Over the years he has perfected his wines. They come from several vineyards, and are now made more complex by blending. His labeling has changed: The vineyard's name has disappeared in favor of the single word "Mendoza." The grape variety is listed when there is no blending (e.g. Catena Alta, Malbec), but the most sophisticated—and expensive—wine is a blend of Cabernet Sauvignon and Malbec labeled Nicolás Catena Zapata.

Following pages:
Aerial view of
Château Montrose.

Organoleptic Description

The color is reminiscent of the black wine of Cahors. Plentiful black fruit on the nose, harmoniously blended. Wood is discreet, balanced, and integrated. Nose aromas repeat on the palate; full body, supple. Fine, ripe, liquorish tannins. Long, persistent finish.

Secrets of Quality
Balance, freshness, elegance.

Availability
Exported to numerous countries.

Current Price
$90–100.

Apogee:
2013.

Comparable or almost comparable vintages:
1997, 2002.

Development:
Drink now.

Weather Conditions

The climate allows for full ripening, while the cooler nights at altitude slow ripening down, thereby developing the grapes' aromatic potential.

Château Montrose 2003 Saint-Estèphe
deuxième cru classé

This 70-hectare vineyard, which faces the Gironde River in the *commune* of Saint-Estèphe, was classified *deuxième cru* in 1855—quite a promotion, since it was only in the early 1830s that the brush-covered Montrose Heath had been partially cleared and planted with vines (35 hectares). Created by the Dumoulin family, who had acquired it in 1788, the Montrose vineyard was bought by Mathieu Dollfus in 1866. After his death it became the property of Jean-Jules Hostein, already the owner of Cos d'Estournel (lucky man!), and remained in the family until May 2006, though Hostein had sold Montrose to his son-in-law, Louis Victor Charmolüe, in 1896. Three successive Charmolües inherited the property until the last, after 46 successful years running the operation, sold it to Martin Bouygues. The vineyard is densely planted, with roughly 60% Cabernet Sauvignon and 30% Merlot. Vinification methods are very simple: stainless-steel vats, *remontages* (pumping of the must to the top, where it is sprayed onto the floating "cap" of skins), *délestages* (separation of the must from the cap, which later breaks down and liberates additional must from the sugar and polyphenols, after which the principal must is reinjected), three weeks' natural fermentation followed by malolactic fermentation (the latter still in the stainless steel), and finally a year and a half's aging in partially new (60%) barrels.

Organoleptic Description

The problem with powerful, ample, generous wines is avoiding uncouthness and instead striking a balance between the imposing structure and the aromatic compounds. The more masterful the wine the harder this balance is to achieve, but when it is struck the result is exceptional: concentrated without being ostentatious and possessing unrivalled persistence on the palate.

Secrets of Quality

The 2003 heat wave tempered by the Gironde River (Montrose is the vineyard closest to the water).

Availability

Wine auctions.

Current Price

$350–400.

Apogee:
2020.

Comparable or almost comparable vintages:
1989, 1990.

Development:
Slow.

Weather Conditions

The year is considered atypical and was likely to have been very problematic for French winemakers. After a rather cold spring, June, July, and August were exceptionally hot, the drought in certain regions causing stress to the vines that stopped all growth. Saint-Estèphe, most fortunately, was spared the hailstorm of June 24, and the red grapes were harvested very early, at the beginning of September, while the sun was still blazing. Alcoholic maturity (sugar) largely preceded phenolic maturity, making it difficult to decide exactly when to harvest—all the more so since over-ripeness is to be feared when acidity is low, which was the case in 2003. Without high-performance cooling equipment, it was impossible to make good wine that year.

Pintia 2003 Toro
Spain – Ribera del Duero

Toro is an appellation at the height of fashion, both in Spain and abroad. In fewer than ten years, this arid region and its wine have acquired a huge reputation that has attracted international (particularly French) wine growers and investors. And important ones, at that: Michel Rolland (world-famous oenologist), Bernard Magrez (owner of *crus classés*) and Gérard Depardieu (actor), Ferdinand Mähler-Besse (trader and owner of Château Palmer), and the Lurton brothers (international producers). Why such enthusiasm? The little medieval village of Toro, situated at an altitude of 2,132–2,624 feet, stands on the River Duero (known as the Douro several miles downstream in Portugal, where its banks are home to the country's best port- and red-wine-producing vineyards) which provides the name of the famous Ribera del Duero appellation, where Spain's greatest wine is made. A number of years ago, the owners of Vega Sicilia bought and planted vineyards at Toro, which possesses a midcontinental climate but offers the possibility of planting at altitude (2,460 feet). Vega Sicilia produces its Pintia four miles from Toro using Tempranillo—the great grape variety of northern Spain—known in the region as Tinto de Toro. The vines are planted without grafting, because the soil contains sufficient sand to prevent phylloxera from spreading. When the grape harvest arrives at the Pintia *bodega*, it is cooled to 40°F to allow three to four days' pellicular maceration (which, in 2003, was all the more useful since the weather was very hot). The vinification method is traditional and the aging process much shorter (and simpler!) than at Vega Sicilia.

Organoleptic Description

Very dark in color, Pintia begins with a woody note and continues with black fruit, sustained by its strong construction—a result of rigorous extraction methods—which nevertheless fails to dull the wine's freshness. This is probably in large part due to the cooling of the grape harvest.

Secrets of Quality

Altitude, cooling of the grapes.

Availability

International.

Current Price

Around $50–60.

Apogee: 2015.

Comparable or almost comparable vintages: 2001, 2002.

Development: Should be drunk now.

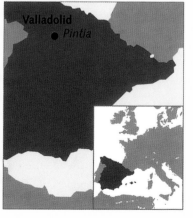

Weather Conditions

Spain did not escape the 2003 heat wave. Does this matter in an arid semi-desert where only 15 inches of rain falls per year? Because supplementary water must always be provided, it could almost be described as hydroponic cultivation. There is consequently never a ripeness problem, except that ripening must be slowed down to improve quality, hence the altitude at which the vineyards are planted.

FOX
NEWS
9:00 MT

1 EXAMPLE OF PUTTING HISTORICAL SITES IN DANGER

2

1. War in Iraq
On March 20, the United States declares war on Iraq, which it accuses of possessing weapons of mass destruction. President George W. Bush's offense is supported by the United Kingdom, Spain, and Italy, but absent real proof, many more countries refuse to join the coalition.

2. Beatification of Mother Teresa
On October 13, Pope John Paul II convenes a grand mass at St. Peter's Cathedral to posthumously bestow the humanitarian the title Blessed Teresa of Calcutta.

3. Year of the heat wave
Cracks in the dry bed of the Rhine River in Dusseldorf widen day by day.

4. SARS epidemic
Severe Acute Respiratory Syndrome, which first appeared in China in 2003, becomes a global epidemic.

5. Final flight of the Concorde
The October 24 flight from London to New York is the famed airliner's last.

2005

The year begins with the unveiling of the Airbus A380, a flying giant that weighs 560 metric tons when fully loaded. On January 5, French journalist Florence Aubenas is kidnapped in Iraq (and then released on June 11). The space probe *Huygens* lands on Titan, Saturn's largest moon. North Korea confirms that it possesses nuclear weapons, while Iran announces its decision to continue uranium enrichment. In Canada, marriage between same-sex couples is legalized. In the United States, Michael Jackson is acquitted of pedophilia charges. The International Olympic Committee chooses London for the 2012 games.

At the end of August, Hurricane Katrina strikes the southern United States, causing heavy flooding in New Orleans. Spanish racing driver Fernando Alonso is declared Formula One world champion. In November, tensions in Paris's suburbs boil over, resulting in three weeks' rioting, during which 10,000 cars are burned. Playwright Harold Pinter wins the Nobel Prize for literature.

Near the end of March, the Vatican announces that Pope John Paul II is dying; he passes away on April 2. A few days later, Prince Rainier III of Monaco also dies, as does King Fahd of Saudi Arabia. The literary world bids good-bye to three authors in August: Larry Collins, Pierre Daninos, and Arthur Miller; French theater loses Jacques Dufilho and Suzanne Flon; and at the end of September, concentration camp survivor and Nazi hunter Simon Wiesenthal also dies.

Facing page:
The winecellar at
Méo-Camuzet.

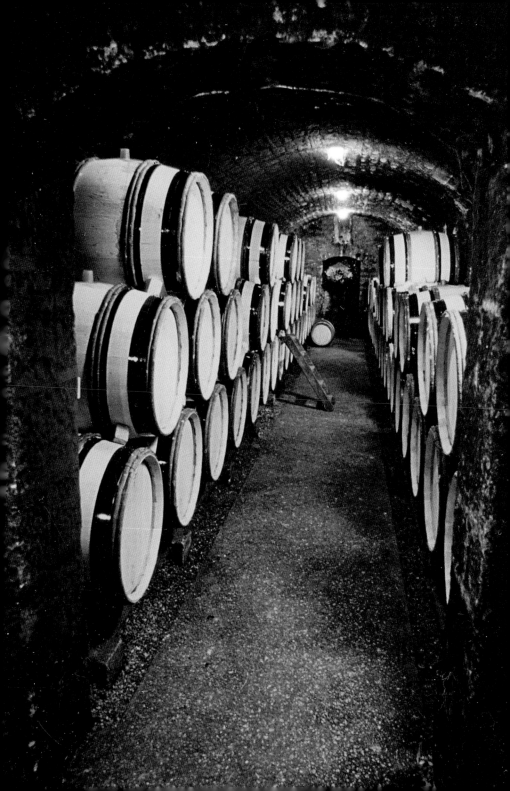

2005

Domaine Méo-Camuzet 2005
Burgundy – Richebourg

The *commune* of Vosne-Romanée is the pearl of the Côte de Nuits, if only because the most famous wine in Burgundy—and perhaps the world—is produced here: Romanée-Conti. The Romanée-Conti vineyard (which has just one owner) is separated from the Richebourg terrain by only a small path. Covering 8 hectares, 3 ares, and 43 centares, the Richebourg appellation is shared among eight proprietors, including the Domaine de la Romanée-Conti, which alone owns almost half! One important vintner in the area was Etienne Camuzet, who owned around 15 hectares, which included three *grands crus*: Clos de Vougeot, Corton, and a small plot of Richebourg. A graduate of the École Polytechnique and a member of de Gaulle's government, Camuzet was uncle to Jean Méo and father of Marie Noirot. On her death in 1959, Noirot left everything to her cousin Jean, hence the creation of the Domaine Méo-Camuzet. The winery was run by *métayers* (a term that roughly translates as "tenant farmer"), one of whom, Henri Jayer, became so famous a vintner that he was immortalized as a character in a Japanese *manga* comic. Until 1983 the wine was sold by volume on the market; six years later, Jean-Nicolas Méo, Jean's son, took over the business and, from 1993, conducted the vinification with the help of Jayer until the latter's retirement in 1998.

Following pages: The team at work in the Clos de Vougeot, Domaine Meo-Camuzet.

This Richebourg is made from Pinot Noir grapes that are grazed rather than trodden and, following Jayer's method, cold macerated prior to fermentation, which lasts three to four weeks. After a year-and-a-half's aging in new wood, the unfiltered wine is bottled.

Organoleptic Description

The color is dark for a Pinot. Strongly marked by red fruit on the nose, it explodes on the palate. The Richebourg "type" asserts itself through an ample, enriched fullness that contributes to its persistence. Because of the noticeable woodiness, one might be inclined to let the wine age in the bottle.

Secrets of Quality

The soil and Henri Jayer's vinification methods.

Availability

Rare: annual production of 1,300–1,400 bottles.

Current Price

About $2,300.

Apogee: 2020.

Comparable or almost comparable vintages: 2000, 2002.

Development: Drink in 2015.

Weather Conditions

The summer was sunny and very dry—so dry that the rain which fell around August 19 was extremely welcome, as growth might otherwise have stopped. The grapes' health was excellent, which was partly due to the cool nights and the north wind. Harvesting began around September 15–20 in good weather, which continued until the first days of October. Pinot Noir grapes have a thick skin—a guarantee of good extraction. Their sugar/acid ratio is favorable and their alcohol level largely sufficient.

1

2

3

4

1. **Death of Prince Rainier III**
Prince Rainier passes away at age 81 on April 6, and his son ascends the throne. Here, Albert of Monaco salutes the flag from the balcony of his palace, November 19, 2002.

2. **Hurricane Katrina**
This satellite image from August 31 shows Hurricane Katrina gathering force as it approaches land. It was one of the most powerful and far-reaching storms to hit the United States.

3. **Marriage of Prince Charles**
The Prince of Wales and Camilla Parker Bowles (in a silk dress by Robinson Valentine and a hat by Philip Treacy) were blessed in marriage at a benediction ceremony at Windsor Castle.

4. **Airbus 380 launched**
All the technicians pose under their newest plane, the Airbus 380, after the official launch of the biggest civil airliner, with a capacity of 853 passengers.

5. **Death of Jean Paul II**
On April 2, Pope Jean Paul II dies. He is shown here delivering a mass at the airport in Maastricht during an official visit to the Netherlands.

5

2008

In January, oil prices cross the $100-per-barrel mark. On the 15th, New York–based finance house Citigroup announces $10 billion of "subprime" losses; the following week, the world's exchanges suffer a "black Monday"; three weeks later, French bank Société Générale reveals that one of its traders has racked up losses of 5 billion euros. In February, Fidel Castro, suffering from long-term ill health, retires as president of Cuba, leaving power in the hands of his brother, Raúl, whom the national assembly elects as president shortly afterward. The Olympic Games open in Beijing against a backdrop of tension in Tibet. In Zimbabwe, Robert Mugabe is returned as president in sham elections. And in November, the United States celebrates the historic victory of its first African American president, Barack Obama.

In Bordeaux, scientists pioneer the use of a particle accelerator to determine the age of a wine bottle without uncorking it. The new method dates the glass, unlike the cesium-137 technique, which dates the wine itself (the bottle must be open) and could not be used for vintages prior to 1950.

At the beginning of the year, the first man to conquer Everest, New Zealander Edmund Hillary, dies, as does the American chess champion Bobby Fischer. The world of literature loses Michel Bataille, Aimé Césaire, Alain Robbe-Grillet, and Aleksandr Solzhenitsyn; the arts, couturier Yves Saint Laurent and artist Robert Rauschenberg. The world of viticulture mourns the death, at 94, of Robert Mondavi, pioneer of high-quality wine production in the United States.

Facing page:
The cellar at
Pol Roger.

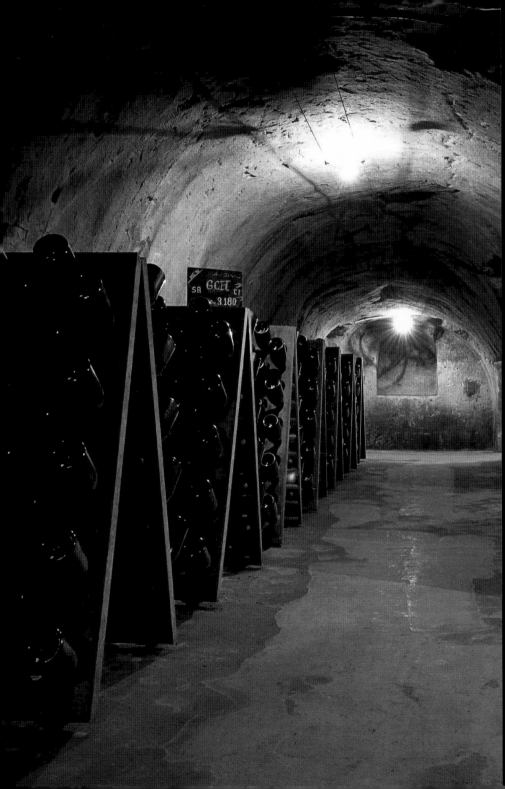

2008

Pol Roger 2008
Épernay

Founded in 1849, Épernay-based Pol Roger has the particularity of being one of the few Champagne houses still in family hands, its founder's direct descendants overseeing its management. The business comprises 85 hectares of vines in the Épernay and Côtes des Blancs areas, as well as nearly 23,000 feet of very deep, very cool cellars. Right from the start, Pol Roger conquered the English market, its most famous patron none other than two-time British prime minister Winston Churchill, who is supposed to have said, "I am a man of simple taste: I am easily satisfied by the best." Not only was Pol

Roger his favorite Champagne, he also named one of his racehorses after it! In homage to the great man, Pol Roger christened its vintage *cuvée spéciale* "Sir Winston Churchill."

In France, but also in Spain and Italy, 2008 was considered difficult, anomalous, and incongruous. Frequent rainfall disrupted ripening of the grapes and encouraged

Above and following page: Bottles of Pol Roger.

different types of mildew. In Champagne, the fact that the summer was slightly cooler than average preserved the grapes' health, which was excellent—an essential condition for producing sparkling wines. The coolness ensured the necessary acidity, and the season's end brought perfect ripening of around 9.5–10° of alcohol, ideal for a great Champagne.

Organoleptic Description

Still in the process of production, this wine already promises to assert itself through its lively balance, marked by a freshness that is a guarantee of poise. The abundant red fruit is seconded by a peachiness resulting from a strong majority of Pinot Noir. A long, ample, creamy wine.

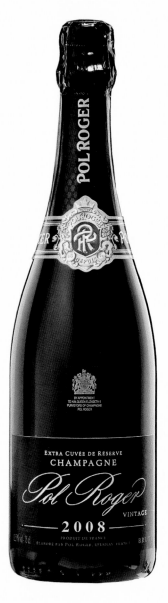

Secrets of Quality

Strong acidity and a good degree of alcohol.

Apogee: Presumably towards 2020.

Availability

Probably not before 2013.

Current Price

Not yet on sale.

Comparable or almost comparable vintages: Close to a 1996, but fruitier.

Development: Impossible to say as yet.

Weather Conditions

This northern region is sometimes favored by the elements, but the type of wine produced here is perfectly adapted to its latitude. In 2008 acidity was strong—9.5 to 9.9 (5.56 after malolactic fermentation and cooling)—and alcohol content sufficient (11° in the finished wine).

1

Living with Cancer
The changing science

Beyond Baghdad: Where The Enemy Has Its Own Surge

The Sopranos' Last Song: What Exit Will Tony Take?

TIME
SPECIAL DOUBLE ISSUE

The Global Warming Survival Guide
51 Things You Can Do to Make a Difference

2

3

4

Pétrole : nouveau record

Prix du baril "light sweet crude" à New York
1 baril = 158,98 litres

102,08* $
27 février 2008

100

58,32 $
3 janvier

80

50,48 $
18 janvier

60

40

*échanges électroniques
précédant la séance

2007 08
J F M A M J J A S O N D J F

5 NEW YO

THE PANI
OF 2008

WALL STR
TO D

SURV

THE HOWL OF THE
3 MILLION DOLLAR MAN

1. Global warming
The April 9, 2007 cover of *TIME* warns of increasing heat, and 2008 is among the ten hottest on record.

2. Death of Robert Mondavi
The American viticulturist, who dies this year at the age of 85, appears here at on his 2,000-hectare vineyard in Napa, California.

3. President Barack Obama
On November 4, the new American president, Barack Obama, emerges victorious at Chicago's Grant Park.

4. Oil prices catch fire
On January 2, oil reaches $100 a barrel, its highest price in history.

5. Financial crisis
The subprime mortgage crisis in the United States unleashes a domino effect among the world's markets and investors, reports *New York* magazine.

6. Olympic Games in Beijing
The opening ceremony is held August 8 at China's new National Stadium.

7. Death of Yves Saint Laurent
The French designer, shown here at home with his portrait by Andy Warhol, passes on.

Other Remarkable Vintages, 1900–2000

This book would be incomplete without a brief mention of some of the other outstanding wines that have graced the history of winemaking in the twentieth and early twenty-first centuries.

Two criteria were observed in compiling this list. One, in the interest of breadth, mention of a winemaker discussed elsewhere in the book has been avoided where at all possible. Likewise, uniformly great vintages for French wines, such as 1945 and 1961, have been omitted in order to highlight particularly successful vintages made during less-spectacular years.

BORDEAUX

Médoc
• *Margaux*
Château Palmer 1929, 1945, 1961
• *Saint-Julien*
Château Léoville Las Cases 1928, 1929
Château Ducru-Beaucaillou 1921, 1929
Château Beychevelle 1928, 1929
• *Pauillac*
Château Mouton Rothschild 1920
Château Pichon Longueville Comtesse 1918
Château Lynch Bages 1955
• *Saint-Estèphe*
Clos d'Estournel 1926, 1928
Château Montrose 1920, 1921
Château Calon Ségur 1916, 1926

Saint-Émilion
Château Ausone 1906, 1943
Château Canon 1955, 1989
Château Figeac 1906, 1950

Pessac-Léognan
Château Pape Clément 1953, 1959
Domaine de Chevalier 1928, 1953

Pomerol
Château Lafleur 1947

Sauternes
Château Climens 1908, 1937, 1949
Château Coutet, Cuvée Madame 1943, 1949
Château Suduiraut 1959, 1989
Château la Tour Blanche 1921, 1990
Château Gilette, Crème de Tête 1937, 1947

BURGUNDY

Chambertin (producer: Leroy) 1969
Clos de Tart 1985
Echezeaux Jayer 1985
La Tâche 1945, 1953
Corton Clos des Cortons Faiveley 1980
Corton-Charlemagne (producer: Bonneau du Martray) 1985
Corton-Charlemagne (producer: Louis Latour) 1989
Pommard (producer: Hubert de Montille), various climates 1989
Puligny-Montrachet "Les Pucelles" (Domaine Leflaive) 1978
Chevalier Montrachet (Domaine Leflaive) 1983
Bâtard-Montrachet (producer: Étienne Sauzet) 1989
Montrachet (producers: Comtes Lafon) 1990

ALSACE

Remarkable vintages: 1921 and 1929, 1937, 1945 and 1949, 1953 and 1959, 1971 and 1976, 1983–1985 and 1989, 1990
Notable producers: Zind Humbrecht, Marcel Deiss, Trimbach, Domaine Weinbach (Faller), Boxler, Landmann, Ostertag

CHAMPAGNE

Roederer 1949, Cuvée Cristal 1959
Dom Pérignon 1981
Dom Ruinart 1988
Taittinger Comtes de Champagne 1979, 1985
Krug Clos du Mesnil 1979
Billecart-Salmon, Cuvée NF 1959, 1961
Pol Roger 1911, 1921
Charles Heidsieck Royal 1966
De Venoge, Cuvée les Princes 1976, 1979

PORTUGAL (port)

Quinta do Noval 1931
Graham 1935
Warre 1945
Dow 1963
Fonseca 1977
Sandeman 1985
Cockburn 1927

GERMANY

Remarkable vintages: 1911, 1921, 1937, 1945 and 1949, 1953 and 1959, 1971, 1983, 1990

Notable producers:
von Schubert (Maximin Grünhäuser Abtsberg), Dr. Thanisch (Bernkasteller Doctor), Schloss Johannisberg, Bürklin-Wolf (Wachenheimer Gerümpel), J. J. Prüm (Sonnenuhr), Langwerth von Simmern (Erbacher Marcobrunn), Staatlichen Weinbaudmänen (Niederhausen-Schlossböckelheim)

ITALY

Remarkable vintages: 1964, 1971, 1975, 1985, 1990

Notable producers:
Piedmont: Ceretto, Aldo Conterno, Bruno Giacosa
Tuscany: Fratelli Antinori (Tignanello, Solaia, Ornellaia), Col d'Orcia. Tenuta Il Poggione, Villa Banfi

HUNGARY

Remarkable vintages: 1924, 1931, 1956 and 1972 (two vintages which were unfortunately vinified by the state farm), 1993, 1995

Notable producers: Hétszölö, Diskökö, Mégyer, Pajzos, Oremus

AUSTRIA

Remarkable vintages: 1963, 1981, 1993

Notable producers: Feiler-Artinger, Harald Kraft, Friedrich Seiler, Heidi Schröck

Remarkable Vintages of the Early 2000s

BORDEAUX

Médoc, Saint-Émilion, and Pomerol:
2000, 2001, 2005

Sauternes:
2000, 2005

BURGUNDY

Reds: 2003, 2005

Whites: 2005

CHAMPAGNE

2005, 2008

PORTUGAL (port)

vintage 2002, 2003

GERMANY

Dessert wines: 2002

ITALY

Piedmont and Tuscany:
2001, 2005, 2006

SPAIN

Ribera del Duero and Toro:
2004, 2007

SOUTH AFRICA

2000, 2001, 2003

UNITED STATES

Napa: 2001 (the driest in 126 years)

Glossary

Aging
Between decanting from the fermentation vat and bottling, the wine is placed in another vat or cask where it is allowed to mature. The period, which may last from a few months to several years, is called the aging period.

Alcoholic fermentation
Conversion of the sugar content of the must into alcohol by means of the microorganisms that cause fermentation.

Ampelography
The science of the vine. One of its aims is to identify grape varieties. An ampelographer is a winemaking expert and historian.

Anthocyanes
Phenolic composite that gives red wine its color.

A.O.C.
Abbreviation for "Appellation d'Origine Contrôlée." This distinction is granted to French wines made from grapes cultivated within a strictly defined district according to codified methods and vinified according to local custom.

Appellation
A designated wine-producing region that conforms to rules and regulations established by the government to ensure quality. Appellations are expressed as A.O.C.s (France), D.O.C.s (Portugal), D.O.s (Spain), D.O.C.G.s (Italy), and A.V.A.s (United States).

Assemblage
Blend of wines of the same origin, usually from the same estate but from different grape varieties or different parcels of land. The great wine is created by blending, and the second wine with the remainders.

Ausbruch
Type of Austrian dessert wine.

Auslese
Late harvests. Used in reference to sweet or dry German wines.

A.V.A.
Abbreviation for American Viticultural Area. Unlike the French appellation A.O.C., A.V.A. designates only that 75% of a wine's grapes come from a particular area.

Beerenauslese (BA)
Type of German dessert wine made from a late harvest, usually affected by noble rot.

Bentonite
Fine powdered clay used for refining wines.

Blanc de blancs
White wine made from white grapes.

Blanc de noirs
White wine made from black (red) grapes.

Botrytis cinerea
Fungal infection responsible for the gray mold so damaging to the quality of wine but which under certain special conditions can cause brown, or noble, rot, which is essential for creating the great white dessert wines.

Cap

The solids floating on the surface of the must or wine as it ferments and matures in vats. They consist mainly of skin, seeds, and pulp. The cap is sprayed to release its color and aromatic content.

Carbonic maceration

Vinification method for grapes that have not been trodden (Beaujolais, for example).

Chaptalisation

Operation consisting of increasing the degree of alcohol in the wine by adding sugar before or during fermentation. Chaptalisation is strictly regulated in France and it is forbidden in wines from the Midi.

Clonal selection

Selection of plants that are genetically identical.

Clone, cutting

Plant obtained by selection for the purpose of asexual propagation.

Collage, clarification

Procedure designed to clarify wines by collecting and discarding the residues in suspension in the bottom of the vat. A colloid (egg white, bentonite, etc.) is added to the wine to encourage precipitation of the deposit.

Cru

French term roughly meaning "growth," also used as a method of ranking within an A.O.C. In France, a wine's specific provenance determines its classification as a *grand cru, premier cru, deuxième cru*, etc.

Cryoextraction

Technique for concentrating the juice by freezing the berries. It is an artificial method of reproducing the effect of frost on the grapes, one which occurs naturally in the German and Canadian vineyards that make Eiswein.

Cuvée

Name given to a particular fine wine. In Champagne the word "Cuvée" on the bottle indicates that the wine was made from the first pressing; elsewhere, it may denote a particular blend of wines.

Cuvaison

The period during which the must ferments in the vat. Variables include length of time and temperature.

Decanting

Transferring wine from a bottle to a carafe, flask, or decanter, in order to leave the lees in the bottle and aerate the wine.

Disgorgement

Removal of the deposit that forms in bottles of sparkling wine by extracting it through the mouth.

D.O.

Denominación de Origen in Spain.

D.O.C.

Denominacion d'Origine Controlada in Portugal.

D.O.C.G.

The highest appellation in Italy.

Dosage

Addition of liquor (wine and sugar) to bottles of sparkling wine to top them up after disgorgement. If wine alone is added, the wine is said to be "non-dosed," for which the official description is *brut nature.*

Dropping off, wilt

Failure of the grape to form because the flower has not been pollinated or is misshapen, or when the immature grapes fall off prematurely. Heavy rain and a cold spell at the wrong time of year are generally to blame.

Éraflage, égrappage

French terms for the practice of separating the twigs and stems of bunches of grapes from the grape berries before fermentation and after the initial treading.

Fermentation vessel

Large wooden, concrete, or stainless steel vessel in which the must is left to ferment. The length of time the must is allowed to ferment and the temperature at which it does so varies according to the wine being made.

Filtration

Pouring the wine through a porous membrane or barrier to strain out the impurities.

Green harvest
Harvesting in summer. Picking the grapes while the leaves are still green tends to reduce the number of usable grapes, and consequently, the yield per hectare.

Lees
Solid matter in suspension in the must or at the bottom of a vat, cask, or hogshead after the wine is drawn off the top. The lees nourish and protect the wine.

Malolactic fermentation
Breaking down the malic acid into lactic acid through the action of lactic bacteria. The wine is made more supple. All red wines are subjected to malolactic fermentation, as are white Burgundies, but white Bordeaux wines do not undergo this type of fermentation.

Marc
Solids, mainly grape skins, extracted from the fermentation vat and pressed separately.

Mass selection
Selection of plants that are genetically different.

Mildew
Fungus disease of vines and other plants. It reached Europe from the United States in the nineteenth century. To prevent it, vines are treated with *bouillie bordelaise* (copper sulfate).

Must
Cloudy juice extracted from grapes prior to fermentation.

Noble rot
See *Botrytis cinerea*.

Oenology
The study of winemaking.

Oidium
A wilt caused by a mold of American origin that first appeared on European grapes and other crops in the nineteenth century. It attacks the leafy parts of the vine and is destroyed by applications of sulfur.

Organoleptic
Pertaining to or perceived by sensory organs—eyes, nose, and mouth, in the case of wine.

Ouillage
French term meaning to top up after a loss of liquid caused by evaporation.

Over-ripeness
Condition of the grape that is past full maturity. Over-ripeness is sought after in Bordeaux white dessert wines.

Oxidation
Any substance which fixes oxygen is oxidable, as are most of the components of wine. Aging is caused by oxidation.

Pellicular maceration
Maceration prior to fermentation of grapes that not been trodden, designed to extract the aromatic elements from the grape skins.

Photosynthesis
The process by which the leaf transforms sunlight into green matter (chlorophyll) and sugar, which it then transfers to the grape.

Phylloxera
Plant-louse accidentally imported from the United States. The insects feed on the roots, causing galls on the leaves and nodules on the roots of the vine. Phylloxera was first identified in the second half of the nineteenth century, and although it could be partially destroyed by immersing the roots in carbon sulfate, it has never been completely eradicated. The only solution was to graft the European *Vitis vinifera* onto the roots of American grape varieties, and this saved the French vineyards from complete destruction.

Polyphenols
Phenols (especially anthocyanes and tannins) that are essential constituents of red wines, contributing aroma, color, and structure.

Pressing
Compression of the grape or marc in a press in order to extract the juice. When grapes are pressed, the liquid obtained is a white must. If marc is pressed, a red "pressed wine" is obtained.

Pruning
Cutting back the woody parts of the vine in order to promote fruiting.

Remontage

A French term for a process which consists of taking the must from the bottom of the fermentation vat and sprinkling it over the matter floating on the surface of the vat in order to activate the aromatic and phenolic components of that surface cap. Remontage is performed several times a day for several days running. It also helps to aerate the must.

Residual sugars

Sugars remaining in the wine after alcoholic fermentation.

Rootstock

Root onto which another vine is grafted. American vine roots are resistant to phylloxera.

Saignée

French term meaning "bleeding." It is the action of removing grape juice from a vat either to produce a rosé wine or to concentrate what remains in the vat.

Soutirage

French term meaning to transfer wine from one vessel to another in order to separate the wine from its lees.

Spätlese

German term meaning "late harvest."

Sulfating

Spraying or dusting vines with a sulfate solution to eliminate fungal pests, such as mildew, oidium, etc. Also used to describe the addition of a sulfurous anhydride to the must or wine to protect it against oxidation and attacks by microorganisms.

Sulfuric dioxide (SO₂)

An aid to vinification that is antioxidant and bacteriocidal. The proportion is regulated as it can constitute a health hazard if used in large quantities.

Tannin

A phenolic astringent and bitter component found in the grape stalks, skins, and seeds, and in the wood of the casks, that is an essential ingredient in red wines, especially claret.

Trie

French term used to denote harvesting by picking only those grapes or bunches that are ripe, leaving the rest on the vine. The exercise is performed several times over on the same vines.

Trockenbeerenauslese (TBA)

Type of German wine resulting from very selective harvesting of the grapes affected by noble rot.

Variety, stock

Variety of the grapevine cultivated. The European grapevine, *Vitis vinifera*, is divided into about three thousand different varieties, which produce vastly differing results when vinified.

Vin de goutte

Red wine obtained from the runoff produced by the pressure of the grapes in the vat.

Vin de presse

Red wine produced by pressing the grapes after the vin de goutte has run off.

Vin marchand

Wine of merchantable or saleable quality. A wine is deemed to be merchantable if it has recognizably good organoleptic qualities when analyzed and tasted.

Vinage

Adding alcohol to a wine. The practice is banned unless it is for the production of a non-sparkling sweet white wine.

Volatile acid

Acid of the acetic type whose content is controlled by regulation (less than a gram per liter). This is what gives vinegar its flavor.

Address Book

FRANCE

Bordeaux

Château Margaux
Château Margaux S.A.
BP 31–33460 Margaux
www.chateau-margaux.com
Château Margaux 1900

Château d'Yquem
33210 Sauternes
www.yquem.fr
Château d'Yquem 1921

Château Latour
SCV de Château Latour,
Saint-Lambert
33250 Pauillac
www.chateau-latour.fr
*Château Latour 1928
and 1961*

**Château Haut-Brion and
La Mission Haut-Brion**
Domaine Clarence Dillon S.A.
33602 Pessac Cedex
*Château Haut-Brion 1989
and Château la Mission
Haut-Brion 1929*

**Château Mouton
Rothschild**
Baron Philippe de Rothschild
S.A.
10, rue Grassi
33250 Pauillac
www.bpdr.com
*Château Mouton Rothschild
1945*

Château Cheval Blanc
SC du Cheval Blanc
33330 Saint-Émilion
www.chateau-cheval-
blanc.com
Château Cheval Blanc 1947

Château Lafite-Rothschild
SC du Château Lafite-
Rothschild
33250 Pauillac
www.lafite.com
*Château Lafite-Rothschild
1959*

Château Pétrus
SC du Château Pétrus
33500 Pomerol
www.moueix.com
Pétrus 1982

La Mondotte
Château Canon La Gaffelière
BP 34, 33330 Saint-Émilion
www.neipperg.com
La Mondotte 2000

Château Montrose
33180 Saint-Estèphe
www.chateau-montrose.com
Montrose 2003

Burgundy

**Domaine de la
Romanée-Conti**
SC du Domaine de la
Romanée-Conti
1, rue du Derrière-le-four
21700 Vosne-Romanée
*Romanée-Conti 1921 and
La Tâche 1937*

**Domaine du Clos
des Lambrays**
Société du Domaine des
Lambrays
31, rue Basse
21220 Morey-Saint-Denis
www.lambrays.com
Clos des Lambrays 1945

**Domaine Comte Georges
de Vogüé**
7, rue Sainte-Barbe
21220 Chambolle-Musigny
Musigny de Vogüé 1949

**Domaine du Château
de Beaune**
Domaine Bouchard Père et Fils
BP 70, 21202 Beaune
Montrachet 1989

Domaine Méo-Camuzet
11, rue des Grands-Crus
21700 Vosne-Romanée
www.meo-camuzet.com
Richebourg 2005

Loire Valley

Château de Fesles
Vignobles Germain and Ass.
Loire
49830 Thouarcé
www.fesles.com
Château de Fesles 1947

Rhone Valley

Paul Jaboulet Aîné
Les Jalets
BP 46, La Roche de Glun
26600 Tain-l'Hermitage
www.jaboulet.com
Hermitage la Chapelle 1961

Château de Beaucastel
Famille Perrin
Château de Beaucastel
Chemin de Beaucastel
84350 Courthézon
www.beaucastel.com
Château de Beaucastel 1967

Château Rayas
Route de Courthézon
84230 Châteauneuf-du-Pape
www.chateaurayas.fr
Château Rayas 1978

Champagne

Champagne Bollinger
16, rue Jules-Loband
51160 Aÿ
www.champagne-
bollinger.com
Bollinger 1911

Champagne Salon
5-7, rue de la Brèche-d'Oger
51190 le Mesnil-sur-Oger
www.champagnesalon.com
Salon 1928

Champagne Philipponnat
13, rue du Pont
51160 Mareuil-sur-Aÿ
www.philipponat.com
Clos des Goisses 1975

Champagne Moët et Chandon
20, avenue de Champagne
51200 Épernay
www.moet.com
Dom Pérignon 1985

Champagne Veuve Clicquot Ponsardin
12, rue du Temple
51100 Rheims
www.veuve-clicquot.com
Veuve Clicquot Grande Dame 1990

Champagne Krug
5, rue Coquebert
51100 Rheims
www.krug.com
Krug 1996

Champagne Pol Roger
1, rue Henri-Le-Large
BP 199, 51206 Épernay cedex
www.polroger.com
Pol Roger 2008

GERMANY

Weingut Egon Müller
D-54459 Wiltingen
Scharzhof
www.scharzhof.de
Scharzhofberger Auslese 1971

Domänenweingut Schloss Schönborn
Hauptstrasse 53
D-65347 Hattenheim
Rheingau
www.schoenborn.de
Hattenheimer Pfaffenberg 1976

Dr. Bürklin-Wolf
Gutsverwaltung
67153
Wachenheim/Weinstrasse
www.buerklin-wolf.de
Kirchenstrück Riesling Trocken 2002

ARGENTINA

Nicolàs Catena Zapata
J. Cobos s/n Agrelo
Luján de Cuyo
Mendoza
www.catenawines.com
Nicolàs Catena Zapata 2003

AUSTRALIA

Penfolds Magill Estate
78 Penfold Road
Magill 5072
www.penfolds.com
Penfolds Grange 1962

AUSTRIA

Weingut Friedrich un Georg Seiler
Stezgasse, 10
7071 Rust
Ruster Ausbruch 1934

SPAIN

Bodega Vega Sicilia SA
Finca Vega Sicilia
47359 Valbuena de Duero
www.vega-sicilia.com
Vega Sicilia 1970, Pintia 2003

Bodega Alejandro Fernandez
Calle Real 2
47315 Pesquera de Duero
Valladolid
www.grupoesquera.com
Pesquera Janus Reserva 1982

UNITED STATES

Diamond Creek Vineyards
1500 Diamond Mountain Road
Calistoga, CA 94515
www.diamondcreekvine-yards.com
Diamond Creek Lake 1994

Frog's Leap
8815 Conn Creek Road
Rutherford, CA 94573
www.frogsleap.com
Frog's Leap 2002

HUNGARY

Oremus
András Bacsó, Bajcsy-zs u. 45
3934 Tolcsva
Tokay Aszü 1995

ITALY

Franco Biondi Santi
Villa Greppo, Loc Greppo, 183
53024 Montalcino
www.biondisanti.it
Brunello di Montalcino 1964

Tenuta San Guido
CITAI SpA
loc. Le Capanne 27
57022 Bolgheri Livorno
www.sassicaia.com
Sassicaia 1985

Gaja Angelo Societa Semplice
Azienda Agricola,
Via Torino 38
12050 Barbaresco
Barbaresco Sori San Lorenzo 1989

Ca' del Bosco SpA
Via Albano Zanella, 13
25030 Erbusco
www.cadelbosco.it
Ca' del Bosco 1996

Barbaresco Rabajà
Via XX Settembre, 52
Neive (Cn)
www.brunogiacosa.it
Barbaresco Rabajà 2001

NEW ZEALAND

Te Awa
2375 State Highway 50
RD5, Hastings–Hawkes Bay
www.teawa.com
Te Awa Boundary 2001

PORTUGAL

Taylor Fladgate & Yeatman
Rua do Choupelo, 250
4400-088 Vila Nova de Gaia
Taylor's 1935

Contents

Part Three
Vintages from 2000 to 2008

Appendices

Photographic Credits

Agencies
KEYSTONE – pages 94–95 (except photo 3), 110–111 (except photo 5), 122–123 (except photo 5), 134–135 (except photo 3), 141 (except photo 3), 149 (except photo 3), 154–155 (except photo 3), 160–161 (except photos 2 and 5), 172–173 (except photos 1 and 5), 184–185 (except photo 1), 194–195 (except photos 1 and 5), 200–201 (except photos 1 and 4), 223, 231 (except photo 4), 236–237 (except photos 2 and 5), 244 photo 1, 252–253 (except photos 3 and 5), 270 photo 2.
SYGMA – pages 280–281, 290–291, 306–307, 324–325 (photo 1: 1999 Johan Otto Von Spreckelsen), 334–335, 342–343, 352–353, 362–363.
KEYSTONE-SYGMA – pages 101 photo 3, 123 photo 5, 135 photo 3, 140–141 (except photos 4 and 5), 148–149 (except photos 3 and 4), 154 photo 3, 160 photo 2, 161 photo 5, 172 photo 1, 173 photo 5, 184 photo 1, 194 photo 1, 195 photo 5, 200 photo 1, 201 photo 4, 212–213, 222, 230–231 (except photos 3 and 5), 236 photo 2, 237 photo 5, 244–245 (except photo 1), 253 (except photo 4), 262–263, 270–271 (except photo 2).
MAGNUM PHOTOS – page 45; Evan Fairbanks page 383 photo 3; Martine Franck page 421 photo 7.
SCOPE – Jean-Luc Barde pages 37, 41, 52, 57, 67, 73, 74–75, 81, 86–87, 189, 221, 367; Isabelle Eshraghi page 32; Daniel Gorgeon page 24 (bottom); Philip Gould page 338; Christian Goupi pages 375, 378–379; Jacques Guillard pages 11, 15 (top and bottom), 17, 18, 19, 24 (top and center), 33 (center), 36, 51, 55, 63, 69, 70, 71, 115, 143, 157, 169, 170, 239, 247, 248, 249, 250, 251, 265, 273, 285, 343, 345, 348, 349, 353; Michel Guillard endpapers and pages 12, 14, 21, 25, 28–29, 97, 293, 364; Frédéric Hadengue page 15 (center); Francis Jalain pages 10, 33 (bottom); Kaktus pages 82–83; Sara Matthews page 81; Michel Plassart page 13; Nick Servian pages 89, 90–91.
GETTY IMAGES – Aurora page 404 photo 1; Philippe Desmazes/AFP page 404 photo 2; Eric Feferberg/AFP page 382 photo 2; Evelyn Floret/Time & Life Pictures page 393 photo 3; Tim Graham page 412 photo 3; Pascal Guyot/AFP page 412 photo 1; Acey Harper/Time & Life Pictures page 420 photo 2; NASA/Newsmakers page 382 photo 1; Ian Waldi/AFP page 372 photo 1.
CORBIS-SYGMA – page 372 photo 2; Oliver Berg/dpa page 393 photo 4; Russell Boyce/Reuters page 405 photo 5; Gero Breloer/epa page 421 photo 6; Martin Gerten/epa page 405 photo 3; Gianni Giansanti page 413 photo 5; Antoine Gyori page 373 photo 3; Wang Haiyan/China Features page 405 photo 4; Eduardo Longoni page 395; Tannen Maury/epa page 420 photo 3; NOAA/Zuma page 412 photo 2; Sarai Suarez/epa page 392 photo 1.
AFP – page 420 photo 4; Thomas Coex page 373 photo 4; Larseric Linden/Scanpix Sweden page 383 photo 4; Noticias Uno page 393 photo 2; Georges Gobet page 413 photo 4.

French Producers
Baron Philippe de Rothschild SA pages 164, 165, 166–167; Champagne Bollinger pages 22, 103, 104, 105, 108, 109; Champagne Krug pages 354, 355; Champagne Moët and Chandon pages 291, 292, 296, 297; Champagne Philipponnat pages 256, 257, 258, 259, 260, 261; Champagne Salon pages 130, 131, 132, 133; Champagne Veuve Clicquot Ponsardin pages 43, 255, 325, 326, 327, 328–329, 330, 331; Château d'Yquem page 47; Château Montrose pages 398–399, 401; Domaine Méo-Camuzet pages 407, 409, 410–411; Domaine du Château de Beaune pages 316, 317, 318, 319; Domaine du Clos des Lambrays pages 168, 171 (Jean-Louis Bernuy); Domaine Comte Georges de Vogüé. pages 190, 191, 192–193; Domaines Perrin pages 233, 234, 235; Paul Jaboulet Aîné pages 203, 204, 205, 206–207; Pol Roger pages 415, 416-417, 418, 419; SA du Domaine Clarence Dillon (photographs by Burdin) pages 138, 139, 308, 309, 310, 311; SC du Château Margaux pages 95, 96, 98, 99; SC du Château Lafite-Rothschild pages 197, 198, 199; SC du Cheval Blanc pages 176, 178, 179; SC du domaine de la Romanée-Conti pages 116, 158, 159; SCV de Château Latour pages 27, 33, 125, 126, 127, 207, 211; Vignobles Germain and Associés Loire pages 23, 182, 183.

International Producers
Bodega Alejandro Fernandez pages 284, 286, 287; Bodega Catena Zapata page 397; Bodega Vega Sicilia SA pages 240, 241, 242, 243; Bodegas y Viñedos Pintia SA page 403; Bruno Giacosa page 377; Diamond Creek Vineyards page 337; Domänenweingut Schloss Schönborn pages 266, 267, 268–269; Franco Biondi Santi (Tenuta Greppo) pages 60–61, 225, 226, 227, 228, 229; Frog's Leap pages 385, 391; Gaja Societa Semplice page 314; Marchesi Incisa della Rocchetta (Tenuta San Guido) pages 298, 299, 300, 301; Oremus pages 344, 346, 347; Read Mac Carthy group pages 216, 217, 218, 219; Taylor Fladgate & Yeatman pages 151, 152, 153; Te Awa Winery Ltd. pages 380, 381; Weingut Elisabeth und Friedrich Seiler pages 144, 145, 146, 147; Weingut Dr. Bürklin-Wolf pages 386, 387, 388–389.

As well as
Michel Blanc/comité de promotion de Châteauneuf-du-Pape page 276; Christie's International Wine Department pages 31, 113, 114, 117, 118–121, 137, 163, 165, 175, 187, 199, 211, 215, 220, 274, 275, 277, 281, 282, 283, 302–303, 307, 313, 320, 321, 335; Collection CIVC (Comité Interprofessionnel du Vin de Champagne) 294–296 (Jean-Paul Paireault), 358–359 (Rohrscheid); All rights reserved pages 420–421 photos 1 and 5; Laziz Hamani/Éditions Assouline pages 26, 34, 35, 128–129, 209, 211, 312, 315, 336, 339, 356, 357; Madame de Labarre pages 180–181; Denis Mollat page 177; François Poincet pages 369, 370–371; Jean-Pierre Procureur pages 106–107, 111 photo 5.

Acknowledgments

The author and the publisher would particularly like to thank:
Monsieur Philippe Pascal, whose idea it was to produce this book, Mr. Thomas Hudson (Christie's), Filippa Tiago (Maison Veuve Clicquot Ponsardin), Madame de Labarre, Monsieur Denis Mollat, Monsieur Jean-Pierre Procureur, Madame Marika Nacajo, Monsieur Andras Bacso, Madame Jeannine Coureau, the CIVC (Comité Interprofessionnel du Vin de Champagne), Monsieur Michel Blanc (Fédération des Syndicats de Producteurs de Châteauneuf-du-Pape), Bernard Ginestet, and Étienne Touzot, as well as all the producers who contributed illustrations for this work. Our thanks also to the Scope, Sygma, Keystone, Getty Images, Corbis, AFP, and Magnum Photos photographic agencies, who did so much to make this book a success.